Simon Stafford
Nikon AF Speedlight Flash System

Magic Lantern Guides

Nikon

Nikon AF Speedlight Flash System
Master the Creative Lighting System!

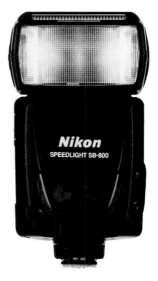

Simon Stafford

LARK BOOKS
A Division of Sterling Publishing Co., Inc.
New York

778.72
S779

Book Design and Layout: Michael Robertson
Cover Design: Thom Gaines – Electron Graphics

Library of Congress Cataloging-in-Publication Data

Stafford, Simon.
 Nikon AF speedlight flash system : master the creative lighting system! /
Simon J. Stafford.-- 1st ed.
 p. cm.
 Includes bibliographical references and index.
 ISBN 1-57990-588-9 (pbk.)
 1. Electronic flash photography. 2. Nikon camera. I. Title.
TR606.S73 2005
778.7'2--dc22

 2005012494

10 9 8 7 6 5 4 3 2 1
First Edition

Published by Lark Books, A Division of Sterling Publishing Co., Inc.
387 Park Avenue South, New York, N.Y. 10016

©2007, Simon Stafford
Photography ©Simon Stafford unless otherwise specified

Distributed in Canada by Sterling Publishing, c/o Canadian Manda Group, 165 Dufferin Street Toronto,
Ontario, Canada M6K 3H6

Distributed in the U.K. by Guild of Master Craftsman Publications Ltd., Castle Place, 166 High Street,
Lewes, East Sussex, England BN7 1XU
Tel: (+44) 1273 477374, Fax: (+44) 1273 478606,
Email: pubs@thegmcgroup.com; Web: www.gmcpublications.com

Distributed in Australia by Capricorn Link (Australia) Pty Ltd.,
P.O. Box 704, Windsor, NSW 2756 Australia

If you have questions or comments about this book, please contact:
Lark Books
67 Broadway
Asheville, NC 28801
(828) 253-0467

Printed in the United States

ISBN 13: 978-1-57990-588-0
ISBN 10: 1-57990-588-9

For information about custom editions, special sales, premium and corporate purchases, please con-
tact Sterling Special Sales Department at 800-805-5489 or specialsales@sterlingpub.com.

Contents

Introduction

The introduction of the SB-24 Speedlight during 1988 was a watershed in the history and development of the Nikon Speedlight system. It was the first model in a new line of "smart" flash units that offered an outstanding range of sophisticated features. The key to these new features was the communication between the Speedlight and a compatible Nikon camera (at that time the F4 and N8008/F-801). Not only did the SB-24 offer TTL flash control with off-the-film metering measured by sensors in the camera, but the Speedlight and camera also worked together to provide what Nikon called Matrix Balanced Fill-flash. This made it possible to automate the combination of flash and the prevailing ambient light.

The SB-24's flash head could tilt and rotate, and an automatic zoom function adjusted flash coverage to match changes in the focal length of a zoom lens. Another entirely new feature was the ability to synchronize the flash output with the closing of the camera shutter for a technique that is known as Rear-curtain sync or second-curtain sync. The latter and the automated fill-flash capabilities of the SB-24 were the reasons I added one to my camera bag all those years ago without hesitation

The sophistication of the Nikon Speedlight system has continued to evolve steadily over the years. New features, such as built-in diffusers for ultra wide-angle lenses and focal plane high-speed sync flash mode, have been added. In the opinion of many photographers, the system has remained unsurpassed when combined with the company's film cameras. The advent of digital SLR (D-SLR) camera models, however, introduced new technical challenges, particularly with respect to estab-

◁ *Whether you are using Speedlight flash equipment professionally or just for the enjoyment of creating great photos, Nikon's versatile Creative Lighting System (CLS) offers components that will meet your every need.*

lished through-the-lens (TTL) methods for measuring and assessing flash exposure and using multiple Speedlights. For a time, the functionality of Speedlights with digital cameras, such as the Nikon D1, launched during 1999, left something to be desired compared with their capabilities when used with a Nikon film camera.

Thanks to the efforts of its designers and engineers, Nikon has re-claimed its position at the pinnacle of flash system design with the introduction of the SB-800 and SB-600 Speedlight models. Combined with compatible cameras (currently the D2-series, D200, D70s, D70, D50, and F6), the SB-800 and the SB-600 Speedlights represent the cornerstones of what Nikon calls its Creative Lighting System (CLS). During late 2005, Nikon announced the introduction of the SU-800/SB-R200 Macro-Speedlight outfit to complement the two existing CLS Speedlight models to provide a fully integrated, highly flexible, and easily portable lighting system. In addition to the Speedlights, Nikon produced a prolific range of accessories to support their flash units. Thus, the Nikon Speedlight system offers an unprecedented number of features that allow photographers to flex and extend their creativity.

Conventions Used In This Book

A number of Nikon D-SLR cameras have a base sensitivity equivalent to ISO 200, but some literature produced by Nikon uses a sensitivity of ISO 100 when quoting a guide number. Historically this has been the practice adopted when discussing flash for film camera models. It is important to check how the guide number you use is expressed. All guide numbers in this book are provided in the following form: X feet (X meters).

Unless otherwise stated, when the terms "left" and "right" are used to describe the location of a camera or flash control, it is assumed the camera is being held to the photographer's eye in the shooting position.

In describing the functionality of equipment, it is assumed that the appropriate Nikon camera, Speedlight, or Nikkor lens is being used. Since the operation of cameras, lenses, and flash units made by independent manufacturers may vary, please refer to the manufacturer's instruction manual for compatibility.

About This Book

While I will assume you know the basics about how to use your camera, and have a rudimentary understanding of exposure calculations, you do not need to be an expert on either—this book is intended to help the beginner, as well as the experienced Nikon photographer.

In my experience, flash is a topic that seems to generate as many questions as all the others concerning photography combined! Therefore, I have devoted sections to general flash photography techniques, as well as the specifics of the equipment. To get the most from your Nikon Speedlight it is important to not only understand its features, but to have a grasp of the general principles of flash photography as well, so you can make informed choices about how to apply them in conjunction with your style of photography.

The key to success, regardless of your level of experience, is to practice with your Speedlight. If you are using a film camera, this will probably mean paying for some extra film and processing, but it will be money well spent. In this respect shooting with a digital camera has several advantages. The price of memory cards has tumbled in recent times and, once you have invested in one, it can be used over and over again; you can shoot as many pictures as you like, review your results immediately, and then delete your near misses but save your successes—this trial and error method is a very effective way to expand your knowledge and talent!

Simon Stafford
Wiltshire, England.

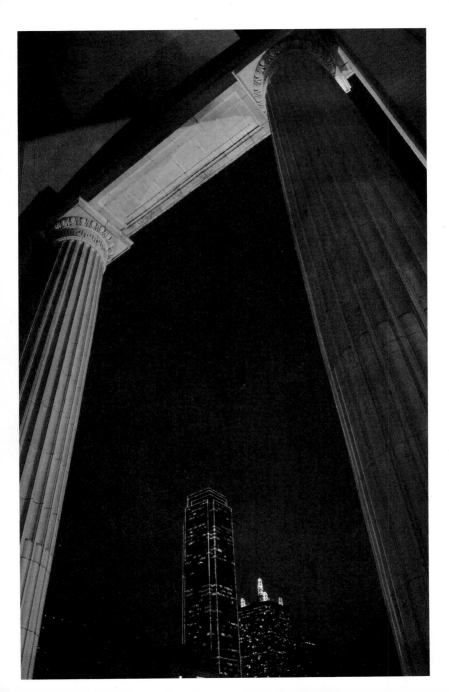

Basic Flash Concepts

The technology used in the Speedlights covered by this book is complicated and very sophisticated. Thankfully, there is no need to understand all the technical intricacies of how a Speedlight functions. However, to use flash effectively at both a technical and creative level, it is necessary to know how the core components of a flash unit work, how flash exposure is calculated, and to understand some basic properties of light.

Core Components
All of the Nikon Speedlights discussed in this book share common components:

- **Power source**
 Batteries power all the Nikon Speedlight models covered in this book. Each model requires four AA sized batteries, with the exception of the SU-800 Wireless Speedlight Commander unit and SB-R200 Speedlight, which are each powered by a single CR123A-size battery.

- **Capacitor**
 Capacitors temporarily store electrical energy so that it can be activated and released rapidly.

- **Flashtube**
 The flashtube fitted to the Nikon Speedlights mentioned in this book all have a single tube filled with xenon gas. Light output occurs in two stages. First, the gas is ionized by a low-level electrical charge; second, the electrical energy stored in the capacitor is discharged in the flashtube. This creates a high voltage across the ionized gas,

◁ *Slow sync allows the use of long shutter speeds with flash. Here, it was used to add flash illumination to the pillars, which nicely framed and offset the background, existing-light exposure of the buildings.*

The Nikon D200, its built-in Speedlight, and the SB-800 are all part of Nikon's new, innovative Creative Lighting System (CLS).

which reacts to the sudden change of state, and the energy released in this process is dissipated in the form of light—the flash burst.

- **Control circuit**
 The control circuit is responsible for managing and shifting the electrical energy from the power source to the capacitor and the flash tube. Operating in conjunction with appropriate Nikon cameras, the control circuit manages when the flash unit is triggered and for how long the flash tube emits light. The accuracy of the flash exposure is largely dependent on a specific section of the control circuit that rapidly diverts surplus electrical charge from the flashtube; as soon as it receives a command signal from the camera; this quenches the light from the flashtube instantaneously.

In addition to the components found within a Speedlight, there are a number of external elements contained in compatible Nikon camera bodies that compliment and significantly enhance the degree of control on the light output.

Principal among these external elements are the circuitry and light sensors that perform the TTL (through-the-lens) flash exposure control. Although these control systems vary depending on the camera model, they are essentially all the same since the calculations for the flash exposure are performed in the camera based on the information gathered by the light sensors. The Speedlight merely responds to a "quench" command to shut off the light output from the flashtube.

Communication between the camera and the Speedlight is accomplished via the electrical contacts set in the hot shoe and flash footplate. Modern Nikon cameras send information about lens aperture, film speed, digital sensor sensitivity, flash mode, flash exposure compensation factor, and shutter release to the Speedlight. The flash corresponds by sending information related to the flash ready signal, flash mode, and warning signals for under or over-exposure.

Flash Exposure

Flash Synchronization Speed

The duration of the pulse of light from a Speedlight is extremely brief. Using the SB-800 as an example, its flash burst can range between about 1/1000 second at full output to 1/40,000 second at 1/128 of its maximum output. This requires the calculations of the flash output and work of the control circuit, discussed in the previous section, to be performed at very high speed as all of these operations are carried out in a fraction of a second after the shutter button of the camera is depressed and the shutter opens.

However, due to the design of the focal plane shutters used in Nikon cameras, each model has a specific shutter speed above which it is not possible to synchronize the

flash. This is known as the maximum flash synchronization speed, or "maximum sync speed."

Why is the shutter speed range limited in this way when combined with flash? The shutters in modern Nikon cameras are comprised of two series of blades (often referred to as curtains). When the shutter is released, the first set of blades moves vertically across the film or digital sensor gate to begin the exposure. Then, depending on the shutter speed, the second set of blades, traveling in the same direction, covers the film/sensor again. In effect, there is a slit between the two sets of blades that sweeps across the film or digital sensor. At slow shutter speeds this slit is as wide as the entire frame area but, as the shutter speed is increased, the slit becomes narrower than the frame area. The maximum flash sync speed is determined by fastest shutter speed at which this slit uncovers the full width of the frame. Typically, recent Nikon cameras feature a top normal flash sync speed of either 1/125 or 1/250 second.

If a Speedlight is fired at a shutter speed that is faster than the maximum flash sync speed, the shutter blades will obscure part of the film or digital sensor, preventing the flash's output from reaching this area. Most modern Nikon cameras, however, will automatically default to the maximum flash sync speed if a higher shutter speed is set inadvertently.

Note: In Focal Plane (FP) High Speed sync mode it is possible to use shutter speeds that exceed the normal maximum flash sync speed, but it has consequences in terms of the shooting distance (see Focal Plane (FP) High-Speed Sync, page 99).

Note: On some Nikon D-SLR models (D1-series, D70/D70s, D50) the maximum flash synchronization speed is a 1/500 second. These cameras have an electro-mechanical shutter that emulates high shutter speeds (above 1/250 second) by opening the shutter for a 1/250 second and then switching the camera's sensor on and off electronically for a shorter exposure time.

Note: On the D2-series cameras and the D200, the flash synchronization speed is restricted to 1/250 second.

Note: With the exception of the D200 camera, all previous and current Nikon D-SLR cameras can be synchronized with non-dedicated third-party flash units at shutter speeds above the maximum flash sync speed possible with dedicated units. This is because shutter speeds above 1/250 second are created by switching the sensor on and off while the shutter remains open for a fixed period of 1/250 second.

Flash Recycle Speed

Immediately after a picture is taken with a Speedlight, its capacitor will have lost some or all of its stored energy. This amount of lost energy depends on the amount of light the flash was required to discharge. The batteries recharge the capacitor to prepare the Speedlight for the next exposure; the time it takes for this to occur is referred to as the "flash recycle time." The length of time that it takes to recycle the unit will vary depending on a number of factors:

Level of flash output: The more light the flash has to produce, the more energy drawn from its capacitor; therefore, the longer it takes to recharge.

Condition of the batteries: The ability of all battery types to recharge the capacitor changes with use—causing recycle times to be extended. However, the performance of some types of batteries is better than others (see Batteries, page 134).

Operating temperature: As battery dependent devices, Speedlights are susceptible to the effects of the ambient temperature. Low temperatures, in particular, affect battery performance, prolonging the recycle time (see Batteries, page 134).

Speedlight model in use: Those models with lower maximum Guide Numbers output less light and, generally, have shorter recycle times than more powerful models. For example, based on Nikon's tests using NiMH (2000mAh) batteries, the SB-600 can recycle in just 2.5, while the SB-800 takes 4 seconds.

Note: If you fire a Speedlight before its capacitor has completed the full recycle of charging, the output of the flash may not be sufficient to illuminate the picture properly.

Exposure with Flash

Before discussing how flash affects an exposure, consider the three factors that influence exposure without flash: the aperture of the lens, the shutter speed, and the sensitivity of the film or digital sensor (the ISO value).

Light reaches the film or digital sensor via a lens. A diaphragm with a variable sized hole (the aperture) in its center, located within the lens, is used to control how much light passes through it. As the aperture is reduced in size, less light passes through the lens; as it is made larger, more light passes through. The length of time the film or digital sensor is exposed to light will also influence the exposure. Thus, the second factor—shutter speed—must also be included in the exposure calculations. Finally, the amount of light required for a proper exposure will also depend on the sensitivity of the film or digital sensor used to record it.

In most cases a photographer will set a particular level of sensitivity, so control of the exposure becomes a combination of the aperture and shutter speed biased in favor of one or the other depending on how the photographer wants to record the subject and the amount of light available. In many types of photography depth of field is the most important consideration, thus the aperture is chosen first, leaving the shutter speed as the only variable to control the exposure. There are exceptions to this, such as sports and wildlife

photographers who often require a fast shutter speed to "freeze" movement, so, they select an appropriate shutter speed and use the aperture to control exposure.

In situations where the ambient light is low, the Speedlight it is likely to provide the primary light for the exposure, which introduces two more variables: the amount of light produced by the flash and the distance between the flash and the subject. In this situation the brief duration of the flash pulse becomes the effective shutter speed and the shutter speed selected on the camera does not influence the resulting picture. Things change according to the ratio of the light produced by the flash and the available light. If the flash is used as a supplementary light source, like daylight fill-flash, the shutter speed is relevant, as it will affect how the available light is recorded.

How Flash Affects Exposure Variables
These concepts can be confusing especially for the less experienced, so consider the following scenarios:

• Imagine you are in a completely dark room with no source of light other than the flash on your camera. When you press the shutter release the flash fires providing the only light for the exposure. In this situation it does not matter how long the shutter remains open, as no other light will be recorded by the film or digital sensor. The duration of the flash pulse becomes the effective shutter speed and "freezes" movement since the subject is only illuminated for this brief period of time.

• A far more common situation is to use flash in a dimly lit interior, where there is a low level of ambient light. The flash remains the primary light source because its output is significantly brighter than the other light(s). Thus, those areas of the scene illuminated by the ambient lighting alone will appear grossly underexposed.

Why is there such a disparity between the two light sources? At full output a Speedlight is designed to provide, for a very brief

period over a short distance—a pulse of light that is equivalent in intensity to daylight sunshine. By comparison, average interior lighting is very dim, typically about 5 stops (32x) less bright. The dynamic range—the range of brightness from the lightest to darkest level of illumination that film or digital sensors are capable of recording—extends over about 5 to 7 stops. So, the flash remains the principal light source as its output is sufficient to illuminate the room at an exposure that emulates daylight, while the much lower level output from the room light is barely recorded. Usually this can result in a correctly exposed subject against a black or near black background. Used this way the flash determines the exposure. Unless a long shutter speed is selected to record the ambient light (which introduces the risk of camera shake), the shutter speed selected on the camera is usually irrelevant, as is the exposure suggested by the through-the-lens (TTL) metering of the camera, because it is based on the prevailing ambient light and not the flash output. (I will discuss using flash to supplement ambient light in other sections of the book.)

The "dark interior lit by flash" situation is compounded when the camera is used in either Aperture Priority (A), or Program (P) exposure modes, because most Nikon cameras will default to a shutter speed in the range of 1/250 to 1/60 second as soon as you attach a Speedlight and switch it on. Shutter speeds in this range are generally too brief to allow those areas of the scene lit by the dim ambient light from room lighting to record properly.

Note: At default settings on most Nikon camera bodies, if you select Shutter priority (S) and Manual (M) exposure modes (or use Slow or Rear flash sync), the shutter speed becomes relevant as it can affect how the ambient light is recorded.

To summarize this section, when you take a picture with flash and it is the principal light source, the exposure is usually determined by four factors:

• The sensitivity of the film or digital sensor

• The lens aperture

22

Light falls off considerably the further it travels from its source, as defined by the Inverse Square Law. Photo ©Kevin Kopp

- The power of the flash unit (see Guide Numbers, page 28).

- The distance between the flash and the subject (see The Inverse Square Law on the following page).

Characteristics of Light

The Inverse Square Law

Here is an important factor—the Inverse Square Law, which applies to light regardless of its source, including your Speedlight! It is the reason that flash units do not provide even illumination throughout a scene.

The Inverse Square Law states that the further light travels from its source, the lower its intensity becomes. Also, the brighter a light source, the greater the distance over which its light can be used.

The Inverse Square Law defines the level of light available from a fixed output source relative to the distance from that source. If the source produces an amount of light equal to A at a distance of X, at a distance of twice X, it produces light equal to a quarter of A.

As a formula, this is stated as follows:

$$\text{Light intensity} = 1 / \text{Distance}^2$$

Consider a subject at a distance of five feet from a light source with a fixed output; the light intensity is $1/5^2 = 1/25$. If the distance is doubled to ten feet, the light intensity is $1/10^2 = 1/100$, or a quarter of the light available at five feet.

To calculate the specific light level from an individual flash it would also be necessary to include the power of the flash in the equation, Light intensity = Flash power x 1 / Distance2 but thanks to automatic flash units, which make these calculations for us, we do not have to get bogged down with them very often, unless we resort to manual flash exposure control.

The important point is to ensure you understand the principle of the Inverse Square Law and how it affects the light from your flash. So, if you double the distance between the flash and the subject, the flash must put out four times as much light to maintain the same level of exposure.

Flash units have a finite amount of power. If you use a quarter of your unit's potential maximum power to properly expose a subject at a distance of 5 feet, you will require a full power output at a distance of 10 feet. At a distance of 20 feet your subject will receive only a quarter of the light required; thus, it will be two stops underexposed! To fix this, you could just open the lens aperture by 2-stops to compensate. However, it may not be quite that simple. First, you may not be able to increase the aperture (i.e. you are already at maximum aperture, or you need to maintain a specific depth-of-field), and second, you are still only adjusting the exposure for the subject.

Remember, the flash output provides proper exposure at a specific distance. In front of this point the light level will be too great and anything lit by the flash will appear over exposed. Beyond this point the light level will be too low and anything lit by the flash will appear underexposed.

Consider the following example: you want to photograph a person 10 feet from the flash in a large room, where a picture hanging on the wall behind the subject is 40 feet from the flash, and a piece of furniture is 5 feet from the flash. If the flash output is correct for proper exposure of the person, the picture on the wall, which is four times the distance from the flash, will receive only one-sixteenth of the light (-4 stops), while the piece of furniture that is half the distance from the flash will receive four times more light (+2 stops) than the subject.

This fall off in illumination often surprises less experienced photographers, and they think the overexposed foreground and underexposed background is a fault of their equipment, when it is the result of the Inverse Square Law. Even for the more experienced photographer, shots that are lit only by flash present a challenge in how to control exposure, so that the overall scene appears to be more evenly lit.

Interiors often contain incandescent lighting. Nikon makes an orange accessory filter that can be used with some Speedlights to approximately match color temperature of the prevailing lights. Photo ©M. Morgan

Color Temperature

During the course of a day natural light goes through a variety of tonal changes, from the red-orange we see at sunrise, to the neutral colors of the clear mid-day sun, and back again to the reds of sunset. Apart from short periods at dawn and dusk, our eyes adapt to these changes so that we barely notice them. Likewise, in artificial lighting we perceive colors as we expect to see them. Try looking at a house in daylight, with its interior lights switched on, and you will see that they have a distinct orange tone. After dark, the light from the lamps will appear much whiter or neutral.

The various colors of light are described by the term "color temperature," which is measured in units known as Kelvin (K). It sounds counter-intuitive, but warm light has a low Kelvin temperature and cool light has a high Kelvin temperature. The reason is that color temperature is based on the color of a piece of heated iron, called a black body radiator. As the metal gets hotter its

Nikon's Speedlight flash units emit light that is about 6000K, which is close in color temperature to outdoor existing light on a slightly over-cast day. Photo ©M. Morgan

color changes from red/orange (low temperature) to blue/white (high temperature). Generally, most daylight film is optimized for a color temperature of 5500K (which closely matches the color of daylight at midday under a clear sky), while tungsten-balanced film is designed for use with tungsten photoflood lamps that have a color temperature of 3400K. When shooting with film cameras, if the temperature of the ambient light you are shooting in differs from the recommended color temperature for your film, the photographs will take on a color cast. Most photographers would remedy the situation by using color-correction filters.

Like most flash units, the flash tube in a new Nikon Speedlight emits light with a color temperature of around 6000K; this can change a little with age and level of use. This slightly higher color temperature accounts for the rather cold appearance that pictures shot on daylight film lit primarily with flash often display (see Modifying Flash Color, page 115).

Digital cameras are far more versatile and most allow you to set a specific color temperature response, or white balance, which is applied during image processing in the camera. In addition to automatic white balance, most Nikon digital cameras also have a specific Flash setting white balance as well as a Pre-set white balance option. You can also set an alternative white balance value for creative purposes.

Guide Numbers
The Guide Number (GN) is a useful and important specification to know about your Speedlight(s). It is the way the output of the flash is quantified and, given the implications of the Inverse Square Law, the GN tells us whether a specific flash can generate enough light for a proper exposure.

The higher the GN, the more light the flash produces. But you need to check closely how the GN is expressed, since the information will vary considerably depending on these factors: the sensitivity (ISO rating), the units of distance (feet or meters), the angle of coverage of the flash tube (usually given as an equivalent to a lens focal length), and use of attachments that modify the path of light from the flash tube.

In Distance-Priority Manual flash, the SB-800 controls the output of light. It uses the flash-to-subject distance, the lens aperture value, which must be set on the flash, and the Guide Number of the Speedlight.

As I mentioned in the introduction, all Guide Numbers in this book are provided in the following form: X feet (X meters) where X is the Guide Number expressed in feet, and within the parentheses in meters. When appropriate, the Guide Number is given for both ISO 100 and ISO 200. I have done this because the base sensitivity of some Nikon digital camera models is equivalent to ISO 200. However, Nikon still quotes a GN for ISO 100. Likewise, all the GN information in this book is calculated for an angle-of-coverage equivalent to a 35mm lens for the 135-film (35mm) format.

If you know two of the three following values—GN, lens aperture, and flash-to-subject distance—you can calculate the third value.

- Guide Number (GN) = Aperture (f) x Distance (m/ft)

- Aperture (f) = Guide Number (GN) / Distance (m/ft)

- Distance (m/ft) = Guide Number (GN) / Aperture (f)

So, if you know the GN of your Speedlight and the distance between it and the subject, you can calculate the aperture required for a proper exposure. For example using a Speedlight with a GN 120 (ISO 100; feet; 35mm) at a flash-to-subject distance of 15 feet, the lens will need to be set to an aperture of f/8 to obtain a "correct" exposure.

GN 120 (feet) / 15 feet = f/8

Alternatively, you can work out the flash-to-subject distance, if you know the GN and lens aperture. For example, using a Speedlight with a GN 100 (ISO 100; feet; 35mm) at an aperture of f/4, the flash will emit sufficient light to expose the subject properly at a distance of 25 feet.

GN 100 (feet) / f/4 = 25 feet

Remember, these calculations are based on the assumption that the flash produces its maximum output and, if you have read the last section carefully, you recall that all calculations refer to the distance between the flash and the subject, not the camera and the subject. In many instances, which will be discussed later in this book, you may wish to move the flash off the camera, which will affect the GN value. If the flash remains within 30° of the lens-subject axis, there is no need to apply any compensation. However, at greater angles, the exposure should be increased as follows:

- At 45° of the lens-subject axis increase exposure by +0.5 stop

- At 60° of the lens-subject axis increase exposure by +1.0 stop

- At 75° of the lens-subject axis increase exposure by +2.0 stop

Remember that Guide Numbers are expressed in either feet, or meters. You must check which measurement system is used for the specifications of your Speedlight, and use the same one consistently throughout your calculations.

When shooting with a wide-angle lens, remember that most Speed- ⇨
light zoom heads adjust to match the lens coverage, which effectively reduces the unit's Guide Number.

Also, GN values are expressed for a specific zoom-head position, which is related to the lens focal length in use. Since the focal length of the lens will determine the angle-of-view, it is important to confirm the GN you use in your calculations correlates to the coverage of the lens if the full frame area is to be illuminated properly.

Note: The focal length that Nikon quotes for a GN value relates to the 35mm film format. If you are shooting on a Nikon digital SLR with a DX format sensor (23.7mm x 15.6mm), the angle-of-view of the lens is reduced, and its effective focal length is approximately equivalent to 1.5x that of the same lens used on a 35mm film camera. For example, on a Nikon D-SLR, a 24mm focal length provides coverage equivalent to a 36mm lens on a Nikon 35mm film camera; so, if the flash head of the Speedlight is also set to 24mm, light will be wasted at the periphery, illuminating an area outside the coverage of the lens. Thus, when you make flash calculations for a lens on a DX format D-SLR camera, make sure you use the Guide Number given for the effective focal length on the 35mm film format, and not the actual focal length of the lens. In the example here, calculation can be based on a Guide Number for a focal length of 35mm rather than 24mm.

Note: All manufacturers base their Guide Number values on an assumption that the flash will be used indoors to light an averaged-sized room, with pale-colored walls and a ceiling at an average-height. So, if you use your Speedlight out-doors, you will need to adjust the Guide Number value by multiplying it by 0.7 before using it to calculate the lens aperture or shooting distance.

Note: Nikon generally provides Guide Number values for an ISO film speed of ISO 100, but many films have different ISO ratings. A number of Nikon digital SLR cameras have a base sensitivity equivalent to ISO 200. To calculate a Guide Number value for any ISO rating/equivalent sensitivity other than ISO 100, multiply the Guide Number by the factor in the following list:

You can compute fill flash manually, but for snapshots it is easier to use Standard TTL and apply around −1.7 flash exposure compensation. Photo ©J. Hiller

ISO Rating	GN Factor	ISO Rating	GN Factor
25	0.5	250	1.6
32	0.55	320	1.8
40	0.63	400	2.0
50	0.7	500	2.25
64	0.8	640	2.5
80	0.9	800	2.8
100	1.0	1000	3.15
125	1.12	1250	3.55
160	1.25	1600	3.95
200	1.4		

Nikon Nomenclature

When it comes to flash photography it seems that no other aspect unfurls the veil of confusion more effectively than Nikon's flash modes. I have watched the furrows on the brows of even seasoned photographers become progressively deeper as they sit huddled over their Speedlight(s) trying to fathom which settings they should be using and, more importantly, why!

Nikon's terminology can at times be very confusing, which is hardly surprising, since over the years various descriptive terms have been modified. Even worse—some of them have been used to define several different functions and/or controls in the manuals of the various camera and Speedlight models. I hope by the end of this chapter the terminology and definitions will be much clearer.

Overview of Flash Modes

The flash mode determines the way in which a Speedlight is controlled, how much light it emits, and whether this output is monitored and managed by the photographer, the camera, or the Speedlight.

There are three general flash modes and, depending on the particular camera, lens, and Speedlight combination in use, some or all of them will be available.

○ *The Nikon Speedlight system has evolved to stay ahead of the needs of photographers and has often been the market leader in innovative features and functions. Accordingly, Nikon's flash terminology has changed, or been redefined, as its flash units have become more sophisticated.*

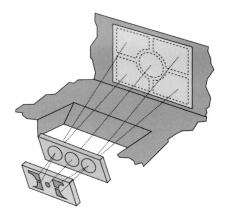

This drawing illustrates Nikon's off-the-film (OFT) TTL flash metering system.
©Nikon Inc.

Through-the-Lens (TTL)

In **TTL** or Through The Lens (TTL) mode, the camera controls the amount of light output by the Speedlight based on its assessment of the light passing through the lens. This is measured and calculated by sensors in the camera, although the precise method of control will depend on the functions available with the specific equipment in use.

Nikon has introduced three distinct TTL flash control systems as their range of cameras has developed over the years; they are TTL, D-TTL and most recently i-TTL. These are discussed in detail later in this chapter.

Automatic Flash—Non-TTL (A)

In **A** or non-TTL Automatic (A) mode, the output of the Speedlight is controlled by its own built-in sensor, which detects light reflected from the scene and uses this to assess when the flash should be shut off. As the Speedlight controls the output of the flash and receives no additional information from the camera, there is no limitation on Nikon camera models that can be used with a Speedlight in this mode.

Auto Aperture (AA) Flash

Most of the more recent Speedlights support a refined version of **A** that Nikon calls Auto Aperture (AA) flash or **AA**. Auto Aperture flash is set, automatically, by default when a Speedlight that supports this mode is attached to a compatible camera (see Camera/Flash Compatibility charts pp. 262-265). The sensor in the Speedlight is still responsible for measuring and controlling the flash output but additional data, including the lens focal length and aperture, ISO sensitivity and any set exposure compensation value is transmitted automatically from compatible cameras and lenses to improve the accuracy of the flash exposure.

Manual (M) Flash

In **M**, or Manual (M) flash mode the required output of the flash is predetermined by the user and this value is set on the Speedlight which fires at this fixed level. Neither the Speedlight, nor the camera makes any assessment of the flash output. Generally, at default settings the Speedlight will fire at its maximum output but some models, including those featured in this book, enable the user to adjust output. For example at 1/16 the flash output is reduced to a sixteenth of the maximum output available with that model.

Note: Regardless of which flash mode you choose on any specific model of Speedlight, it will always emit light at the same intensity; it is the duration of the flash pulse that determines how much light is emitted.

Choosing a Flash Mode

Choice of flash mode will depend on which are supported by the equipment in use, plus the nature of the subject and the prevailing conditions. When deciding between TTL flash control and non-TTL Automatic flash control consider the following:

• In TTL mode the camera controls the flash based on subject conditions detected by its through-the-lens metering sensors along with other system information. This includes,

The SB-800's LCD panel in TTL mode.

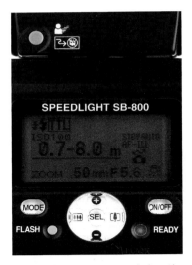

information from the camera's focusing system, and details of the lens' focal length and aperture. All of these factors are combined in the flash exposure calculations to improve accuracy (generally this requires a CPU-type lens, although some current cameras support the use of non-CPU lenses).

• In AA mode although the camera transmits information to the Speedlight in real time to supplement the computations used to assess the flash output (requires CPU-type lens), it is the sensor mounted in the Speedlight that actually measures the light. This sensor can detect light reflecting from surfaces either inside or outside (hence not seen by the lens) the frame area of the camera, which may influence the exposure adversely.

• In A mode, the same applies as it does to the AA mode (i.e. the light is measured by the built-in sensor of the Speedlight, which may detect light that is not seen by the camera lens). However, there is no additional information supplied from the camera to the Speedlight to supplement its flash output calculations (lens type is irrelevant). Therefore flash exposure is often less accurate compared with AA mode.

Hint: In almost every situation a TTL flash mode will produce flash exposures with greater accuracy more consistently, compared with either **AA** or **A** automatic flash modes.

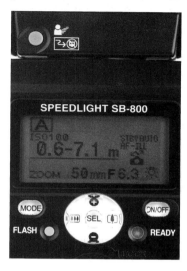

The SB-800's LCD panel in A mode.

Why Use Automatic (A) or Auto Aperture (AA) Flash Modes?

The **A** mode certainly has a place but it is confined, generally, to use with cameras that do not support TTL flash control, such as the FM2N, FM10, and F55. The **AA** mode can be useful when Speedlights that support the wireless control feature of the i-TTL system are used as remote units (see page 164).

Why Use Manual (M) Flash Mode?

When you want to take complete control of your flash select **M**. This is advisable in situations where you cannot depend on any of the various TTL flash control options, when it is not appropriate or possible to use the Speedlight's built-in sensor (some models such as the SB-600 do not have a sensor), or you require a specific duration for the flash output.

The SB-800's LCD panel in M mode.

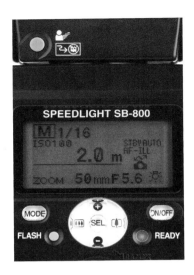

In this mode you will have to adjust either the settings of the camera, lens, and Speedlight to match the flash output to the flash-to-subject distance and sensitivity (ISO) rating, or calculate the amount of flash output required based on the Guide Number of the Speedlight. This will vary according to the flash output level and position of the flash reflector zoom-head selected, the ISO sensitivity, and flash to subject distance.

Note: Manual flash is also used in three other flash control methods: Focal Plane (FP) High-Speed Sync **GN** , distance-priority manual flash (SB-800 only), and **RPT** repeating flash, which are discussed in more detail in the Flash Techniques section.

Nikon TTL Flash Control Protocols

So far I have discussed the three main flash modes used by Nikon. As I suggested above, the TTL mode will, in most instances, provide the most reliable method of controlling flash exposure. Nikon's TTL flash exposure control system

has evolved through a variety of stages since its introduction in 1980. The first iteration of TTL flash control was fairly simplistic: The shutter was released; the flash would fire and emit its light, which would then be reflected back from the scene through the lens where it would strike the film. A proportion of this light would then be bounced off the film (OTF) and down on to a sensor located in the bottom of the camera's mirror box. This sensor would measure the flash light reflected from the film during the course of the exposure, until the camera's flash exposure control system determined that sufficient light had been emitted for a proper exposure. At this point the flash output would be turned off almost instantaneously.

The principal drawback with this system occurs when the subject occupies a relatively small part of the total frame area and, therefore, reflects only a small amount of the light from the flash. In this instance, the nature of the background will have a considerable affect on the flash exposure. For example, if the background is very dark or is a long distance behind the subject, the level of reflected light from the flash will be low. The camera will register this and compensate by increasing the flash output, which causes the subject to be overexposed. Conversely, if the background is very light or highly reflective, a much greater proportion of light from the flash will be reflected, and the camera will reduce the flash output, which will cause the subject to be underexposed.

TTL with Film Cameras

In an effort to overcome the problems of calculating flash exposure in situations where there is a wide range of contrast between the subject and its surroundings, Nikon introduced a significantly enhanced TTL flash control system with the introduction of the Nikon N90/F90 and SB-25 Speedlight in 1992. The system uses what Nikon calls "monitor preflashes" (often abbreviated to "pre-flashes"), which are a series of weak light pulses emitted by the Speedlight prior to the exposure. These preflashes provide the system with important information about the reflectivity of the scene. A

five-segment TTL flash sensor reads light from five distinct regions of the frame during both pre-flash and exposure. These regions are: a central area about the size of the central circle marked on the focusing screen, and four outer regions covering the top and bottom left side and top and bottom right side of the frame. In addition to these innovations, Nikon introduced a new class of Nikkor lens known as the D-type, which contains a microchip that communicates the focused distance to compatible cameras. This information is used by the TTL metering systems for both ambient and flash exposure control, since the system assumes that the main subject will be at the point of focus.

With a D or G-type Nikkor lens, a compatible camera and Speedlight will perform what Nikon call 3D multi-sensor balanced fill-flash, if any other CPU-type lens is used, a compatible camera and Speedlight will function in multi-sensor balanced fill-flash. In each mode either ▥▥▣ or ⚡ + **TTL** + ▣ will be displayed in the LCD panel of the Speedlight, depending on the Speedlight model. Monitor pre-flashes are always fired. It is common for Nikon to refer to these two terms under the single title of automatic balanced fill-flash with TTL multi-sensor.

Note: The following Nikon film cameras support the monitor pre-flash system: F5, F100, N90s/F90x, N90/F90-series, N80/F80-series, N75/F75-series, and N70/F70-series.

Note: Monitor pre-flashes are cancelled in the following circumstances: the flash mode is set to ▥▥ standard TTL flash, a non-CPU type lens is used, or the flash head is tilted up and/or swiveled left or right from its normal horizontal, front position. Setting the SB-80DX to its wireless flash mode also cancels monitor pre-flashes when used with compatible cameras.

Note: The later G-type Nikkor lenses, which lack a conventional aperture ring, also communicate focus distance information to compatible Nikon cameras.

Note: The 5-segment TTL flash sensor, used by Nikon since the N90 (F90) in its film and digital cameras, covers the entire frame area; is not restricted to the areas covered by the autofocus sensor(s) as suggested by some reviewers.

Note: If the flash head of a compatible Speedlight is tilted or swiveled away from the normal, horizontal/front position, or the -7° (down) position, monitor pre-flashes are not emitted. The calculation and control of flash exposure relies on the measurement of flash output OTF during the actual exposure.

The following is a summary of the sequence of events used to calculate flash exposure in Nikon film cameras (N90/F90, or later) with compatible Speedlights (SB-25, or later) and a D or G-type Nikkor lens:

1. Once the shutter release is pressed, the camera reads the focus distance from the D-type lens.

2. The reflex mirror lifts up out of the light path to the shutter.

3. The camera sends a signal to the Speedlight to initiate the pre-flash system, which then fires up to eighteen weak pulses of light from the Speedlight. The first two do not contribute to the flash exposure calculation, but are used to stabilize the flash to ensure it is emitting the same intensity in each pre-flash pulse. If necessary the Speedlight will emit a third stabilizing pre-flash. After this, up to a maximum of fifteen pre-flash pulses are emitted.

4. The light from these pre flashes is bounced back from the scene, through the lens on to the front face of the shutter curtain, and finally down to the 5-segment TTL flash sensor housed in the base of the mirror box.

5. The TTL flash sensor information is analyzed along with information from the camera's ambient light sensor and the focus distance. If the camera has multiple AF sensors (such as in the F5 and F100), the system also notes which AF sensor is active—see below. The camera's micro-

processors then determine the amount of light required from the Speedlight and set the duration of the flash discharge accordingly.

6. At this point the shutter opens.

7. The camera sends a signal to the Speedlight, which triggers the main flash discharge. The TTL flash sensor monitors the light reflected off the film and then sends the signal to stop the flash discharge at the instant the calculated exposure has been achieved.

8. The shutter closes at the end of the predetermined shutter speed duration and the reflex mirror returns to its normal position.

Note: The duration of the flash discharge from most Speedlights is very short. Even at maximum output, it is generally between 1/500th and 1/10,000th of a second and often much briefer. So, the film will continue to be exposed to ambient light after the flash discharge has been completed, as the maximum normal flash sync speed on Nikon film cameras is 1/250th second or less, depending on the model.

Digital TTL for D-SLRs without CLS Support

The design of the first Nikon digital SLR camera, the D1, presented a problem for Nikon's engineers—it was no longer possible to conduct real-time monitoring of either the ambient or flash exposure using the OFT method. This is due to the configuration and optical qualities of a digital camera's sensor and its associated filter array, which do not reflect sufficient light for a TTL light sensor to be able to measure either ambient or flash generated light with any degree of accuracy.

The following is a summary of the sequence of events used to calculate flash exposure in Nikon digital cameras (D1-series, and D100) with compatible Speedlights (SB-28DX, SB-50DX, or SB-80DX) and a D, or G-type Nikkor lens:

1. Once the shutter release is pressed, the camera reads the focus distance from the D-type lens.

The upper photo is the RGB sensor, and the lower is the TTL flash sensor, which are used in the D2-series, D200, and F6 cameras. Photos ©Nikon Inc.

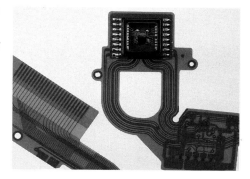

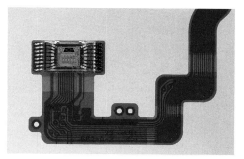

2. The reflex mirror lifts up out of the light path to the shutter.

3. The camera sends a signal to the Speedlight to initiate the pre-flash system, which then fires up to eighteen weak pulses of light from the Speedlight; the first two do not contribute to the flash exposure calculation but are used to stabilize the flash to ensure it is emitting the same intensity in each pre-flash pulse. If necessary the Speedlight will emit a third stabilizing pre-flash. Once these stabilizing pre-flashes have been fired, up to a maximum of fifteen monitor pre-flashes are emitted.

4. The light from these pre-flashes is bounced back from the scene, through the lens on to the front face of the shutter curtain, and finally down to the 5-segment TTL flash sensor housed in the base of the mirror box.

5. The TTL flash sensor information is analyzed along with information from the camera's TTL ambient exposure sensor, and the focus information. The camera's microprocessors determine the amount of light required from the Speedlight and set the duration of the flash discharge accordingly.

6. At this point the shutter opens.

7. The camera sends a signal to the Speedlight to initiate the main flash discharge, which is quenched the instant the amount of light pre-determined in Step 5 has been emitted.

8. The shutter will close at the end of the predetermined shutter speed duration and the reflex mirror is lowered to its normal position.

Note: In D-TTL monitor pre-flashes are fired in all TTL flash modes regardless of the position of the flash head.

Note: In D-TTL, as with the TTL system used by Nikon film cameras, the monitor pre-flashes are emitted after the reflex mirror has been raised but before the shutter opens.

Intelligent TTL for CLS-Compatible D-SLRS
The most recent version of Nikon's TTL flash exposure control system, Intelligent TTL (i-TTL) offers an enhanced and refined method of flash exposure control. The system uses only one or two pre-flash pulses that have a shorter duration and higher intensity than those used for the TTL and D-TTL methods, described above. Currently, the D2-series, D200, D70-series, and D50 digital SLR cameras, and the F6 film camera support i-TTL with compatible Speedlights (SB-800, SB-600, and SB-R200).

Note: Due to its design the SB-R200 cannot be mounted on the accessory shoe of a camera; it can be used only as a remote flash controlled by either the SU-800 Commander unit, or an SB-800 Speedlight.

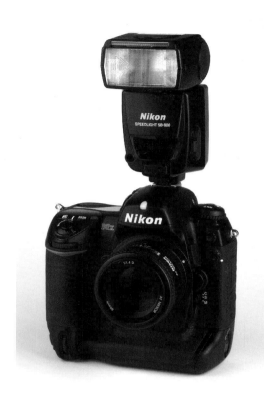

Nikon's latest TTL technology for digital SLR cameras is called "intelligent," or i-TTL.

There are several key differences between the i-TTL system and earlier TTL and D-TTL systems:

- i-TTL uses fewer monitor pre-flashes but they have a higher intensity. The greater intensity of the pre-flash pulses improves the efficiency of obtaining a measurement from the TTL flash sensor, and by using fewer pulses, the amount of time taken to perform the assessment is reduced.

- In i-TTL the monitor pre-flashes are emitted either before or after the reflex mirror has been raised. This timing is determined by the camera model and/or the number of Speedlights in use.

- The D200, D70-series, and D50 cameras have a single TTL flash sensor located in their viewfinder head. With these cameras, monitor pre-flashes are always emitted before the reflex mirror is raised, regardless of whether they are used with a single CLS Speedlight, or multiple CLS Speedlights in a wireless configuration.

- The D2-series and F6 cameras have two TTL flash sensors; one located in the viewfinder head and the other in the base of the mirror box. These models perform pre-flashes after the reflex mirror is raised, when used with a single CLS Speedlight, and before the mirror is raised when using multiple CLS Speedlights in a wireless configuration.

The sequence of events used to calculate flash exposure in Nikon digital cameras that support i-TTL (D2-series, D200, D70-series, D50, and F6) with compatible Speedlights (SB-800, SB-600, or SB-R200) and a D, or G-type Nikkor lens, will vary according to the camera model and number of Speedlights in use.

The following is a summary of the process used by the D200, D70-series, and D50 models with a single, or multiple Speedlights, and the D2-series and F6 when used with multiple Speedlights:

1. Once the shutter release is pressed, the camera reads the focus distance from the D or G-type lens

2. The camera sends a signal to the Speedlight to initiate the pre-flash system, which then emits one or two pulses of light from the Speedlight(s).

3. The light from these pre-flashes is bounced back from the scene, through the lens to the reflex mirror which directs it to the i-TTL flash sensor housed in the camera's viewfinder head.

Accessory Shoe Contacts

Viewed from above, the accessory shoe, or "hot shoe," as it is commonly known, has a series of four circular white metal electrical contacts (solid black dots in the diagram below) and a small hole toward its front edge, bounded by the two retaining rails, one each side of the hot shoe plate.

1. Speedlight locking pin socket
2. TTL monitor contact (flash to camera)
3. Flash trigger (X-sync) signal contact (camera to flash)
4. Ready light signal (flash to camera)
5. TTL flash stop signal – (camera to flash)
6. Accessory shoe rails – (provide electrical ground contact)

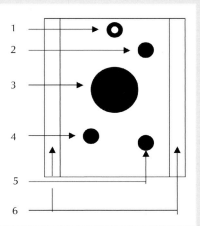

Note: By applying a specific voltage across contacts 2, 3, and 5 a variety of signals are passed between the camera and flash that indicate the flash mode, camera type, flash warning signals, auto focus illuminator activation, and useable sensitivity range.

Note: SB-28/28DX has a knurled wheel around its hot shoe foot that is rotated to lower the Speedlight's locking pin into the socket of the camera's hot shoe. Other Speedlights in this book have a lever on the back of their hot shoe foot that is rotated clockwise to lock the Speedlight to the camera. This is more efficient and quicker to operate.

Note: Nikon advises that negative voltages in excess of 250V applied to the contacts of the accessory shoe are likely to cause damage to the electrical circuitry of the camera.

4. The i-TTL flash sensor information is then analyzed along with information from the camera's TTL ambient exposure sensor, and the focus information. The camera's microprocessors determine the amount of light required from the Speedlight(s) and set the duration of the flash discharge accordingly.

5. The reflex mirror lifts up out of the light path to the shutter, and the shutter opens.

6. The camera sends a signal to the Speedlight(s) to initiate the main flash discharge, which is quenched the instant the amount of light pre-determined in Step 4 has been emitted.

7. The shutter will close at the end of the predetermined shutter speed duration, and the reflex mirror is lowered to its normal position.

The following is a summary of the process used by the D2-series and F6 when used with a single Speedlight:

8. Once the shutter release is pressed, the camera reads the focus distance from the D or G-type lens

9. The reflex mirror lifts up out of the light path; the shutter curtains, at this point, are closed.

10. The camera sends a signal to the Speedlight to initiate the pre-flash system, which emits one or two pulses of light from the Speedlight.

11. The light from these pre-flashes is reflected from the scene, through the lens on to the front side of the shutter curtain from where it is bounced to a 5-segement TTL flash sensor in the base of the mirror box.

12. The TTL flash sensor information is then analyzed with information from the camera's TTL ambient exposure sensor and the focus information. The camera's microprocessors determine the amount of light required from the Speedlight(s) and set the duration of the flash discharge accordingly.

A single Speedlight can often improve outdoor exposures and make colors pop. Focus distance information from a D-type lens helped to assure an excellent exposure.

13. The shutter opens and the camera signals the Speedlight(s) to initiate the flash discharge, which is quenched when the amount of light pre-determined in Step 4 has been output.

14. The shutter closes at the end of the predetermined shutter speed duration, and the reflex mirror is lowered to its normal position.

Flash Output Assessment

The crucial phase in each of the three sequences, above, is the point at which the required output from the flash is calculated. This is Step 5 in TTL and D-TTL, and Step 4/Step 12 in i-TTL. According to Nikon's technicians and engineers, in addition to the amount of light detected by the TTL flash sensor, three distinct elements are considered during this process when the camera is set to Matrix metering mode. These are brightness, contrast, and focus information.

Brightness

In Matrix metering mode the camera will assess the overall level of brightness. The actual number of metering segments used to achieve this will depend on the camera model used. Generally this varies between five and ten.

Note: On film cameras such as the F5 and F6, a five-segment Matrix sensor is used to assess brightness; these cameras do not use their 1005-pixel RGB sensor for this purpose. The system differs with digital cameras, such as the D2-series, which use a five-segment Matrix sensor to assess brightness when a single flash is connected to the camera, but use their 1005-pixel RGB sensor when multiple Speedlights are used in a wireless TTL configuration.

Contrast

The camera compares the relative brightness of each metering segment in its Matrix or multi-sensor metering system. Compatible cameras are pre-programmed to recognize specific patterns of light and dark across the metering segment array. For example, outer segments that record a high level of brightness and a central segment that detects a lower level of brightness would indicate a strongly back-lit subject at the center of the frame.

The camera then compares the detected pattern with those pre-stored in its database of example exposures. If the first comparison generates conflicting assessments, the segment pattern maybe reconfigured and further analysis is performed. Finally, if any segment reports an abnormally high level of brightness in comparison to the others, as might occur if there is a highly reflective surface in part of the scene that causes a specular reflection, such as glass or a mirror, the camera will usually ignore this information in its flash exposure calculations.

Focus Information

Focus information is provided in two forms: camera-to-subject distance, and the level of focus/defocus at each focus sensor. Compatible cameras use both forms in tandem not

only to assess how far away the subject is likely to be, but also its approximate location within the frame area.

Generally the focus distance information will influence which segment(s) of the Matrix (or multi-sensor) metering sensor and TTL flash sensor affect overall exposure calculations. For example, assuming the subject is positioned in the center of the frame and the lens is focused at a short range, the camera will place more emphasis on the outer metering segments and less on the central ones. An exception to this occurs if the camera detects a very high level of contrast between the central and outer sensors; it may, and often does, reverse the emphasis and weights the exposure according to the information received from central sensors. Conversely, if the subject is positioned in the center of the frame with the lens focused at a mid to long range, the camera will place more emphasis on the central metering segments and less on the outer ones. Essentially what the camera is trying to do in both cases is prevent over exposure of the subject, which it assumes is in the center or the frame.

Note: The focus distance information requires a D or G-type lens to be mounted on the camera distance.

Individual focus sensor information is integrated with focus distance information, as each AF sensor is checked for its degree of focus. This provides the camera with information about the probable location of the subject within the frame area. Using the examples given in the previous paragraph the camera notes that the central AF sensor has acquired focus, but the outer AF sensors each report defocus. Therefore, exposure is calculated on the assumption that the subject is in the center of the frame and the camera biases its computations according to the focus distance information it receives from the lens, as described.

However, it is important to understand that other twists occur in this story of interaction between exposure calculation and focus information. For example, if you acquire and lock focus on a subject using the center AF sensor, and then

recompose the shot so that the subject is located elsewhere in the frame such that the central AF sensor no longer detects focus the camera will, generally, use the exposure value it calculated when it first acquired focus. However, if it finds that the level of brightness detected by the central metering segment has now changed significantly from the point when focus was acquired with the subject in the center of the frame the camera can, and often does adjust its exposure calculations—not necessarily for the better!

Note: To help improve flash exposure accuracy in situations, where the photographer wishes to recompose the picture after acquiring focus, Nikon introduced the Flash Value (FV) lock feature on CLS compatible cameras (see below for a full description).

Nikon TTL Flash Terminology

The method used for TTL control of flash exposure will depend on the combination of the camera model, lens type, exposure mode, and system of TTL metering used for ambient light.

In Nikon film and digital cameras there are six distinct methods of TTL flash exposure control; five can be grouped under the generic term "Automatic Balanced Fill-flash," while the sixth, "Standard TTL flash" is fundamentally different from the others.

Automatic Balanced Fill-flash
This is an overall term used by Nikon to describe one or more of the following methods of performing TTL flash exposure control:

- **3D multi-sensor balanced fill-flash:** This is the most sophisticated version of Nikon's TTL flash exposure control system, and is only available when you have a D or G-type lens attached to a compatible camera body. The camera takes the following factors in to consideration

Because it helped to reduce contrast levels in the scene and keep the exposure within the dynamic range of the digital sensor, 3D multi-sensor balanced fill-flash created a photo with outstanding detail and rich colors.

when calculating the required flash output: focus distance information from the lens (hence the "3D" designation), information from the camera's TTL light metering system, and information based on the assessment of the monitor pre-flashes emitted immediately prior to the exposure. This system is particularly effective at detecting instances where the background is abnormally light (e.g. sky) or dark (e.g. dimly lit interior), or there are highly reflective surfaces in the scene (e.g. glass or a mirror). Generally, the system does not consider these in flash exposure computations, as normally such factors would have an adverse affect on exposure accuracy.

- **Multi-sensor balanced fill-flash:** This is essentially the same as 3D multi-sensor balanced fill-flash except focus distance information is not taken in to consideration during flash exposure calculations. The icons displayed on Nikon Speedlights to indicate you are in either 3D multi-

sensor balanced fill-flash, or Multi-sensor balanced fill-flash are identical. The only way to determine which mode the camera/flash is using to calculate flash exposure is to be aware of which mode is supported by the particular camera and lenses you are using. For example, if you attach a non-D, or non-G type autofocus lens to a camera capable of performing 3D multi-sensor balanced fill-flash, flash exposure control will default to multi-sensor balanced fill-flash. On some recent cameras (D2-series, D200, and F6) it is even possible for multi-sensor balanced fill-flash to be performed with a non-CPU lens mounted on the camera.

- **Matrix balanced fill-flash:** In this case, the camera's TTL Matrix metering system measures the ambient light to calculate the exposure. The required flash output is calculated during the exposure from measurements made by the TTL flash sensor; the pre-flash system is not used. This method is restricted to earlier Nikon film cameras such as the F4-series and N8008/F801-series; consequently focus distance information is not included in the computations even if a D or G-type lens is attached.

- **Center-weighted fill-flash:** This is similar to Matrix balanced fill-flash except the camera's TTL center-weighted metering system measures the ambient light to calculate the exposure. This mode is restricted to certain cameras when a non-CPU type lens is used—consequently, focus distance information is not included in the computations. With compatible film camera models (F5, F100, N90/F90-series) the required flash output is calculated during the exposure from measurements made by the TTL flash sensor (the pre-flash system is not used). With compatible digital camera models (D1-series), the calculations of required flash output are based on the assessment of the monitor pre-flashes.

- **Spot fill-flash:** This mode is limited to just a few older Nikon film camera models (N90/F90-series, N90s/F90x-series, N70/F70-series, and N8008s/F801s-series) when a

56

non-CPU type lens is attached; so focus distance information is not included in the computations. The required flash output is calculated during the exposure from measurements made by the TTL flash sensor (the pre-flash system is not used). To activate Spot fill-flash it is necessary to select Spot metering on a compatible camera body.

Note: Matrix balanced fill-flash is not the same as multi-sensor balanced fill-flash, although I have often heard the two terms interchanged by photographers when discussing TTL flash control. It does not help that the same mistake has been made in documentation produced by Nikon!

Note: Although it depends on the camera body in use in some cases where Matrix metering is selected on the camera (D1-series, F5, and F100), attaching a manual focus lens, such as an Ai or Ai-S-type (Nikon refers to this type of lens as a non-CPU type), will cause the metering system to default to center-weighted metering. As a result, the camera performs center-weighted fill-flash. However, a number of current cameras (D2-series, D200, and F6) support Matrix metering with non-CPU lenses, and can perform multi-sensor balanced fill-flash when used with them.

Note: Selecting Spot metering on most current Nikon cameras will cause the flash exposure control to default to Standard TTL flash.

Standard TTL flash
Standard TTL flash differs from the automatic balanced flash control methods described above because with standard TTL, the TTL flash sensor exclusively determines the output of the flash. Any measurement of the ambient light performed by the camera's TTL metering system remains wholly independent; it is not integrated in any way with the flash exposure calculations.

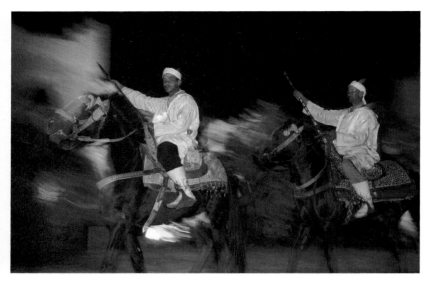

Using Slow sync mode for this shot allowed the photographer to use a long shutter speed.

This has very important implications when mixing ambient light with light from a Speedlight for the fill-flash technique, as any compensation factor selected for either the ambient exposure, the flash exposure, or both, will be applied at the level pre-determined by the photographer (see below).

Understanding Nikon's Terminology

Many photographers fail to understand how their choice of exposure mode can affect the appearance of a photograph made with a mix of ambient light and flash. All too often they assume that, because the camera is using automatic balanced fill-flash, both the subject and background will be rendered properly. Their frustration deepens when they realize that any exposure compensation factor that they set on the camera, Speedlight, or both, is often either overridden or ignored completely!

So what is going on? Read the title again—automatic balanced fill-flash. The photographer is not the one in control here—it is the camera that is responsible for all flash and ambient exposure computations in the various balanced fill-flash options when the camera is set to any of the automatic exposure modes (P, A, and S), and all flash exposure computations in the various balanced fill-flash options when the camera is set to Manual exposure mode.

Furthermore, if you select either Aperture-priority (A), or Program (P) exposure modes the available shutter speed range is restricted on most camera models to between 1/250th and 1/60th second. If the level of ambient light requires a shutter speed outside of this range, as is usually the case when shooting in low-light conditions such as a dimly lit interior, the areas of the scene lit predominantly by ambient light will be underexposed.

Hint: If you use Aperture-priority (A) exposure mode habitually with flash, consider setting Slow-sync flash mode (do not confuse this with Rear-sync mode) as it overrides the restriction on shutter speed range, and allows the full range of speeds available on the camera between the maximum flash sync speed and the slowest shutter speed to be used, so areas lit by ambient light appear more balanced with those lit by flash.

Note: Alternatively, on some current Nikon cameras, D2-series, D200, D70-series, and F6, it is possible to select the slowest shutter speed to be used with flash when the camera is set to either Aperture-priority (A), or Programmed-automatic (P) exposure modes; this option is found in the Custom Settings menu of these models.

The second clue is the word balanced, which means that the camera uses both its TTL metering system to measure ambient light and its TTL flash sensor to measure flash output and combine these to create a roughly equal exposure from both light sources. For example, a background lit by ambient light and a subject in the foreground lit by the flash

are each exposed at a similar level. The camera achieves this more often than not by compensating the exposure for either the ambient light, the flash, or sometimes both. As mentioned above any exposure compensation factor applied by the photographer is frequently overridden or even ignored, because in all the automatic balanced fill-flash options the camera and flash operate automatically, which makes consistent repeatable results difficult to accomplish.

The third part of this generic term automatic balanced fill-flash just serves to confuse users even further! Fill-flash is a recognized lighting technique in which the flash is used to provide a supplementary light to the main ambient light source, and, as such, its output is always set at a level below that of the ambient light. Generally, the purpose of this fill light from the flash is to provide additional illumination in the shadows and other less well-lit areas of a scene to help reduce the overall contrast range; many photographers also use the technique to put a small catch light in their subject's eyes.

Nikon's use of the term fill-flash is misleading on two counts within the context of the title automatic balanced fill-flash: first, depending on the prevailing light conditions, when the level of ambient light is very low, using one of the automatic balanced fill-flash options will often cause the Speedlight to become the principal light source for illuminating the scene, and second, as discussed above, balanced implies that the exposure for the ambient light and flash comprise equal proportions.

Note: Whenever you see the term automatic balanced fill-flash remember that existing ambient light and flash will be mixed to produce the final exposure; how the two light sources are mixed and in what proportion will depend on the combination of camera, lens, exposure mode, and selected flash exposure control option. A more accurate term for this system would be automatic balanced flash.

Speedlight LCD Panel Icons

The range of icons used in the LCD panel of various Speedlight models can also be the source of confusion for the user as then same combination of icons is used to indicate different flash exposure control methods!

The icons for the various flash modes are clear enough:

TTL : TTL flash exposure control
A : Non-TTL automatic balanced flash
AA : Auto Aperture flash
M : Manual flash

However, the icons used for the various TTL flash exposure control options are less concise and you must check other factors, such as the model of camera (does it support TTL, D-TTL, or i-TTL flash control?), the type of lens (a D, or G-type lens will provide 3D multi-sensor balanced fill-flash, while with some other lenses only multi-sensor balanced fill-flash is supported), and the metering mode.

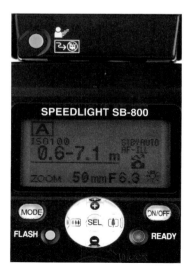

The SB-800's LCD panel in A mode.

The following table shows some common combinations of icons and what they mean:

LCD Icon	TTL flash exposure control option	Speedlight Model
TTL BL	3D multi-sensor balanced fill flash with digital and film SLR	SB-800, SB-600, SB-R200
TTL BL	Multi-sensor balanced fill flash with digital and film SLR	SB-800, SB-600, SB-R200
D TTL ⊙	3D multi-sensor balanced fill flash with digital SLR	SB-80DX, SB-28DX
D TTL ⊙	Multi-sensor balanced fill flash with D-SLR	SB-80DX, SB-28DX
TTL ⊙	3D multi-sensor balanced fill flash with film SLR	SB-80DX, SB-28DX, SB-28
TTL ⊙	Multi-sensor balanced fill flash with film SLR	SB-80DX, SB-28DX, SB-28
D TTL 📷	Center-weighted balanced fill-flash with digital SLR	SB-80DX, SB-28DX
TTL 📷	Matrix balanced fill-flash	SB-80DX, SB-28DX, SB-28
TTL 📷	Center-weighted fill-flash	SB-80DX, SB-28DX, SB-28
TTL 📷	Spot fill-flash	SB-80DX, SB-28DX, SB-28
D TTL	Standard TTL flash with digital SLR	SB-80DX, SB-28DX
TTL	Standard TTL flash with digital and film SLR	SB-800, SB-600, SB-R200
TTL	Standard TTL flash with film SLR	SB-80DX, SB-28DX, SB-28

The following icons are displayed when the appropriate settings are made either on the Speedlight or a compatible camera:

LCD Icon	Flash exposure control
⚡	Indicates that monitor pre-flash system is active (SB-800, 600, R200 only)
FP	Automatic FP high-speed sync (CLS cameras only)
FP	Manual FP high-speed sync (compatible with certain non-CLS cameras)
RPT	Repeating flash (SB-800 only)
M ⚡⚡⚡	Repeating flash (SB-28, 28DX, 80DX only)

Note: The tables, above, include icons displayed by Speedlights covered by this book: SB-800, SB-600, SB-R200, SB-80DX, SB-28DX, and SB-28. Earlier Speedlight models will also display some of these icons depending on the camera in use and the settings applied to it.

Creative Lighting System

Since this chapter deals with the terminology used by Nikon, it is an appropriate place to discuss the additional features available in what Nikon calls its Creative Lighting System (CLS).

Currently, compatibility with the CLS is restricted to the D2-series, D200, D70-series, D50, and F6 cameras, although I expect all future SLR cameras introduced by Nikon will also support the system. Significantly, it is the camera not the Speedlight that determines the level of functionality of many of the key features within the system. The following is a list of these features not mentioned previously, although some are discussed in greater detail later in this book.

Daffodils in spring—captured with the help of two SB-800s—one in the role of Commander and the other used as a remote flash.

Wireless TTL Multiple-flash Control

The Advanced Wireless Lighting system of the CLS allows you to operate multiple Speedlights wirelessly with full TTL control from a compatible camera. In addition to the master flash unit, the remote flash units can be divided into sub-groups, which can be controlled independently.

Communication between the Speedlights is performed by a sophisticated signaling system that uses low-intensity pulses of light. When using the SB-800 and built-in Speedlght as the master flash, the spectral range of the light used for these pulses is the same as the light emitted during the main flash output, except it is only the non-visible IR wavelengths (800-1000 nm) that are used to send instructions from the master flash to the remote units. Compatible Speedlights (SB-800, SB-600, and SB-R200) have a built-in sensor that detects the IR light signals emitted from the master flash. The camera and

master flash do all the communication work; signals sent from the master flash instruct the remotes how they should operate and the camera monitors their output to control the overall flash exposure. The remote flash units do not send, or relay, any signals themselves as has been suggested by some. Normally, the master flash will contribute to the overall flash exposure but there is an option—Nikon refers to it as the Commander function—where the output from the master flash can be cancelled, so it only emits the wireless control signals to trigger remote flash units.

Note: Whenever you see a reference to "Commander function," it means the unit controlling any remote flash (SB-800, or SU-800 or built-in Speedlight), will only emit the required control signals; it does not, or is not able to, in the case of the SU-800, contribute light to the flash exposure.

Note: The SB-600 and SB-R200 can be used as part of a multiple-flash, wireless TTL set-up, but only in the role of a remote unit. The SB-800 can be used as either the master or remote unit.

Note: In Advanced Wireless Lighting mode several flash functions do not operate. These include: flash color Information, wide-area AF-assist, and the auto-zoom of the remote Speedlight(s).

Flash Value (FV) Lock

Flash Value (FV) Lock allows you to use the camera and Speedlight to estimate the required flash output for a subject and then retain this value temporarily, before making the main exposure. This is a very useful feature if your want to compose with the main subject located toward the edge of the frame area, particularly when the background is very bright or dark. Under these circumstances, using TTL, D-TTL and normal i-TTL flash modes, there is a risk that the camera may calculate an incorrect level of flash output, causing the main subject to be either under, or over exposed.

FV lock must first be activated via the camera's custom setting menu. Next, a multi-stage process requires you to compose the picture, initially with the main subject in the center of the viewfinder area, acquire focus by partially the shutter release, before pressing the AE-L/AF-L button on the camera. This causes the pre-flash pulses to be emitted by the Speedlight, which are used to assess the required amount of flash output. The camera remembers this value and a warning signal appears in the viewfinder display to remind you that the function is active. Now, you can recompose the picture and make the exposure by fully depressing the shutter release button. The flash will fire at the predetermined level. If you alter the focal length of a zoom lens, or adjust the lens aperture, the FV function will compensate the flash output automatically.

Note: FV Lock is available with all CLS compatible cameras in the following flash modes: i-TTL, Auto Aperture (AA) with D2-series, D200, and F6 only, and non-TTL Automatic flash with SB-800 only.

Note: The camera-to-subject distance must remain unaltered during the use of the FV lock, otherwise the flash exposure may be incorrect.

Flash Color Information Communication

Used with compatible cameras, the SB-800 and SB-600 automatically transmit information about the color temperature of the light they emit to the camera. When the camera is set to automatic white balance control, it will use this information to adjust its white balance setting to match the color temperature of the flash output.

Note: This function only operates when "Auto" white balance has been selected and set on a compatible camera body.

Auto white balance sets the system to match the color of the flash output. ➪

66

Auto FP High-Speed Sync

Available with both the SB-800 and SB-600, currently this feature is supported by the D2-series, D200, and F6 cameras.

One of the limitations of using daylight fill-flash is the maximum flash sync speed of the camera, which is limited to 1/250th second on many models. When working in bright lighting conditions, you may find it is often not possible to open the lens aperture much, due to the restriction of the maximum shutter speed imposed by the use of flash. The auto FP high-speed sync function, which is selected from the custom menu of the camera, allows you to use the full range of high shutter speeds on compatible cameras while adjusting the flash output automatically. This adds great flexibility when using fill-flash. To achieve this, the flash emits a very rapid series of pulses instead of a single continuous burst. The downside is that the flash output is reduced significantly, which reduces the effective range of the Speedlight.

Note: Although the D70-series and D50 cameras are not compatible with the auto FP high-speed sync function, they feature a maximum flash sync speed of 1/500th second. These cameras accomplish this by emulating shutter speeds above 1/250th second by switching their sensors on and off, rather than opening and closing the shutter blades.

Wide-Area AF-Assist Illuminator

The purpose of the AF-assist lamp built in to the SB-600 and SB-800 is to facilitate auto-focus in low light situations. The benefit delivered by these two units is the much wider area that the illumination from the lamp covers, compared with previous Speedlights. This is particularly useful with cameras such as the D2-series, D200, and F6 with their array of eleven AF-sensors, which covers a greater proportion of the frame area.

The effective range of the wide-area AF-assist lamp varies according to the focal length of the lens in use and the location within the viewfinder area of the selected AF sensor. For example, with a 50mm lens and AF sensor areas in the central portion of the viewfinder area, the effective range of the lamp is between about 3-1/4 feet (1 m) and 33 feet (10 m) but this is reduced at shorter focal lengths. Shooting with a 50mm lens and AF sensor areas at the periphery of the viewfinder area reduces the effective range to between 3-1/4 feet (1 m) and 23 feet (7 m), but again this is reduced at shorter focal lengths.

Note: The wide-area AF-assist Illuminator feature requires an AF lens to be mounted on the camera, which must be set to single-servo AF with focus priority selected.

Note: The AF-assist function can be used in isolation on the SB-800 by selecting "Cancel" for the flash "FIRE" option in the custom setting on the Speedlight.

Flash Techniques

As photographers we know that light is the fundamental ingredient of a photograph—without light there can be no exposure! So, many photographers tend to "pigeon hole" the use of flash for picture taking when the ambient light is dim. However, the decision-making process for creative photography is in our hands when we have control over some, or all, of the light in a photograph. For this reason, using flash as the main light or to supplement ambient light opens the door to a very wide range of visual effects. In this chapter I will discuss some of the techniques you can use with a single Speedlight to add extra dimensions to your photography.

Direct Flash

For a photographer faced with the "any picture is better than no picture" situation, direct flash represents the most straightforward and unsophisticated way of lighting a subject. Direct flash offers the maximum efficiency because it travels the shortest possible route, is not diffused, and it maintains a constant color temperature (assuming you do not filter the flash head). However, the quality of the light is harsh, uncompromising, and flat, particularly if the Speedlight is mounted on the camera directly above the lens axis. Shadows cast by direct flash are deep and distinct with hard edges. That is not to say that direct flash does not have its uses—that is the delight of having control over your light source, you can use it as you see fit!

◁ *Even it the light is adequate, the judicious use of fill flash—in this case, to place catchlights in the dog's eyes and highlight its fur—will almost always improve an image.*

Bounce Flash

As suggested in the previous section, direct light from a flash can be appropriate in some shooting situations or for certain creative purposes. However, modifying the nature and quality of the light from your Speedlight is often beneficial. One of the simplest techniques for doing this is bounce flash, which involves lighting the subject indirectly by "bouncing" the light from the flash off a nearby surface, such as a wall or ceiling. Most shoe-mount Speedlight models from the SB-24 onwards have a flash head that can be tilted and/or swung to angle the direction of the light output.

It is important to understand that bounce flash influences both the quality and quantity of light that illuminates the scene. Bouncing light off a surface diffuses the light that's reflected—the more irregular the surface, the more the light will be diffused. Because diffused light is less directional, it tends to wrap itself around any object in its path, so that the edges of shadows appear far softer than shadows cast by a direct light source.

When a compatible Speedlight is set to TTL flash mode, it will fire the monitor preflashes to help assess the required flash exposure. However, if you move the flash head of such a Speedlight from its normal position (when attached to a Nikon film camera that supports TTL flash control) the monitor preflash is cancelled. This causes the flash exposure control to default to using measurements obtained during the actual exposure from the OFT metering system. Consequently, in situations such as setting Rear-curtain synchronization, the accuracy of the flash exposure can often be affected adversely. In my experience there is a tendency for Nikon film cameras to produce slightly underexposed results when using bounce flash illumination.

Note: Monitor preflashes are always fired by compatible Speedlights whenever they are used with Nikon digital SLR cameras, regardless of the flash head orientation or whether they are used in D-TTL or i-TTL mode.

Bounce flash (right) diffuses the light so it appears more natural. With the flash off camera (left) bouncing the flash allows the light to be directed so that shadows are less noticeable.

The Bounce Surface

One of the most important decisions you will make when using bounce flash is the choice and location of the bounce surface. To the less experienced photographer walls and ceilings may seem an obvious choice as bounce surfaces but they can spell disaster!

When choosing a bounce surface you should ensure that it is not colored. This is because the reflected light will include the surface color, causing a noticeable and generally unwanted color cast throughout picture. You also should be careful with surfaces that have a seemingly neutral color as many of the bright- or near-white paints used in modern decor contain pigments and other agents that could impart slightly blue or pink tints to the light from the flash. These will have an adverse affect of your subject, particularly if you want to maintain accurate skin tones!

The nature of the bounce surface is also important, because light is reflected at the same angle at which it struck the surface (e.g. if the light strikes the bounce surface at 60° it will be reflected at 60°). Hence, a bounce surface that is uneven has a multitude of tiny angles that will cause the light to be reflected with a similar number of angles. This increases the level of light dispersion compared to a flat surface. To ensure that as much of the light from the Speedlight as possible illuminates your subject, consider the angle of reflection with care. Perfectionists may want to resort to trigonometry after measuring the relevant distances and angles, but as a rule of thumb, if you angle the flash head toward the bounce surface at the point mid-way between the flash and the subject you should achieve good results. However, you should also be aware of surfaces other than the bounce surface that are close to either the flash or the subject, as these will reflect light as well, which could affect the nature and quality of the lighting.

Location of the bounce surface is also important as it has a direct affect on the amount of light that will illuminate your subject. Clearly, when the light travels to the bounce surface and then to the subject, it must cover a greater distance than if it traveled straight to the subject. I discussed the affect of distance on the intensity of light in the section on the Inverse Square Law in Chapter 1, Basic Concepts: Characteristics of Light (see page 24).

To strike a balance between the proximity of the bounce surface and the amount of diffusion that you want it to create, generally, it is better to keep the bounce surface close to the flash to minimize the distance the light has to travel and thus maximize the amount of light available to illuminate the scene. It is often better to use a portable bounce surface with known reflective qualities, such as a piece of card or a polystyrene sheet, rather than rely on walls and ceilings. Plus, you can control the angle of bounce by adjusting the angle of the portable bounce surface.

Hint: If your Speedlight incorporates a small "bounce card" that extends from the top of the flash head (such as with the SB-800), use it! It will reflect a small amount of subtle fill-light directly at the subject.

Note: Whenever you shift the flash head away from its normal position, the flash shooting-range distances in the Speedlight's LCD panel disappear (the SB-600 does not display any flash-shooting range distance scale). The system cannot provide reliable information because the camera and flash have no way of knowing how far the light will have to travel to reach the subject.

Slow Synchronization

Attaching a Speedlight to most Nikon camera bodies that offer either Program or Aperture Priority automatic exposure mode, causes the camera to set a shutter speed in the range of 1/60th to 1/250th second, as soon as you switch the Speedlight to ON. The camera selects a shutter speed within this narrow range based on the level of ambient light. It makes no difference whether the flash is mounted in the camera's accessory shoe, or attached via a Nikon SC-17, SC-28, or SC-29 TTL flash card.

The restriction imposed on the range of available shutter speeds when using flash in P and A modes can have a significant affect on the overall exposure. For example, in situations when you photograph a subject outside at night, or in a dark interior, any area of the scene that will be illuminated by ambient light alone is lit dimly compared with those areas that will be illuminated by the flash. It is more than likely that the level of ambient light will not be sufficient for a proper exposure within this restricted range of shutter speeds and consequently these areas of the scene will be underexposed. A typical photograph taken under these conditions has a well-exposed subject set against a very dark, featureless background.

To prevent this, select Slow synchronization flash mode (usually abbreviated to Slow sync), which enables the camera to use all shutter speeds below 1/60th second to the longest shutter speed available on the camera; on most modern Nikon camera this is, generally, 30 seconds. The camera will be able to select an appropriate shutter speed for the low level ambient light, so the correct exposure can be achieved for the background (remember the flash output will have little if any effect in this region as the intensity of light from the flash will diminish according to the Inverse Square Law), and the flash output will be controlled for a proper exposure of the subject and foreground.

Note: If your camera supports either manual or automatic FP High-Speed sync mode, and this has been selected, the available shutter speed range is extended to between 1/60th second and the shortest shutter speed available on the camera, generally, 1/8000th second with D-SLR cameras, and 1/4000th second with film cameras, except the F6 which can synchronize at 1/8000th.

Setting Slow Sync
Recent Nikon cameras (N90/F90 or later) have an automated Slow sync mode that allows the use of all shutter speeds from the maximum flash sync speed to the longest shutter speed available on the body, generally this is 30 seconds.

On most of these camera models you set slow sync as follows:

• Select your preferred metering and exposure modes

• Press and hold the flash mode button and rotate the main command dial until "SLOW" appears in the flash mode icon displayed in the relevant control panel LCD on the camera. Then release the flash mode button.

• Select an appropriate exposure value for the ambient light

◁ *Slow sync allows the use of long shutter speeds to portray motion. By also using Rear curtain sync, the photographer created realistic motion blurs that follow the action.*

- Press the shutter release button to take the picture

Some Nikon camera models such as the F4-series, N8008/F801-series, F3-series, FM3A, and FM2N do not have an automated slow sync option. If you use one of these cameras you can still balance the ambient light (even if it is at a low level) and flash with the steps below.

Note: If the camera models have P or A exposure modes, the range of available shutter speeds is restricted to between 1/250th - 1/60th second, hence the need to use manual exposure mode as described below.

- Attach the Speedlight but do not switch it ON.

- Select manual (M) exposure mode.

- Select an appropriate aperture for the depth of field you require.

- Meter the scene and set an appropriate shutter speed (at or below the maximum flash sync speed) to obtain a proper exposure with the aperture you have selected

- Switch the Speedlight ON and set it to TTL flash mode or A (automatic) flash mode.

- Focus on the subject and note the focus distance.

- Check the flash shooting range display to ensure the Speedlight has sufficient power to light the main subject. If not, select a wider aperture (smaller f/ number) and do not forget to adjust the shutter speed accordingly.

- Press the shutter release button to take the picture.

The Slow sync technique is useful in any situation when the level of ambient light is relatively low and you want to shoot with flash, particularly in either P or A exposure modes. Since proper ambient light exposure will usually

require a lengthy shutter speed you should mount your camera on a tripod or some other rigid support to prevent camera shake from ruining your picture. If you do not use Slow sync in P or A modes, the restricted shutter speed range of normal flash sync can often cause the ambient light to be underexposed.

If the ambient light is very bright and you want to use flash with a wide lens aperture, the maximum flash sync speed may not be adequate. In such situations consider using the FP High-Speed sync feature if your camera and flash support it (see Focal Plane (FP) High-Speed Sync, page 99).

Note: The upper limit of available shutter speeds used in Slow sync matches the maximum flash sync speed available on the camera. On most modern Nikon cameras this is 1/250th second, except the D1-series, D70-series, and D50 models, which can synchronize with flash up to 1/500th second.

Rear Curtain Sync

Rear-curtain synchronization is similar to Slow synchronization but with one significant difference. As with Slow sync, Rear sync removes the restriction on the lower range of shutter speeds that can be used with flash, but what distinguishes the two techniques is the point at which the flash output occurs during the exposure. In Slow sync the flash fires at the beginning of the exposure, as soon as the shutter curtains have opened fully. With Rear sync, the flash fires right before the shutter curtains begin to close at the end of the exposure.

If the shutter speed is relatively short, the timing of the flash output is of little consequence, as it has no perceptible effect on the final result. However, with longer shutter speeds, even as brief as 1/30 second, and other factors (see below – Using Slow Sync), the timing of the flash output when it is mixed with the ambient light exposure can often influence the appearance of the photograph significantly.

Note: Using Rear-curtain sync with compatible Nikon film cameras will cause the monitor preflash system to be cancelled, which may result in slightly less accurate flash exposure control. However, when using Rear-curtain sync with compatible Nikon digital cameras, the monitor preflash system continues to operate. If the shutter speed is sufficiently long you will probably see two outputs from the Speedlight; the first is the weak monitor preflash pulse(s) emitted before the shutter has opened, and the second is the main flash output, which occurs immediately before the shutter curtains begin to close.

Setting Rear Sync
When using recent Speedlights (SB-28 or later), the Rear-curtain sync option is selected from compatible camera bodies. Press the camera's flash sync mode button and rotate the Main Command Dial until "Slow" appears in the flash mode icon on the camera's control panel. If Rear-curtain sync is selected when the camera is set to Program or Aperture Priority automatic exposure modes, Slow sync is also set automatically.

Note: If you use the SB-24, SB-25, or SB-26 set the Speedlight's sync mode switch to REAR.

Using Slow and Rear Sync in Creative Photography

By combining the effects of the brief pulse of light emitted by a Speedlight with the long exposure for the ambient light, and mixing in movement of the subject and/or camera some visually stunning effects can be achieved! While I will describe some of the principal techniques and tricks in this section, they are by no means exhaustive – experimentation is the name of the game here!

Light Trails or Motion Blur
Creating trials of light to emphasize movement is probably the most popular effect using Slow sync flash. It is most effective when used in combination with Rear-curtain sync.

Even bumper cars can be a thing of beauty with some creative blur.

The trails are created by the ambient light exposure, and best results are achieved if the subject moves relative to the camera during the exposure. Although with some subjects, you can also get good results if you move the camera deliberately in a panning motion to follow the subject—I did say experimentation was the key!

I will start by describing the basic technique for shooting with a stationary camera and moving subject. There are a number of factors to consider—the first is whether you want the light trails to appear in front of the subject or behind it. The duration of the full output burst from a Speedlight is about 1/1000th second or briefer. When you select Slow sync mode, the shutter speed used for the ambient light exposure will be considerably longer than the flash exposure, especially if the ambient light level is low. In this case,

say that the shutter speed will be 1/8 second. If you have not selected Rear-curtain sync, the flash discharge will occur at the beginning of the exposure. This will "freeze" the subject at its location within the frame at that instant. However, the shutter remains open for the remaining duration of the exposure, which amounts to almost 1/8th second. Consequently, the trails created by the moving subject will be recorded as time passes and they will appear to be in front of the image of the subject recorded at the start of the exposure by the flash illumination. To our visual memory the image appears "wrong" because we expect the trails to occur in the space that the subject has moved from, not in the space where the subject is heading. If you want the light trails to follow the moving subject you must select Rear-curtain sync so the flash discharge occurs at the very end, after the light trails have been created during the ambient light exposure.

There are two further considerations to make concerning the length and density of the light trails:

• The length of the light trail depends on the duration of the shutter speed, speed of the subject, and how large the subject is relative to the total area of the frame. If the subject is not large in the frame and moving slowly, and you select a moderately short shutter speed of around 1/30th second, the light trails will probably appear quite small. However, a similar sized subject, moving rapidly, shot at the same shutter speed, will create much longer trails.

• The density of the light trails is dependent on the amount of ambient light exposure the subject receives relative to the exposure from the flash. Because the subject is moving through the frame (remember the camera is stationary), the exposure it receives at any point within the frame area is generally far less than the exposure it receives during the flash output. Consequently, the trails will nearly always appear less dense than the flash-lit subject. The exception is when the subject is moving very slowly, causing the trails to appear overly dense and like

a dose of severe camera shake! The solution is to deliberately reduce the ambient light exposure while maintaining the flash exposure level, so that the subject is slightly underexposed. (Try setting the ambient light exposure at -0.5EV to -1.0EV.)

Hint: Shooting a subject against a background that is relatively dark (though not necessarily black) will help the light trails to appear more defined.

Creating a Halo Effect

I cannot guarantee that this "halo" technique will turn your subject in to a minor deity, but it certainly can be very effective for portraits. It is a modified version of the light trails technique described previously. Start by selecting Slow sync flash mode to create an effect that appears around the edges of the subject (as opposed to distinct trails leading in a particular direction). To accomplish this, either the subject or camera must move in a very specific manner. There are a number of options you can use to create the "halo" effect by moving the camera:

- Selecting a shutter speed in the range of 1/8th to 1/15th second; at these speeds most people will be able to record a reasonably well-defined subject but with some unavoidable natural camera shake.

- Introduce a deliberate amount of camera shake (this does require some practice!); the best form of camera movement occurs randomly around a specific central point. The downside to this option is that it is almost impossible to repeat with anything that approaches consistency.

- Move the camera in a specific direction; a rotational motion of the camera gives best results generally. Try adopting a variation of the panning technique by moving the camera before the shutter opens and continue with as smooth a rotating motion as you can achieve throughout the exposure. Then follow through once the shutter closes.

Alternatively, there are a number of options you can use to create the "halo" effect by getting the subject to move:

- Select a very long shutter speed (I would suggest 1/2 second as a minimum, even longer to increase the effect); you can ask your subject to remain still as you release the shutter and then get them to move at some later point during the exposure.

- Select a moderately faster shutter speed and have your subject perform a more vigorous movement. Ask them to jump toward the camera, turn their head from side to side, or swing their arms around.

- For more repeatable results set the camera on a tripod and have your subject start at a constant distance from the camera; you can use any of the tricks described above concerning subject movement or, for a subtle effect, just ask them to walk slowly toward the camera. (If they move away from the camera they will be smaller in the frame and the "halo" will appear inside the normal edges of the subject.)

Hint: With any technique that requires subject motion, it helps to trip the shutter after the subject has begun to move. It is difficult for subjects to anticipate the opening and closing of the shutter.

Note: The tricks and techniques described above are a starting point. If you use a digital camera there can be no excuse if you do not experiment for yourself – just remember to keep careful notes so that when you do hit upon a successful technique you can repeat it!

Panning with Slow Sync Flash

Panning occurs when the camera is moved in a constant, smooth action to follow a moving subject. When combined with Slow sync flash (with or without Rear-curtain sync), it can add another dimension to your flash photography. Typically, you will end up with a cross between the light trails and halo effect technique!

Panning with Slow and Rear sync works particularly well when the camera is perpendicular to the movement. Using a tripod with a pan head creates smooth, straight motion trails.

For best results try a shutter speed of 1/15th second or slower, and select Rear-curtain sync. The flash exposure "freezes" the subject (just as it does in the light trails technique). Also, you are deliberately moving the camera during the long ambient-light exposure to track the moving subject. However, since it is rarely possible to track a moving subject with such precision that you keep it perfectly "still" within the frame, you often end up with a halo effect created by the ambient light. The background, which is only lit by the ambient light, is moved across the frame as a result of the camera's motion and thus, is recorded as a series of trails. The longer the shutter speed the longer and more blurred the trails become.

Panning Tips

A little experimentation with this technique can often produce some unique results! Try using long shutter speed and finishing the pan with an exaggerated movement such as a twist just before the shutter closes. It will take some practice to anticipate the shutter action but the effort will be worthwhile.

Modifying the ambient light exposure while maintaining the flash exposure level will help to ensure that the trails stand out. The same applies when panning with Slow sync but you can add extra variations:

- If you reduce the ambient exposure and leave the flash exposure unaltered, the light trails become very distinct.
- Alternatively, you can modify the flash exposure and leave the ambient light exposure unaltered, which reduces the apparent crispness of the flash-lit subject against the light trails, adding softness to the entire picture.
- If you want to keep the light trails straight, mount the camera on a tripod. However, the technique can work just as well if you handhold the camera as natural camera shake will soften the definition of the light trails. Experiment!

Zoom Lenses and Slow Sync Flash

If the techniques described above are not enough for you here is another to try with your zoom lens and Slow sync or Rear-curtain sync flash. The most popular effect is to have the light trails radiating in toward the main subject. To achieve this you need to zoom out from the subject when using Slow sync flash and zoom in to the subject when using Rear-curtain sync flash. To give sufficient exposure for the ambient light, which is likely to quite low, you will need to set a long shutter speed. This also helps as you can vary the speed of the zoom action, or even stop and start the zoom action during the exposure.

Flash Output Level Compensation

The main purpose of flash output level compensation is to alter the balance between those areas of the scene not lit by flash (usually the background) and those that are (usually the subject and foreground).

However, fundamental difference between flash output level compensation and exposure compensation. The former only affects the output of the flash and those sections of the scene illuminated by light from the flash; the latter affects the overall exposure, for both the ambient light and flash.

When flash is used as supplementary light source, as in fill-flash, flash output level compensation value may or may not influence those areas of the photograph lit by flash rendering them as properly, under- or overexposed, depending on the level of ambient light, the tonal range of the scene, the flash mode in use, and the exposure settings made on the camera.

If you apply a flash output level compensation value when flash is the principal source of light it will affect the overall exposure in the same proportion as the compensation value (i.e. if you set a flash output level compensation value of +1EV those areas of the scene lit by flash will overexposed by up to one-stop).

Typical scenarios for when flash output compensation can be used to adjust the balance between ambient and flash light might include:

- The level of ambient light is low, the camera is set to P or A exposure modes (which restricts the range of available shutter speeds as described previously), and Slow sync is not selected. Applying a flash output level compensation value in this case will result in the flash-lit areas of the scene being either under- or overexposed. Those areas lit by the ambient light will be grossly underexposed, as the longest shutter speed is limited to 1/60th second.

For a subtle use of fill flash, apply a negative flash output level compensation value. Remember that setting flash output level compensation only affects the flash exposure, not the ambient light exposure. Photo ©M. Morgan.

- The level of ambient light is low, the camera is set to P or A exposure modes and Slow sync is selected, or alternatively the camera is set to S or M exposure modes. In each case there is no restriction on the range of available shutter speeds between the fastest flash sync speed and the longest shutter speed available on the camera. Usually, those areas of the scene lit by the low level ambient light will be properly exposed, as it is possible to choose an appropriate shutter speed. So, applying a flash output level compensation value in this case alters the balance between the flash and ambient light. (Depending on the shutter speed in use, you may need a camera support to get a sharp picture.)

- The flash is used as a supplementary, or fill light, and the exposure setting is based on the prevailing ambient light level. In this instance applying a flash output level compensation value only alters the level of the fill light, which is unlikely to affect the overall exposure unless the output from the flash is adjusted to a point where it dominates the ambient light falling on the subject and foreground. The purpose of fill flash is to help reduce contrast between the ambient and flash-lit portions of a scene. In most cases if the fill flash is too bright, the technique looks obvious and is rarely successful. To prevent this from occurring it is usually necessary to apply a negative flash output level compensation value.

Setting Flash Output Level Compensation

On Speedlights SB-24 or later, flash output level compensation is set on the flash unit. However, it can also be set on recent camera bodies that feature a built-in Speedlight, or on the appropriate multi-function control backs for cameras such as the N90s/F90x, F100, and F5 (check the equipment's instruction manual - see Note: below). Most Speedlights display **TTL** next to the flash output level value while it is being set (the icon flashes), and after it has been set (the icon is displayed continuously). On the SB-800, SB-600, and SB-R200 Speedlights, the flash output level compensation is displayed as an EV value.

If you set a flash output level compensation factor on those Nikon camera bodies (and multi-function control backs) that support the feature, and also set a flash output level compensation factor on an external Speedlight the overall flash exposure is modified by the sum of both compensation values (e.g. if you set -1 stop flash output level compensation factor on the camera, and -2 stops flash output level compensation on the Speedlight, the flash output will be compensated by a total of -3 stops).

Note: Neither exposure compensation values, nor flash output level compensation values set on the camera are displayed in the Speedlight's control panel LCD, although the flash shooting range display will be altered accordingly (i.e. if a negative exposure compensation value is applied, the flash shooting range will increase, and vice versa).

Hint: To avoid any confusion and incorrect flash exposure when working with an external Speedlight and a camera body that allows you to set flash output level compensation, you should always make sure that the camera's flash output level compensation value is set to "0." My advice is to set flash output level compensation on the external Speedlight only.

Avoid Compensation Confusion!
It is imperative that you understand the difference between exposure compensation set on the camera, and flash output level compensation, set on an external Speedlight or a camera (with a built-in Speedlight, or multi-function control back).

Remember that setting flash output level compensation only affects the output of the flash and, therefore, the parts of the scene illuminated by light from the flash. It has no affect on the ambient light exposure.

On the other hand, setting an exposure compensation value on the camera modifies the overall exposure—both the exposure for the ambient light and the flash exposure will be altered in direct proportion to the compensation value you set. In situations where the scene has a predominance of

light or dark tones, exposure compensation may be neces-
sary to record them properly. However, if the scene being
photographed has a range of average tones, the global affect
of exposure compensation will usually render it as either
underexposed or overexposed.

Adjusting Flash Output Manually

Even with earlier Nikon film camera models and/or external
Speedlights that do not offer flash output level compensa-
tion, it is still possible to control flash output manually, in
most cases, provided the Speedlight supports automatic (A)
flash mode. Here is how it is done:

- Set Manual exposure (M) on the camera.

- Take a meter reading in the normal way and adjust the
 shutter speed and lens aperture accordingly.

- Adjust the ISO film speed value on the camera and/or
 Speedlight by the required amount of compensation (e.g.
 if you want to reduce the level of flash by 1 stop and you
 have an ISO 100 film in the camera, set the ISO value to
 ISO 200).

- Regardless of any adjustments you make on the
 camera/Speedlight to the ISO film speed value, do not
 change the shutter speed and lens aperture you set in the
 second step above.

- Switch the Speedlight to ON and ensure it is set to auto-
 matic (A) flash mode.

- You are now ready to release the shutter; the ambient
 light will be exposed properly according to the settings
 you applied in the second step; the flash output will be
 adjusted according to the change made to the ISO film
 speed value.

Fill flash with flash exposure compensation improved the results in this study. The photo on the far left is an ambient light exposure without flash; the middle-left was photographed with Standard TTL flash with no flash compensation.

Note: If the level of the ambient light changes you must repeat the entire procedure from the beginning.

Fill Flash

Have you have ever seen photographers working outdoors in bright, sunny conditions and wondered why they used flash? Fill-flash is one of the most useful flash techniques since it allows you to achieve an overall exposure that would be impossible to record otherwise, and it works just as well with digital as it does with film-based photography.

The human eye is capable of dealing with an extremely wide range of contrast (the difference between the brightest and darkest area in any scene), and our vision is further enhanced by the interpretation carried out by the brain of

The middle-right was shot with Standard TTL flash and flash output level compensation set to −1EV; for the photo on the far right, flash output level compensation was increased to −2EV.

the signals it receives from the eye. In some instances our visual response to specific lighting conditions is the result of adaptive processes in our eyes.

Unlike our eyes, film and digital sensors have a fixed range of contrast that they can record. The response of both film and digital sensors to light does vary but, in most cases, it is close to being linear (especially with digitasl sensors). Below a certain level of illumination, neither media will be able to record light; once past this minimum threshold, both begin to record light until reaching their maximum threshold where they are unable to retain any information. Users of transparency film will be familiar with having to work within a narrow dynamic range of about 5 stops between the darkest and lightest areas of a scene, if they want to record detail in both. Print film and many digital sensors are generally

more tolerant and can often cope with a range of 7 to 8 stops difference but even this is narrow compared with our eyes, which can often cope with a range of 12 stops, sometimes more!

This means your eyes you will see far more detail in the shadow and highlight areas than your camera can record, particularly if the lighting conditions exhibit a wide range of brightness levels between the darkest and lightest areas.

Note: Some digital camera models allow the user to define the response to specific lighting conditions by inputting information on how to process the signal from the sensor. However, this does not overcome the limitation of the sensor's ability to record contrast.

Using Fill Flash
By increasing the illumination of the darker areas of a subject and thus reducing the range of contrast, we improve the ability of the camera to record the subject. This "fill" light gives its name to the technique—fill flash.

As discussed in the previous chapter (See page 92), there are a range of fill-flash options that depend on the configuration of both your camera and Speedlight. Remember that essentially there are two options: let the camera and Speedlight control the fill-flash automatically (as in Automatic Balanced Fill-flash) or control the fill-flash yourself using Standard TTL flash.

Automatic Balanced Fill-Flash
Setting this is very straightforward and there is very little for you to consider. You have no control over the process because the camera performs it automatically. Automatic Balanced Fill-flash is available on virtually all Nikon cameras beginning with the F4, N8008/F-801 series and all Speedlight models from the SB-24 onward.

• Set the camera to Matrix metering

- Set the exposure mode. For the minimum of effort select Program (P), Aperture Priority (A), or Shutter Priority (S). If you want to set the exposure values yourself select Manual (M).

- Use the flash mode button (on some models this is just marked with an M) on the Speedlight to select **TTL** and ensure that either **TTL ⊙**, or **TTL ⊡**, or **TTL** **BL** appear next to it. Finally, if your Speedlight has a switch to select either Normal or Rear-curtain sync set it to Normal.

Note: If you select Manual (M) exposure mode on some cameras such as the D70-series the TTL flash mode defaults to Standard TTL.

Note: Using these settings with a D or G-type Nikkor lens attached to your camera will, typically, provide 3D Multi-sensor Automatic Balanced Fill-flash. If the lens is not a D or G-type, or on some earlier camera models that do not support the focus distance feature, these settings will provide either Matrix or Multi-sensor Automatic Balanced Fill-flash.

Mode Restrictions

I have already referred to some potential pitfalls when using certain combinations of exposure and flash modes in specific conditions, but a little review may be helpful.

- Program (P) and Aperture Priority (A) exposure modes impose restrictions on the available range of shutter speeds when a Speedlight is attached to the camera and is switched ON. Typically, these speeds extend between just 1/60th and 1/200th second, which may mean that you will be unable to attain a proper exposure for parts of the scene not lit by the Speedlight. So, set Slow sync flash to extend the range of lower shutter speeds to the slowest available on the camera.

- Program (P) mode imposes limits on the range of lens apertures that can be set depending on the ISO in use. So, select an alternative exposure mode. I recommend Aperture Priority for most shooting situations and subjects.

- Nikon's automated flash exposure control system works extremely well but despite its sophistication, it is not infallible! As discussed in the previous chapter, it relies on a range of different information sets about the brightness and contrast range of a scene, focus data, and estimated position of the main subject within the frame area. All of this is compared with a database of shooting parameters stored in the camera. However, abnormally high or low levels of reflectance, subjects located at the periphery of the frame, and subjects not located at the recorded focus distance can all cause different results from those you expect! So, select Standard TTL flash and set the fill value manually using the flash output level compensation feature on the Speedlight.

- Most Nikon cameras have a maximum flash sync speed of 1/250th second or less at their default settings. In extremely bright conditions, particularly when you want to use a wide aperture value (low f/ number), the prevailing ambient light may be too bright to allow you to select the desired combination of shutter speed and lens aperture. This situation will be compounded if you are using a medium to high ISO (sensitivity) setting. So, select Focal Plane (FP) High-speed flash sync mode if your camera and Speedlight combo supports it. If not use a lower sensitivity (ISO) setting.

Manual Fill-Flash

For 99% of my photography I use my cameras set to Matrix metering and Manual exposure (M) mode. I switch to spot metering when I want to take a precise reading for comparison purposes so that I can exercise even more control over exposure. (I usually do this if I disagree with the camera's suggested exposure value.)

Occasionally, when using fill-flash, I have found my control of exposure for the ambient light to be at odds with Nikon's automated control of flash exposure, so I use Standard TTL flash and set flash output level compensation manually.

To exercise greater control over exposure, here is how to set fill-flash manually with most recent Nikon cameras beginning with the F4, N8008/F-801 series, and all Speedlight models from the SB-24 onward:

- Select your preferred metering mode.

- In Manual exposure mode set the desired shutter speed/aperture combination.

- Switch the Speedlight to ON and use the mode button to select Standard TTL flash mode – only **TTL** should be displayed. If either **TTL ⊙** , or **TTL ⊠** , or **TTL** **BL** appear next to it you are still in an automatic balanced fill-flash mode. To cancel these modes keep pressing the flash mode button until just **TTL** is displayed.

- To set the flash output level compensation press the **SEL** button until the flash exposure compensation value (on most modern Speedlights this is located in the top right corner of the control panel LCD) begins to flash. Then, depending on which model of Speedlight you are using press the **▲** and **▼** buttons, or the **⊕** and **⊖** buttons to select a compensation level. Press the **SEL** button again to confirm and lock the required level of flash output compensation.

The secret to successful fill-flash is to ensure the technique does not look obvious! In most situations you will want to reduce the flash output by selecting a negative compensation variables. This compensation factor will depend on several factors: the level of ambient light, the reflective qualities of the subject, and the range of contrast in the scene. As a general rule of thumb, for outdoor photography with a subject or scene that is made up of a range of average tones, a compensation factor of -1.7EV is a good starting point. If the subject is predominantly lighter than a mid-tone, you may wish to reduce the level of flash even further to around -2.0EV; conversely, if it is much darker than a mid-tone it will absorb more light and you will need a higher output from the flash, so try a compensation factor of about -1EV.

Why should you modify the flash output in this way? If you leave the flash set to Standard TTL flash mode, the flash output will be set by the system to illuminate the subject as though flash was the main light source. The Speedlight won't be working as a fill light, so you will end up with the flash and ambient light close to a 1:1 ratio. Thus, the subject will often look as though it has been over lit.

If you have an older Nikon film camera and Speedlight that support TTL control but do not offer flash output level compensation you can still use the fill-flash technique. It just requires a little deception on your part! To reduce the flash output you need to "fool" the flash into believing that it is working with a film that has a higher sensitivity (ISO) rating.

• Start by adjusting the ISO/ASA setting on the camera by the level of flash compensation you require (e.g. if you want to reduce flash output by 2-stops and the camera is loaded with ISO 100 film set the camera to ISO 400.

• Set Manual exposure mode and select a shutter speed, ensuring of course that it is at or below the camera's maximum flash sync speed.

• Meter the scene and set an appropriate aperture value.

• To compensate for the adjustment made to the ISO/ASA rating open the lens aperture by an equivalent amount (e.g. if your metered exposure suggests an aperture of f/5.6 and you increased the ISO/ASA rating by 2-stops open the lens to f/2.8)

• Note the focus distance from your lens and compare this with the flash shooting range shown on either the dial or display of the Speedlight to ensure the flash is within range of the subject for a proper exposure.

• Switch the Speedlight ON and once the flash has fully charged make the exposure.

Note: It is best to use slow films (i.e. ISO 100 or less), as most cameras that can be used with this version of the fill-flash technique only perform TTL flash control up to a maximum sensitivity setting of ISO 400.

Focal Plane (FP) High-Speed Sync

I discussed flash synchronization speed in the first chapter of the book (see page 17), and stated that most recent Nikon cameras have a maximum flash sync speed of 1/250th second at their default settings. In extremely bright conditions, when you want to use a wide aperture (low f/ number), you will often have a limited choice of shutter speeds and apertures. This is because with normal flash synchronization you cannot exceed a shutter speed of 1/250th second. If the prevailing ambient light is very bright, you will often find that even with a shutter speed of 1/250th second, you need to use a relatively small aperture value (large f/ number) to attain a proper exposure. In many instances such aperture values provide too much depth of field, making it difficult, or impossible, to isolate the subject from its surroundings.

The only other option available at this point is to reduce the sensitivity (ISO) rating. But what can you do if you are already using the slowest film available or the lowest sensitivity (ISO) supported by your digital camera?

The solution is to select Focal Plane (FP) High-speed flash sync mode, if your camera and Speedlight support it. (FP) High-speed sync is available in two forms depending on the model of camera and Speedlight being used. Cameras from the N90/F90 series on, used with the SB-26 Speedlight or a later model, offer manual (FP) High-speed flash sync mode. The most recent cameras and Speedlights that support Nikon's Creative Lighting System (CLS) support automatic (FP) High-speed flash sync mode.

Manual (FP) High-speed flash sync mode is a variant of normal manual flash exposure control, whereas with the CLS

cameras it is a variant of both TTL Automatic Balanced Fill-flash and Standard TTL flash, and depending on the camera model used additional non-TTL flash modes are also available. In both cases selecting FP mode removes the restriction of the camera's normal maximum flash sync speed and permits flash to be synchronized at all shutter speeds up to the maximum available on digital SLR cameras and the F6, and 1/4000th second on all other compatible film cameras. Before you say why not have FP mode selected all the time, it is important to understand how FP mode alters the behavior of the Speedlight. In FP mode the Speedlight does not emit a single continuous flash pulse but a series of relatively weak pulses in very rapid succession. This has the effect of reducing the level of illumination from the Speedlight by approximately 2-stops, which in turn reduces the effective flash shooting range. Whenever you set FP High-speed sync mode always check the distance scale shown in the control panel of the Speedlight to see if the subject is within the distance covered by the flash. The higher the shutter speed you select, above the normal maximum flash sync speed, the weaker the flash pulses emitted by the Speedlight in FP mode become. This is due to the fact that the duration of the pulses is reduced. This has a direct effect on the effective flash shooting range, which is reduced further and further as the shutter speed increases.

Manual FP High-speed sync mode is available with the N90/F90 series, F90s/F90x, F100, F5, and D1 series cameras. Auto FP High-speed sync mode is available on the D2 series, D200, and F6 cameras. It is not supported by the D70 series and D50.

Note: On some Nikon digital SLR models (D1-series, D70/D70s, and D50) the maximum flash synchronization speed is a 1/500 second. These cameras have an electro-mechanical shutter that emulates high shutter speeds (i.e. those above 1/250 second) by opening the shutter for a 1/250 second and then switching the camera's sensor on and off for a shorter period of time.

Repeating Flash

Repeating flash is a variant of manual flash mode and is available with the SB-24, 25, 26, 28, 28DX, 80DX, and the SB-800. On all but the SB-800 and SB-R200 it is selected when both **M** and **555** appear together in the Speedlight's control panel LCD. It is selected on the SB-800 when **RPT** appears in the control panel.

In repeating flash mode, the Speedlight fires rapid bursts during the course of a single exposure. This mode is ideal for creative flash photography or when you want to record multiple images of a moving subject during a single exposure, but otherwise it has limited practical application. The level of each flash pulse is fixed and is pre-determined by selecting the output level before releasing the shutter. The mode also requires you to pre-select both the frequency and the total number of the flash bursts that will occur during the exposure. As this technique records multiple images of a moving subject during a single exposure, make sure that you use a shutter speed of sufficient duration to record the total number of images you desire.

Each flash pulse emits sufficient light to illuminate the subject correctly based on the flash shooting range, the lens aperture, and flash output level selected by the photographer. Thus, it is important to ensure the subject moves a sufficient distance between each flash pulse to prevent any image overlap from occurring. If the subject, or part of the subject, does overlap itself for two or more flash pulses those areas will be overexposed.

Hint: The best results are usually achieved when the subject is photographed against a dark background, or the background is deliberately under-exposed so that it is rendered in a darker tone(s). If you do not do this the background, which receives light from each of the multiple flash outputs may become over-exposed, and/or it is difficult to distinguish the subject from its background.

Note: Although compatible with i-TTL flash exposure control and the CLS, the SB-600 does not support repeating flash mode when it is used in isolation. However, it is possible for it to perform repeating flash when used as a remote flash in the Advanced Wireless Lighting System.

Red-eye Reduction

I am sure most photographers who shoot with flash have experienced the dreaded red-eye effect, which causes the instant transformation of your subject into a demonic character from a horror film!

What Causes Red-eye?

The retina of the human eye is covered with two types of light sensitive cells known as rods and cones; behind these there is a dense layer of blood vessels. If light of sufficient intensity is shone directly into our eye it is reflected back through this layer of blood vessels, which imparts a red color cast to the light. Very specific conditions must occur for red-eye to be seen: high intensity light directed straight at the retina, and a line of sight at, or very close to, the same axis as the light that's reflected. Unfortunately, using direct flash to photograph a person often satisfies both these conditions: the intensity of most flash units is sufficient to create the reflection from the retina, and the central axis of the lens is usually very close to the source of the light, especially if the flash is mounted in the accessory shoe of the camera.

It is also possible to get reflections from the eyes of animals. This is often referred to as eye-shine but the cause of the reflection and the color of the reflected light is quite different than with the human eye. Many vertebrates have an additional layer either in, or immediately behind the retina of their eye, known as the tapetum lucidum (Latin for "bright carpet"). Its function is to reflect light back into the retinal cells to increase the amount of light they receive, and is found, primarily in nocturnal animals with good low-light vision such as cats, owls, and foxes.

The tapetum lucidum is responsible for eye-shine in a variety of species and its effects are analogous to the red-eye effect seen with humans, except that, depending on the species of animals, the color of light can be blue, green, yellow, and pink.

Red-eye Reduction Theory

While, the red-eye effect occurs when the angle between the central axis of the lens and the axis between the center of the flash tube and the subject's eyes is very narrow (about two to three degrees), there is no definitive value for this angle, as it will vary according to the diameter of the eye pupil. When the pupil is dilated the angle is increased, and conversely if the pupil is constricted the angle at which red-eye occurs is reduced. The red-eye reduction feature used by camera manufacturers relies on this principle. Photographers will most likely encounter red-eye when taking flash pictures of people in dimly lit interiors. Under these conditions the subject's pupils are likely to be dilated so the red-eye reduction feature uses an output of light before the exposure is made, which causes the eyes to react to this relatively brighter light by constricting the pupils. This helps to reduce the angle at which red-eye is likely to occur, and is most advantageous at short shooting ranges, generally less than 10 to 12 feet (3 to 3.5 m).

Note: The nature of the red-eye reduction output varies between different Speedlight models – see below.)

Setting Red-eye Reduction

Using red-eye reduction is straightforward on those cameras and Speedlights that support the feature, and is set as follows:

• Switch both the camera and Speedlight to ON.

• It is advisable to set the camera to single fame advance and single-servo autofocus, or manual focus.

- Press and hold the flash mode button on the camera and turn the Main Command dial until ⊕ appears in the flash mode displayed in the relevant control panel LCD on the camera. Note, ⊕ is also displayed in the control panel LCD of most Speedlight models when this feature is active.

- To cancel the feature, repeat the step above and ensure ⊕ is no longer displayed.

Note: While red-eye reduction can be set in conjunction with Slow sync mode, it cannot be set with Rear-curtain sync, or if repeating flash is selected.

Note: The regime of red-eye reduction varies between Speedlight models; the SB-800 and SB-600 emit a series of three flash pulses, whereas the earlier Speedlights that support this feature (SB-80DX, SB-28, SB-27, SB-26, and SB-25) rely on a separate lamp that illuminates for approximately one second before the flash fires, as do a number of Nikon camera models.

Note: The monitor pre-flashes used for flash exposure assessment are too weak and occur to close to the main flash output to have any appreciable affect on the size of a subject's pupils.

Reasons for Not Using Red-eye Reduction
In my opinion, all red-eye reduction features are fairly ineffective and they are often a hindrance to successful flash photography. Here are some of the reasons:

- Setting red-eye reduction introduces a significant delay between pressing the shutter release button and the actual exposure being made. This allows time for the red-eye reduction light output to occur. Usually this means you will miss that "magic moment," as you will not be able to anticipate the subject that far in advance, or react quickly enough to changing circumstances.

- The light used by the red-eye reduction feature sends a clear an unequivocal message to your subject that you are in the process of taking a picture and, to make matters worse, most people will react in a defensive manner when a bright light is shines in their face. This often causes them to stiffen their posture, squint, and even blink. Unfortunately the delay between the red-eye reduction light and the main flash output is usually just long enough for this reaction to occur!

- The additional light output will increase the power demand on the Speedlight's batteries, which in the short term extends flash recycle times and in the long term reduces your overall shooting capacity.

- There is no guarantee the red-eye reduction will eliminate all traces of red-eye. At flash-to-subject distances over about 10 to 12 feet (3 to 3.5 m), the angle between the central axis of the lens and the line between the flash tube and subject's pupils will usually cause red-eye.

The Best Ways to Reduce Red-eye
- Take the flash off the camera. If you use a dedicated TTL flash cord such as the SC-28, or the discontinued SC-17, you can maintain full TTL support of the Speedlight while increasing the angle between the flash-to-subject line and central axis of the lens.

- Increase the level of the ambient illumination, as this will cause the subject's pupils to constrict and thereby reduce the critical angle at which red-eye is likely occur.

- Ask you subject(s) to look off slightly from the central axis of the lens; if they look at a point about 1.5 to 2 feet (0.5 to 0.7m) to one side of the camera it is unlikely that your pictures will be afflicted by red-eye within most normal flash shooting ranges (i.e. up to about 30 feet or 10 m).

Using Your Speedlight

Control of Speedlight Illumination

The Nikon Speedlight systems offer a variety of ways to fine-tune and control the light from the flash. One of these is the adjustable zoom head, but there are also accessories that modify light, and adjustments that can be made to color temperature. This chapter shows you how these tools can be used to refine the light from your flash, and take your flash photography to the next level of sophistication. There is also a discussion of batteries at the end of this chapter.

Speedlight Zoom Heads

When attached to most recent Nikon cameras (F4 or later), the majority of Speedlight units from the SB-24 on have the ability to automatically adjust their zoom head to ensure flash coverage of the angle-of-view of the lens focal length in use. However, the position of this "automatic zoom head," as Nikon calls it, does not precisely match the focal length of the lens. Instead, it sets itself to fixed positions. On models with this capability, from the SB-25 to the SB-600, these preset focal lengths are: 24mm, 28mm, 35mm, 50mm, 70mm, and 85mm. The SB-24 covers a slightly shorter range between 28mm to 85mm, and the SB-80DX and SB-800 models feature coverage between 24mm to 105mm. These units also allow finer adjustments in increments of 5mm, between 35mm and 105mm.

The changes in flash coverage are achieved by moving the flash tube in relation to a Fresnel lens that is mounted at the front of the flash head. The angle at which the light from the flash is dispersed depends on the distance between the flash

○ *Nikon offers photographers a great deal of options in using the components of its Speedlight systems. This photo was created using an SB-800 off camera with an SC-29 TTL remote cord.*

tube and this Fresnel lens. Most Speedlights from the SB-25 onwards feature an additional lens, usually called a wide-angle adapter, which can be placed across the front of the flash head to increase the dispersal of light even further. At zoom head positions of 28mm or above, these wide-angle adapters disperse light very efficiently and provide an even level of illumination. However, at wider settings, particularly when using the additional wide-angle adapters, (see below) you can sometimes see evidence of light fall off toward the extreme corners of the frame area.

Note: If you use a focal length that falls between two of the zoom head positions, the Speedlight will always defaults the shorter position to ensure sufficient coverage of the full frame. This will have the effect of reducing the flash-to-subject shooting range, as the Guide Number is reduced, because the illumination from the flash must cover a larger area. Usually this is not an issue with lenses of 50mm or longer, but it can become significant with very wide-angle lenses. Guide Number values for all Speedlights covered by this book are in the section that covers each model.

Note: Although the setting of the zoom head position is performed automatically, it can also be adjusted manually by pressing the Zoom button, or (insert triple tree & single tree button icons from SB-800) buttons depending on which Speedlight model you are using.

Speedlight Wide-Angle Adapters
Speedlights, prior to the SB-24, use either a manually adjusted zoom head, or an optional accessory wide-angle adapter to increase their angle of their coverage; these typically extend coverage to match the angle-of-view of a 28mm lens, 24mm in the case of the SB-16A/B, (for full-frame 35mm format).

Additional wide-angle adapters are still used on recent Speedlights to provide coverage for focal lengths less than 24mm. Beginning with the SB-25 Speedlight this process is semi-automatic, because the photographer must pull out the

wide-angle adapter, located under the top of the flash head. This action causes the zoom head to automatically move to its default zoom head position (20mm, 18mm, or 17mm depending on the model). Further adjustment between this default position and a wider setting, if possible, is possible by manually pressing button(s) on the Speedlight.

The wide-angle adapter provides coverage equivalent to the following minimum focal length values:

- On the SB-25—20mm only.

- On the SB-26, SB-28, SB-28DX—18 and 20mm.

- On the SB-80DX and SB-800—14mm and 17mm.

- On the SB-600—14mm only.

Speedlight Diffusion Domes
The SB-80DX and SB-800 accept an additional light-modifying device, the SW-10H diffusion dome. Attaching this dome to either Speedlight depresses a small switch located on the underside of the flash head, which causes the zoom head to move to provide coverage for a focal length of 14mm. This occurs regardless of whether the built-in wide-angle adapter is extended or not, and no matter what lens focal length is in use. Rather than dispersing the light in a controlled way, the SW-10H diffuses the light so that it becomes less directional, which helps to "wrap" the light around the subject and soften the edges of shadows. Attaching the SW-10H reduces the distance the light from the flash will travel because the light is dispersed over a larger area but, at short ranges, it can make a significant difference to the quality of the lighting. This is especially useful when using standard Speedlights for close-up and macro-photography (see page 127).

Note: Because the SW-10H can only be attached to the flash head in one specific orientation, it is helpful to place a small piece of colored tape along the top of the rear edge for a guide.

This scene was photographed in ambient light with the sun behind the camera. (See page 112 for a rendition of the subject using flash.)

The DX-Format Factor

Most readers are probably aware that the dimensions of the 15.6 x 23.7 mm sensor used in Nikon digital SLR cameras produced to date are smaller than the 24 x 36 mm frame of 35mm film. Nikon calls this smaller size the "DX-format." It is significant when D-SLRs are used with Nikon Speedlights because the focal length positions on their zoom heads and thus, the coverage the flash provides, were designed for 35mm film camera systems, but not the reduced angle-of-view recorded by the DX-format sensor. This reduced size causes the sensor to record light from a smaller central area, when compared with the full 35mm frame. This has the effect of reducing the angle-of-view of a lens to that of a focal length 1.5x longer used on the full 35mm frame format.

For example, if you use a lens with a focal length of 50mm on a DX-format camera, its angle-of-view is equivalent to a focal length of a 75mm lens on a 35mm film cam-

era. Consequently, if you were to attach a Speedlight to this DX-format camera, the zoom head would automatically provide coverage for the actual lens focal length (50mm), when the flash is switch to ON. In this instance, the angle-of-coverage provided by the Speedlight is equivalent to the actual angle-of-view of the 50mm lens on a 35mm camera, not the effective angle-of-view on a digital SLR of a 75mm lens. So, light that falls outside the narrower angle-of-view recorded by the DX-format sensor is wasted. To maximize the illumination provided by your Speedlight, when shooting with a DX-format Nikon digital SLR, manually set the zoom head as indicated in the following table:

Actual focal length of lens on DX-format camera	Equivalent focal length on 35mm camera [1]	Speedlight zoom head setting for DX-format
12mm	18mm	18mm
14mm	21mm	20mm
17mm or 18mm	25mm – 27mm	24mm
20mm	30mm	28mm
24mm	36mm	35mm
28mm	42mm	50mm
35mm	53mm	60mm
50mm	75mm	70mm
60mm or 70mm	90mm – 105mm	85mm
85mm or more	127mm	105mm [2]

1. *The 1.5x factor is not exact but rounded down (defaults to lower number.)*
2. *The 105mm setting is only available on the SB-80DX and SB-800 Speedlights.*

Practical and Creative Uses of the Zoom Head

Regardless of whether the zoom head is set automatically for a film camera or manually to match the coverage of the DX-format sensor, you don't have to use these settings! If you take control of the zoom head and adjust it to suit your own photographic style, you will find even more practical and creative ways to use your Speedlight(s).

Here is the same scene as on page 110, shot with the same 14mm lens, but the sun was in front of the camera and the Speedlight zoom head was manually set to 85mm to create a narrow beam of light. This acted as a spotlight, which illuminated a small section of the ironwork in the lower center of the scene.

Zoom Head Variations

- By concentrating the flash output into a narrower beam than the angle-of-view of the lens, you can spotlight elements in the composition and give them greater emphasis. This technique is particularly effective with wide-angle lenses, and when using the flash(es) as a remote unit(s) in multiple Speedlight lighting setups.

- When shooting portraits, reduce the flash output level by about 2-stops and set the flash zoom head to it narrowest coverage (longest focal length setting). This puts a highly directed, small amount of light into the subject's eyes to create a distinct catch-light—you will be amazed at how this brings eyes to life!

- Another practical reason for setting a Speedlight zoom head to produce a narrow beam of light occurs when the flash is used to control remote (slave) Speedlights in multiple flash set ups. Narrowing the beam allows you to precisely direct the flash output toward the remote Speedlight's sensor. This will not only improve the efficiency of the system, but will also increases the range over which the remote Speedlight(s) can be controlled (see the following chapter – Using Multiple Speedlights page 145).

- If your subject is closer than 10 feet (3 m) and there are no suitable surfaces for bounce flash, you can set the zoom head to a much wider setting than the focal length in use. This disperses the light over a larger area, which provides a softer, more diffuse light than firing the flash directly with the zoom head matched to the focal length of the lens.

- Flash is not just for portraits of people and animals, it can be used very effectively for landscapes and architectural shots. For example, in a scene when the foreground is less well-lit than the background, because the sun is low in the sky, shadows in the foreground of the scene are long and deep. In a situation like this, take care not to over-light the foreground. The flash should provide just enough illumination to lift the shadows to a point where they receive 1 to 2-stops less exposure than the background.

- Similarly, when your foreground is very close to the camera (i.e. less than 3 ft, or 1 m), you can avoid over-lighting the immediate foreground by taking the flash off the camera. This is often necessary when the foreground is lit properly and you want to keep the mid and distant foreground from being underexposed. Remember, light from your flash will fall off according to the Inverse Square Law (i.e. if the flash illuminates an element in the foreground properly at 3 ft (1 m) from the camera, an element that is 6 feet (2 m) from the camera will receive 2-stops less light). By using a directional fill light from the flash you can usually create a better balance between the foreground and background illumination.

Here is an SB-28 with its bounce card extended. Instructions for making a variety of settings are on the card's reverse side.

Hint: To achieve accurate flash exposure with a camera/lens/flash combination, that uses focus distance information as part of the flash exposure calculations, it is important that off camera flash units (connected by a dedicated TTL cord, such as the SC-28 or SC-29), are at the same distance from the subject as the camera.

Note: Due to the broader coverage caused by the use of wide-angle adapters, the GN of the Speedlight is reduced, often by a significant amount. I have listed these values for the models covered by this book in the relevant section for each Speedlight.

Modifying Flash Color

Nikon Speedlights are designed to produce light that matches, as closely as possible, the color of direct sunlight at midday. In practical terms, this means that the light they produce has a color temperature in the narrow range between about 5,400K and 6,000K. The precise color temperature depends on the duration of the flash output. If the duration is very brief, as in the case of fill-flash, the color temperature tends toward the higher end of this range. As the duration of the flash increases to provide more illumination, the color temperature shifts toward the lower end of the range indicated above.

However, the assessment of color by the human eye is a subjective process, and opinions will vary, about whether a photograph appears to have a cool bias, a warm bias, or is color neutral. If you shoot with a mix of flash and other light sources, such incandescent (tungsten) lighting, there will be a disparity in color rendition between the areas of the scene illuminated by flash and those lit by the incandescent source. So, you may want to modify the color of the light produced by your Speedlight(s). Before I present how and why this is done, here is some background on color temperature and how it influences the appearance of photographs, regardless of whether they are shot on film or digitally.

Color Temperature
The color of light is often referred to as its "color temperature," which is expressed using the absolute centigrade scale in units of degrees Kelvin (K). It sounds counter-intuitive, but warm light (higher red wavelength content) has a low temperature and cool light (higher blue wavelength content) has a high temperature.

Why is this? Well, the color temperature of a light source correlates to the color of a "black body radiator" (a theoretical object that re-emits 100% of the energy it absorbs) as it is heated; its color changes from black, to red, orange, yellow, through to blue, as it gets hotter. The spectral output of

a particular light source is said to approximate to a "black body" at the same temperature; thus, at low color temperatures, light contains a high proportion of red wavelengths, and conversely, at a high color temperature it comprises, predominantly, of blue wavelengths.

Generally, during its manufacture most film is balanced to the color temperature of either daylight under a clear sky at mid-day (5500K), or the light emitted by a tungsten photoflood lamp (3400K). If the color temperature of the light in which you expose film differs from these values your photographs will show a color cast, which you have to counter by using color correction filters.

Digital cameras are far more versatile and most allow you to set a specific color temperature, usually referred to as the white balance. Assuming the white balance value set on the camera corresponds to the color temperature of the light illuminating the scene, photographs will be rendered without any color cast; thus, obviating the need to use color correction filters.

However, if the color temperature value set on the camera is lower than the actual value present in the light falling on the subject, the photograph will look rather cool (i.e. too blue); conversely, if the color temperature value set on the camera is higher than the actual value present in the light falling on the subject, the photograph will look rather warm (i.e. too red).

Filtering Flash Output For Film
Although it is closely matched to the color temperature of direct sunlight at midday, many photographers find that the light produced by Nikon Speedlights is a little too accurate. That is, pictures taken with flash can appear slightly cool (blue), particularly when the flash is used as the main light source, and in many cases when it is used as supplementary light source, as it would be for daylight fill-flash (see Flash Techniques – Fill-flash page 92).

Using fill-flash with daylight transparency film is a prime example of an occasion when you may wish to consider modifying the color of the light from your Speedlight by using a color correction filter. The color temperature of daylight varies considerably depending on the time of day and the level of cloud cover, whether you are shooting in direct light or under shade. Under an overcast sky, or in open shade beneath a clear blue sky, the color temperature of daylight is significantly higher than the value of 5,500K that most daylight film is balanced for.

So, a pale amber color correction filter (e.g. an 81a, or 81b type) would be used to remove the blue cast that would otherwise occur. However, this only corrects for the disparity between the color temperature of the ambient daylight and the color temperature to which daylight film is balanced. Unmodified, the color temperature of the light from the flash can range between 5,400K and 6,000K; so, those areas of the picture lit by flash may still appear slightly cool (blue) compared with those areas illuminated exclusively by daylight. Of course the strength of this effect will depend on the proportion of flash to daylight but, if it is perceptible, the success of the photograph may be reduced; because the use of fill-flash will be obvious, and the rendition of colors in the subject may look slightly different to the rest of the scene.

The solution is to "color" the light from the flash by using a gel type filter of the same type (i.e. 81a or 81b) to filter the ambient light. The improvement to the balance between the light sources has to be set against a slight loss of light transmission from the flash due to the filter, but, for an 81a or 81b filter this will be no more than about 1/3EV. In light of this last point, and to avoid over-filtering the light from the flash, you will probably want to experiment as to how much of the face of the flash head is covered by the filter. Start by covering 50% of the flash head face and see what works for you.

Note: The gelatin or polyester type filters made by a variety of manufacturers for use with lenses are NOT suitable for filtering flash, because the flash head can produce sufficient heat to melt them. You should use filter material designed specifically for high-heat generating lamps, such as stage lights, which you should be able to source through professional photographic stores.

Alternatively, there may be situations when you want to shoot a scene lit by an artificial light source, such as tungsten, and use flash as a supplementary light. If you were to shoot on daylight-balanced film in these circumstances, it would require a deep blue color correction filter (e.g. 80a type) to balance the color temperature of the light source with the film and light from the flash. However, since the level of ambient light is likely to be rather low, adding a filter that typically reduces light transmission by 2-stops will cause you to resort to even longer shutter speeds, which may not be desirable or practicable.

As an alternative to using a color correction filter on the lens, you could use film that is balanced for the color temperature of tungsten lighting (3,400K); however, although the light source and film would be balanced, light from the flash would not be. Hence, those areas lit by flash will appear very cool (blue) by comparison with the rest of the scene. Again the solution is to "color" the light from the flash by using an appropriate color correction filter (e.g. 85-series type). Please bear in mind the caveats I issued above about the type and amount of filter material that should be used.

Flash Color with Digital Cameras
Digital cameras offer far more user control over the way light is recorded in regard to color temperature. This is due to the camera's white balance feature. Most cameras, and certainly all Nikon digital SLR types, allow a variety of settings to be made within their white balance feature to achieve correct color in pictures shot in light with a wide range of color temperature values.

Many photographers, including myself, consider the color temperature values used by Nikon for their digital cameras (for example, Daylight at 5,200K and Flash at 5,400K) to be rather low. Remember, if the color temperature value set on the camera is lower than the actual value of the light falling on the subject, the photograph will exhibit a very slight bias toward blue.

As mentioned above the color temperature of light emitted from a Speedlight falls within the range of 5,400K to 6,000K, depending on the duration of the flash output: the greater the duration, the lower the color temperature value. So, when a Speedlight is used with a camera set to the white balance options of either Daylight (5,200K), or Flash (5,400K), as is likely for daylight fill-flash in certain conditions, the images produced can look a little cool (i.e. too blue).

Hint: Although visual assessment of color is very subjective, and every photographer has their own preference for white balance settings, it is worth taking a little time to experiment. On those camera models that do not offer the ability to set a specific color temperature value, try setting an alternative white balance option when working with or without flash in bright sunlight, such as Cloudy (6,000K) and refine this using the fine tuning control.

Note: If you connect any of the DX-model Speedlights to a compatible Nikon digital SLR camera, and set the camera's white balance to the Auto option, the white balance color temperature defaults to the Flash value of 5,400K, and remains fixed.

Note: If you connect either the SB-800, or SB-600 Speedlight models to a Nikon digital SLR camera that supports the Creative Lighting System (CLS), and set the camera's white balance to the Auto option, the color temperature defaults to the Flash option (5,400K) for white balance. Depending on the chosen flash mode, the color temperature will either vary, or remain fixed at 5,400K (see the next section - Flash Color Information Communication).

The picture on the left was photographed using just natural daylight—no flash. The same scene, in the photo on the right, was shot in near total darkness using the open flash technique. The exposure was built

Flash Color Information Communication

The SB-800, SB-600, and the built-in Speedlights of cameras (D200, D70-series, and D50) that support the Creative Lighting System (CLS) offer what Nikon calls "Flash Color Information Communication." This feature works exclusively with the Auto white balance option of compatible digital cameras. Nikon provide precious little information in the Speedlight instruction manuals about how this feature works beyond stating the following: "When the SB-800 (SB-600) is used with compatible digital SLRs, color temperature information is automatically transmitted to the camera. In this way, the camera's white balance is automatically adjusted to give you the correct color temperature when taking photographs with the SB-800 (SB-600)."

The instruction manuals to relevant cameras also often contain an oblique reference to Flash Color Information

up using multiple outputs from an off-camera flash. Each time the flash was fired, it was directed at a different area of the scene. A total of 15 flashes were used to complete the final exposure.

Communication, which states that when using either a built-in Speedlight, or the external SB-800 and SB-600 Speedlights, the recorded white balance "reflects conditions in effect when flash fires."

You need to also know that Flash Color Information Communication system only works when the camera's white balance option is set to Auto. If an alternative white balance option is selected, it takes priority, and the color temperature for that option is applied. Regardless of whether the Speedlight is set to one of the **TTL BL** (Automatic Balance Fill-flash) modes, or **TTL** (Standard TTL flash) mode, if a CLS compatible camera is set to its Auto white balance option and the Speedlight is switched to ON, the camera's white balance is automatically set to the default color temperature of 5,400K for the Flash white balance option, regardless of the color temperature of the prevailing ambient light.

However, if the Speedlight is set to TTL BL mode, the color temperature of the ambient light is taken into account. Here, the final white balance value assigned by the camera may differ, although only slightly, from the 5,400K value of the Flash white balance option. Nikon has not documented the degree of variation that may occur in these circumstances, but I understand it is no more than approximately +/- 1,000K.

Note: If you select Manual (M) exposure mode on the D70-series and D50 cameras, Standard TTL flash mode is set automatically. If you select spot metering with any CLS compatible digital SLR camera, Standard TTL flash mode is set automatically

If the Speedlight is set to TTL mode, the color temperature of the prevailing ambient light is ignored completely; the white balance value assigned by the camera has a color temperature of 5,400K (the value of the Flash white balance option).

Flash Color Information Communication is an entirely automatic feature; when a Speedlight is set to TTL BL the user has no control over the adjustments to color temperature made by the camera in respect to the prevailing ambient light. Remember: the color temperature of the light produced by a Speedlight is fixed within a range of 5,400K to 6,000K, depending on the duration of the output. If the difference between the color temperature values of the two light sources is small, it is unlikely that any change will occur to the color temperature of picture. However, if the difference is considerable, it is highly likely that a perceptible shift in color temperature will occur.

Therefore, in circumstances where the color temperature of the ambient light is significantly different (i.e. >1000K) to the color temperature of the Flash white balance option (5,400K), I recommend that you avoid using the Auto option for white balance. In these conditions, if you want to attain consistent, repeatable results, I suggest you set the camera's white balance to match the color temperature of the ambient

light, and control the color temperature of the flash output by using appropriate color correction filters (see the next section - Filtering Flash Output For Digital).

Filtering Flash in Digital Photography

Balancing the color temperature of light produced by a Speedlight and the prevailing ambient light, particularly when there is a significant difference between the two values, is beyond the limitations of the Flash Color Information Communication system described in the previous section. Besides, this is a fully automated process over which the photographer has no control.

For example, you are working in Slow sync mode, or you have selected a slow shutter speed in Manual (M) exposure mode. Consider what would happen if you used flash (5,400K to 6,000K) to photograph a subject in an interior lit by tungsten lighting (3,000K), when the camera and flash have been configured to record the ambient light as well as the illumination from the flash. If the Speedlight was set to TTL BL mode and the Auto option was selected for white balance, the camera would drop the white balance color temperature from its default value of 5,400K by the maximum amount possible in the Flash Color Information Communication system. This would be a value around 4,400K. However, since the ambient light has a color temperature of about 3,000K, any area in the scene lit by this source will be rendered with a noticeable red/orange cast.

The solution is analogous with the techniques described in Filtering Flash Output For Film, page 116; set the white balance on the camera to the Incandescent option (3,000K) and use a color correction filter (an amber 85B type) over the flash head to match the output of the flash to this color temperature value. Using this method, you will render the entire scene with a far more neutral color balance. The same principal can be applied for light sources; match the white balance set on the camera to the color temperature of the ambient light and use an appropriate color correction filter to modify the color temperature of the light from the Speedlight(s).

Note: For this purpose, Nikon supplies the SB-800 Speedlight with two filters made of a polyester-type material: the TN-A1 (orange) that reduces light transmission by 1EV, and the FL-G1 (green), for use with fluorescent light sources that reduces light transmission by 1/3EV. The optional, Nikon SJ-1 filter set, contains two filters of different strengths for fluorescent and incandescent light respectively. If you use other filter materials on your flash, make sure that they are resistant to high temperature.

Note: Due to the phosphors used in fluorescent tubes, the light they emit tends to have a predominance of green/blue wavelengths; thus, the green color of the Nikon FL-G1 and FL-G2 filters for the SB-800.

Using A Flash Meter

Using a separate handheld flash meter to measure the light output of a Nikon Speedlight is fraught with potential problems. Other than when using any of the Manual flash mode options, monitor pre-flashes are fired by recent Nikon Speedlights in virtually all available TTL flash modes, when used with film cameras, and all of the available TTL flash mode options plus AA Auto Aperture with digital cameras. A handheld flash meter will react to the first light output it detects from the flash (i.e. the meter measures the first pre-flash pulse), and provides a totally inaccurate reading!

If you use a Nikon film camera (F5, F100, N90s/F90x, N90/F90-series, and N70/F70-series) and a Speedlight that supports the monitor pre-flash system, there are specific circumstances when using TTL flash exposure control (see list below) when the flash will not emit pre-flashes.

Note: In these cases only, the reading obtained using a handheld flash meter can be relied upon:

• The flash head is tilted and/or rotated from its normal horizontal/front-facing position and the flash shooting range distance bars are no longer displayed in the control panel LCD of the Speedlight

• Rear-curtain sync mode is set on the camera or flash depending on the model of Speedlight

• The Speedlight is set to Standard TTL flash mode

• A Nikkor lens without a CPU (e.g. an Ai or Ai-S type) is mounted on the camera

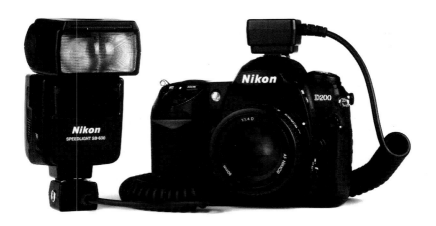

A Nikon D200 with an SB-600 connected via an SC-28 TTL cord.

Using a Speedlight Off-Camera with a TTL Cord

When you work with a single Speedlight it is often desirable to take the flash off the camera. Nikon produces a number of dedicated cords for this purpose: the SC-17, SC-28, and SC-29. All three cords are 4.9 feet (1.5 m) long, and up to three SC-17 or SC-28 cords can be connected together to extend the distance from the camera.

The benefits of taking a Speedlight off camera include:

- Increases the angle between the central axis of the lens and the line between the flash head and a subject's eyes. This will significantly reduce the occurrence of red-eye effect with humans or eye-shine with animals.

- In situations when it is not practical to use bounce flash, moving the flash off camera will usually improve the quality of the lighting, especially the degree of modeling, compared with the typical flat, frontal lighting produced by a flash close to the central axis of the lens.

- By taking the flash off camera, and directing the light from the Speedlight accordingly, it is often possible to control the position of shadows, so they become less distracting.

- When using fill-flash it is often desirable to direct light to a specific part of the scene to help reduce its contrast.

Hint: Whenever you take a Speedlight off camera and use any flash mode that incorporates focus distance information in the flash exposure computations, be careful where you position the flash. If the Speedlight is a different distance from the subject than the camera, the accuracy of the flash output may be compromised, because the TTL flash control system assumes that the flash is located at the same distance from the subject as the camera.

Note: Compatible with either the SB-800 or SB-600 Speedlights, the SC-29 has an AF-assist lamp built into its terminal block, which is mounted in the camera's accessory shoe. This positions an AF-assist lamp immediately above the central axis of the lens and can improve the accuracy of autofocus, compared to using an off-camera Speedlight's AF-assist lamp. This is because the light emitted by the Speedlight's AF-assist lamp may not be reflected with sufficient strength, if it strikes the subject at an oblique angle.

Note: A Speedlight connected to the camera via one of Nikon's dedicated TTL cords can be used as the master flash to control multiple off-camera Speedlights (see the chapter, Using Multiple Speedlights).

Using Standard Speedlights in Close-up Photography

Nikon's instruction manuals for most recent Speedlights (SB-24 or later) suggest that their effective shooting range is 2 – 66 ft (0.6 – 20 m), depending on the zoom head position, lens aperture, and ISO in use. However, it is possible to use these Speedlights at flash-to-subject distances less than 2 feet (0.6 m) for close-up photography. Nikon does offer information in their Speedlight instruction manuals about using flash down to a range of 2 feet (0.6 m), but instructions for use at shorter distances are incomplete and ambiguous, particularly in regard to calculating a lens aperture. Generally, Nikon has only provided information on calculating lens aperture in relation to the sensitivity (ISO) ratings across broad ranges (e.g. ≤ ISO100, ISO125-ISO 400, and ? ISO 500). To add to the confusion between the SB-28 and the SB-80DX, Nikon revised the value of the coefficients used to calculate lens aperture.

Since the equation below generates a value for the maximum aperture that can be used with a particular ISO, this revision of the coefficient value will cause an even more conservative maximum aperture to be calculated. However,

Taking a single flash off-camera for fill-flash work allows the photographer to direct light to a specific area of the subject and create interesting lighting effects.

in my opinion, Nikon takes caution too far by suggesting that the same coefficient value can be used for sensitivity ratings between ISO 32 and ISO160!

As these revised coefficents apply to both the SB-80DX and SB-800, which have a slightly higher maximum output compared with previous Speedlights, it is safe to use the same values for the SB-24, SB-25, SB-26, and SB-28/28DX.

To calculate the maximum aperture (smallest f/ number) for flash used at a subject-to-camera distance of less than 2 feet (0.6 m), use the following equation:

Aperture = Coefficient / Flash-to-subject distance

At a shooting distance of 1.6 ft (0.5 m), assuming a sensitivity setting equivalent to ISO 200, and using the coefficient value provided in the table below:

Aperture = 13.1(ft) / 1.6 ft = 8.18
Aperture = 4(m) / 0.5m = 8

Therefore, the maximum aperture that you can use is f/8; although, in most instances, you will probably want to set a smaller aperture (higher f/ number) to gain greater depth-of-field.

Note: You must use the same scale of measurement for the coefficient and the subject-to-camera distance.

Sensitivity (ISO)	Coefficient (feet)	Coefficient (m)
25	4.6	1.4
32	4.9	1.5
40	5.6	1.7
50	6.6	2
64	7.2	2.2
80	8.2	2.5
100	9.2	2.8
125	10.5	3.2
160	11.5	3.5
200	13.1	4
250	14.8	4.5
320	16.4	5
400	18.4	5.6
500	20.7	6.3
640	23.3	7.1
800	26.3	8
1000	29.6	9

Setting Up A Standard Speedlight for Close-Up Photography

To use a Speedlight for close-up photography at less than 2 feet (0.6 m), follow the procedure below:

- Connect the Speedlight to the camera, using one of the dedicated TTL cords (see page 139), making sure that both are switched to OFF while you do this. Taking the flash off the camera is necessary to ensure that the lens or its hood, if fitted, do not obstruct the flash illumination, which is likely when the flash is attached to the camera's accessory shoe.

- Set the Speedlight to Standard TTL mode. (Do not use any of the automatic balanced fill-flash modes). Only $\boxed{\text{TTL}}$ should be displayed in the LCD control panel of the flash. If $\boxed{\text{TTL}}$ appears with either $\boxed{\text{TTL}}\,\text{O}$ $\boxed{\text{TTL}}\boxed{\text{S}}$or $\boxed{\text{BL}}$, you are still in automatic balanced fill-flash mode, and at such short ranges the focus distance information obtained from D and G-type lenses will not be sufficiently precise to guarantee an accurate flash exposure.

- Pull out, or attach, the Speedlight's wide-angle diffuser and, if appropriate, manually adjust the zoom head to its widest coverage (shortest focal length). I also recommend, on the SB-80DX and SB-800, that you attach the diffusion dome (this automatically sets the zoom head to 14mm on these two models). It is important to diffuse the light so that it wraps around the subject as far as possible. At very short ranges the unmodified output from a Speedlight will be too collimated; it will produce a highly directional light that casts shadows with extremely hard edges.

- Calculate an appropriate maximum lens aperture, as described above, and set this,or a smaller,aperture (larger f/ number) on the lens, or via the camera depending on the model in use. Using a smaller aperture increases the depth-of-field, which is very limited at such short shooting ranges.

- Set the camera to either Aperture-priority (A), or Manual (M) exposure mode, and check that an appropriate shutter speed is being used. It is probably best to set the flash to Slow sync mode,if you use (A) exposure mode to avoid any restriction on the range of available shutter speeds.

Hint: To achieve consistent, repeatable results and ensure exposure accuracy, it is important to position the Speedlight properly and maintain its location. You are unlikely to achieve this by hand holding the Speedlight off camera, so invest in a good flash bracket for close-up work (see Resources page 266 for a list of suppliers).

Hint: In order to rely on TTL flash exposure control, you must make sure that the Speedlight is no more than 30° off the lens-to-subject axis. At a larger angle you will probably have to compensate for the fall off of reflected illumination by applying a flash output level compensation (see Flash Output Level Compensation page 87) to increase the flash output.

Note: The procedure described above is applicable to a single Speedlight used for close-up photography, when connected to the camera via a cord. Use of the SB-R200 and SU-800 close-up flash equipment is described in the next chapter.

Using Built-in Speedlights

Although this book is concerned, principally, with external Speedlights, a number of Nikon camera bodies feature a built-in Speedlight,located in the prism head of the camera. The flash reflector in these units is fixed,unlike the zoom heads of accessory units such as the SB-800 or SB-600, for example. While the built-in Speedlights are not as powerful as external units, they can provide useful illumination at short ranges, especially for fill-flash,because most support flash output level compensation (see Fill-flash page 92).

However, if you want to use one these built-in Speedlights as the main light source you should be aware of the following:

• Their Guide Number (GN) is typically on the low side. For example, the unit in the D200 has a GN (ISO100, 39 ft (12 m), so at an aperture of f/5.6 this unit provides full power at a range of a little less than 7 ft (2 m), as the distance is equal to the GN divided by the lens aperture.

• The proximity of the flash head of these built-in Speedlights is much closer to the central lens axis compared with an external flash; hence,the likelihood of red-eye occurring is increased significantly (see Red-eye Reduction page 102).

Motion blur can create compelling images. Here, the camera was ▷
panned with a slow shutter speed (1/4 s) and Rear-curtain flash sync.

- Again, the proximity of the built-in Speedlight to the central lens axis often means that the lens obscures the output of the flash, especially if you are using a lens hood. If the camera is held in a horizontal orientation the obstruction of the light from the flash will cause a shadow to appear on the bottom edge of the picture.

- The angle of coverage of the built-in Speedlights tends to be rather limited. Typically, on a film camera, it only covers the field of view of a 28mm lens and 18mm on digital SLR cameras, such as the D200 and D70-series. If you use a shorter focal length, the flash will not be able to illuminate the corners of the frame and these areas will appear underexposed. Even at the widest stated coverage, it is not uncommon to see a slight fall off of illumination in the extreme corners of the full frame.

Note: Any flash unit places a high demand on its batteries. The built-in Speedlights draw their power from the camera's battery, so extended use will deplete these batteries quickly.

Note: The built-in Speedlights of the D200, and D70-series cameras also support wireless control of CLS compatible (SB-800, SB-600, and SB-R200) external Speedlights (see the chapter, Using Multiple Speedlights – Wireless Flash Control: Creative Lighting System).

Batteries

All of the Speedlights mentioned in this book are powered by batteries. With the exception of the SU-800 and SB-R800 units, which use a single 3V CR123A-size battery, the rest accept the ubiquitous AA battery that is available in a variety of types. Typically, each Speedlight model requires four batteries, although the SB-800 can be fitted with the SD-800 Battery pack to increase the recycle speed. External power options, such as the SD-8/SD-8A battery pack and SK-6/SK-6A Power Bracket also require AA-size batteries.

Non-Rechargeable Batteries

Alkaline

Alkaline batteries are readily available and are the cheapest of the four AA options. However, they are not the most economical option if you shoot often with flash.

Fresh alkaline batteries are rated at 1.5V, but over time, whether they are used or not, their voltage drops and the recycle time of the Speedlight will slow. As alkaline batteries near exhaustion, recycle times can become impractically long, so it is good to replace them before this occurs. Performance of alkaline batteries is also highly affected by low temperatures; at or below freezing they will often fail to work at all. Once they warm up to normal room temperature, they will function properly again.

Lithium

Lithium batteries offer two distinct advantages over the other three AA battery types mentioned here: superior performance in low temperature and significantly lower weight. They are about 50% lighter than a comparable alkaline battery. However, they are not well suited to high-current demands, especially when those demands are frequent, for example, a flash unit fired rapidly or used in repeating flash mode. In these situations lithium batteries can become excessively hot, and some will even activate a safety feature that causes the battery to shut down to allow it to cool. Once the battery temperature has been reduced sufficiently, the batteries will resume normal operation again.

When stored, lithium batteries have very good charge retention and will lose no more than around 10% of their capacity over a period of ten years. In use, their voltage rating remains stable at or very close to 1.5V. Consequently, flash recycling times remain fairly consistent until the battery is near exhaustion.

Rechargeable Batteries

Nickel Cadmium (NiCd)

NiCd batteries can be recharged many times and offer good value while being environmentally friendly. Fully charged batteries are rated at 1.2V; this will drop slightly as they are used but not nearly as much as alkaline batteries. The lower internal resistance of NiCd batteries means they maintain a higher voltage rating when subjected to a high current demand, which helps to reduce the recycle time of a Speedlight. However, when stored, NiCd batteries have poor charge retention and can lose virtually all of their power in a matter of a few weeks. Therefore, it is advisable to charge them just prior to use. Like alkaline batteries, NiCd batteries are affected by low temperatures, which cause their performance to diminish rapidly. At temperatures below freezing, they will often cease to function at all.

Early NiCd batteries suffered from a "charge memory" problem. If you recharged these batteries when they were only partially discharged, they would fail to take a full charge, which had a significant affect on their performance. To prevent this the batteries had to be fully discharged before recharging. Although this problem was more prevalent in earlier NiCd batteries, current types are not completely immune from this issue, so it is good practice to discharge them fully before recharging.

Nickel Metal Hydride (NiMH)

Nickel Metal Hydride batteries were developed to cope with high-current demand devices. They are the best option for powering a Speedlight, unless you expect to encounter low temperatures or it is essential to reduce carrying weight. For these requirements, Lithium batteries are a better choice.

NiMH batteries provide the shortest recycling time of the four battery types discussed here, can be recharged as many as a thousand times before becoming impaired, and do not suffer from the charge memory problem of NiCd batteries. Thus, it is safe to recharge partially discharged NiMH batter-

ies. As with other battery types, the voltage rating of NiMH batteries will be reduced by use, but only slightly, until they are close to exhaustion. However, unlike NiCd batteries they offer very good storage charge retention and can be stored for weeks with little adverse effect on their performance. NiMH batteries are not affected as much by low temperatures as alkaline or NiCd batteries, but they still cannot match the qualities of lithium batteries in this respect.

Note: To maximize the shooting capacity of a Speedlight and reduce its recycle time, I recommend using NiMH batteries with the highest power rating (expressed as a mAh value) you can obtain. Depending on the make, this will typically be in the range of 2300mAh to 2500mAh.

Note: The AA-size NiCd and NiMH type batteries are usually rated at 1.2V, as opposed to 1.5V for alkaline and lithium batteries; this is quite normal and all the Nikon Speedlights models covered in this book are designed to be compatible with these four battery types.

Lithium-ion (Li-ion)

A number of manufacturers have introduced rechargeable lithium-ion batteries in a variety of popular sizes, including the CR123A. This is particularly useful since the SU-800 and SB-R200 units only accept this size battery, and neither unit has an option for an external power source.

Rechargeable Li-ion batteries offer the same advantages as the disposable lithium batteries discussed above, and since the SB-R800 Speedlight has relatively low power consumption, the issue concerning overheating during a rapid series of charge/discharge cycles is far less relevant.

Take Care with Batteries

Modern batteries are generally very stable. However, it is important to remember that chemicals contained within a battery are toxic and thus, safe handing and disposal is

essential to prevent harm to your equipment and the environment.

- Always switch off the Speedlight before removing or inserting batteries.
- Never reverse the polarity of batteries in a Speedlight.
- Never mix battery types or even different brands of the same type.
- Do not mix partially discharged batteries with fresh or fully recharged batteries.
- If you expect to store your equipment for more than four weeks, always remove the batteries.
- Do not store batteries in high temperature or humidity.
- Do not throw exhausted batteries out with general domestic waste—discard them properly and responsibly at a public waste disposal facility.
- Never throw a battery on a fire or allow it to overheat severely as this could cause the battery to explode.

Speedlight Accessories

Nikon offers a vast array of accessories for their Speedlight system. The accessories listed below support the units covered in this book.

Speedlight Adapters and Stands

AS-7: Flash unit coupler for F3-series cameras—it provides a standard ISO-type accessory shoe over the film rewind crank. This allows film rewind without removing the coupler.

AS-10: TTL flash terminal block—it includes three TTL multiple flash terminals for three-core TTL flash cords (e.g. SC-18, SC-19, SC26, and SC-27).

AS-15: Adapter that attaches to standard ISO-type accessory shoe and provides a single, standard PC-type (pin cylinder) flash synchronization terminal. Can be used with SC-11 and SC-15.

AS-17: Provides TTL flash control capability for the F3-series cameras when used with TTL Speedlights that have an ISO-type mounting foot (i.e. SB-80-DX, SB-800).

AS-19: Speedlight stand with standard ISO-type accessory shoe with standard 1/4" tripod socket.

AS-20: Speedlight stand for SB-R200 Speedlight—it can also be used to mount SX-1 Attachment Ring to standard 1/4" tripod socket.

Speedlight Cords

SC-11: 9.8 in (25 cm) standard PC-type flash synchronization cord.

SC-15: 3.3 ft (1 m) standard PC-type flash synchronization cord.

SC-17: 4.9 ft (1.5 m) five-core, gray sleeved TTL Remote Cord; it maintains full TTL functionality between a Speedlight and appropriate camera.

SC-18: 4.9 ft (1.5 m) three-core, gray sleeved TTL Remote Cord; it can be used with the AS-10, or connected directly to appropriate Speedlights for multiple TTL flash control.

SC-19: 9.8 ft (3 m) long version of the SC-18.

SC-24: 4.9 ft (1.5 m) five-core, gray sleeved TTL Remote Cord—it maintains full TTL functionality between a Speedlight and F5 camera fitted with DW-30 or DW-31 High-magnification Finder, and F4 camera fitted with DW-20 or DW-21 High-magnification Finder.

SC-26: 4.9 ft (1.5 m) three-core, black sleeved TTL Remote Cord—it can be used with the AS-10 or connected directly to appropriate Speedlights for multiple TTL flash control. It replaces the discontinued SC-18.

SC-27: 9.8 ft (3 m) long version of the SC-26

SC-28: 4.9 ft (1.5 m) five-core, black sleeved TTL Remote Cord; it maintains full TTL functionality between a Speedlight and appropriate camera – replaces the discontinued SC-17

SC-29: 4.9 ft (1.5 m) five-core, black sleeved TTL Remote Cord; it maintains full TTL functionality between a Speedlight and appropriate camera. It incorporates an AF assist lamp that attaches to the accessory shoe of the camera.

SC-30: TTL remote cord for connecting SU-800 to SB-R200 Speedlights.

External Battery Packs

SD-7: External battery pack for Speedlights with an external power source terminal (i.e. SB-28DX, SB-80DX, SB-800). Accepts 6 C-type batteries. (Note: not available in European countries,)

SD-8A: External battery pack for Speedlights with an external power source terminal (i.e. SB-28DX, SB-80DX, SB-800). Accepts 6 AA-type batteries.

SD-800: Quick recycling battery pack for SB-800; it accepts a single AA size battery.

SK-6A: Power bracket unit for TTL Speedlights that have an ISO-type mounting foot and an external power source terminal (i.e. SB-28DX, SB-80DX, SB-800). Accepts 4 AA-type batteries.

Make sure you have plenty of batteries for family parties. You'll want to use flash to make wet kids wetter and colors sparkle. ©M. Morgan

General Speedlight Accessories

SG-3IR: Infrared filter panel for attachment to cameras with a built-in Speedlight that support wireless i-TTL flash control.

SJ-1: Gel filter set for SB-800: includes eight filter types, FL-G1 & FL-G2 (for fluorescent light), TN-A1 & TN-A2 (for tungsten light), blue yellow, amber, and red.

SJ-2: Gel filter set for SB-R200: includes eight filter types, FL-G1 & FL-G2 (for fluorescent light), TN-A1 & TN-A2 (for tungsten light), blue yellow, amber, and red.

SJ-R200: Gel filter set for SB-R200: includes four filter types, FL-G1 (for fluorescent light), TN-A1 (for tungsten light), blue and red.

SK-7: Bracket with two attachment screws to allow mounting of a camera and Speedlight side-by-side. To maintain TTL control use with SC-17, SC-28, SC-29.

SS-28: Soft case for SB-28 / SB-28DX.

SS-80: Soft case for SB-80DX.

SS-600: Soft case for SB-600.

SS-800: Soft case for SB-800.

SS-R200: Soft case for SB-R200.

SS-SU800: Soft case for SU-800.

SS-MS1: Soft case for Close-up Speedlight kits R1C1 & R1.

SS-SX1: Soft case for SX1 Attachment Ring.

SU-4: Wireless slave flash controller unit.

SW-10H: Diffusion dome for SB-80DX / SB-800 Speedlight.

SW-11: Diffusion dome for SB-R200—it permits illumination of subjects at extremely short shooting distances.

SW-12: Flat diffuser panel.
SW-C1: Flexible arm clip for use with SX-1 Attachment Ring.

SX-1: Attachment ring for SB-R200 Speedlights.

SZ-1: Filter holder for SB-R200 Speedlight.

UR-5: Adapter ring to attach SX-1 Attachment Ring to the AF Micro-Nikkor 60mm f/2.8D

Using Multiple Speedlights

You can use a variety of different Nikon Speedlights for multiple flash set-ups, either by connecting each Speedlight with a cord, or by using wireless control to fire and monitor the remote (slave) flash units.

During the evolution of the Speedlight system, Nikon has used many technologies to provide TTL exposure control of flash units in a multiple flash set-up; these include: cord connections, Speedlights with built-in remote (slave) sensors, external sensors, the Wireless Slave Flash Controller SU-4, and wireless infrared control of Speedlights compatible with the Creative Lighting System (CSL).

Lighting: Ratios & Angles

Both the level of illumination and the position of the units in a multiple set-up will affect the appearance of the subject and other elements in the photograph. When setting up and using a multiple flash system, it is essential that you consider the relationship and position of the units and how they all affect the lighting of the scene.

In a multiple flash set up with two or more flash units, the flash providing the main illumination is often referred to as the "key" light, and the other flash unit(s) as "fill" light(s). Fill lights can be used for a variety of effects: to reduce the shadows cast on the subject by the key light, to supplement the illumination of the foreground or background, or to cre-

This photo was created using two wireless SB-800 Speedlight flash units fired through a diffusion panel.

ate a lighting effect, such as a rim light around a subject. Regardless of how the Speedlights are connected, it is important to consider the effect that their combined illumination will produce.

The easiest way to express this combined effect is as a ratio between the key and fill light(s). Our eyes are accustomed to seeing three-dimensional objects and using the depth and direction of shadows cast by natural light to form a perception of a subject we are observing. In order to create the same perception when looking at a two-dimensional photograph where the subject is lit with an artificial light source, such as flash, it is necessary to create shadows with similar depth and direction. Otherwise the lack of these visual clues will make the subject look unnatural.

A good starting point is for the key light to provide between two and four times as much illumination as the fill light(s) with the ratio of key-to-fill between 2:1 and 4:1. If the ratio is too low (i.e. it approaches 1:1), there will be a lack of shadows, which will not look natural. If the ratio is too high, the effect of the fill light(s) is negligible; thus, the strong directional shadows cast by the key light will dominate the picture. This usually causes the level of contrast between the highlights and shadows to exceed the latitude of the film or digital sensor, causing a failure to record detail in one or both.

For example, assuming we use two Speedlights that emit the same level of illumination, and they are placed at equal distance from the subject, the lighting ratio between them will be 1:1. If the output of the first flash is increased, so that it provides twice as much light as the second Speedlight, the ratio is 2:1.

Here one wireless SB-800 was used to provide backlight, while a second one was used to provide front fill-flash.

If the two Speedlights are set to produce the same level of illumination we can still adjust the ratio by moving one of them further away from the subject. If one of the Speedlights is moved further away to a position 1.4x the distance from the subject compared with the other Speedlight, the lighting ratio is 2:1 (i.e. level of illumination falling on the subject from the flash furthest away from the subject is half that from the Speedlight closest to it). If one of the Speedlights is placed in a position 2x the distance from the subject compared with the other Speedlight the lighting ratio is 4:1 (i.e. level of illumination falling on the subject from the flash furthest away from the subject is a quarter of that from the Speedlight closest to it).

The direction of light is also an important consideration. Because the light from the sun comes from above the horizon, we expect to see shadows below or to the side of objects we observe in daylight. Therefore, it is usually preferable to position the main (key) and supplementary (fill) light(s), so they are above the lens-to-subject axis. If the lights are placed too high, the shadows they cast can be very dense, which increases contrast (think of daylight shadows when the sun is at its zenith). A more natural look is achieved by placing the lights 30° to 60° above the lens-to-subject axis, depending on the effect you want to create. Likewise, it is preferable to take the key light off the camera to one side of the lens-to-subject axis; again, to give depth and direction to the shadows it casts. Similarly, with the supplementary (fill) light(s), an angle of 30° to 45° is a good starting point. As always, be prepared to experiment to determine an ideal lighting set up for your specific requirements.

Using TTL Flash Cords

You can use TTL flash exposure control for multiple Speedlights by connecting them using the dedicated Nikon TTL cords SC-18, SC19, SC2-26, and SC27. This technique is supported only with film cameras and Speedlights set for **TTL** standard TTL flash or the following TTL fill flash modes: **TTL**

This picture shows the SC-17 TTL flash cord connected to the accessory shoe of an F100 camera.

Matrix Balanced fill flash, Center-weighted fill flash, or Spot fill flash. 3D Multi-sensor Balanced Fill flash or Multi-sensor Balanced fill flash cannot be used as pre-flashes are always fired, which will cause inaccurate flash exposure.

TTL flash exposure control for multiple Speedlights is not possible using TTL cords with any Nikon digital SLR camera regardless of whether it supports D-TTL or i-TTL.

Please note the following suggestions and limitations:

• The SB-800, SD-80DX, and SB-28/28DX can all be used with the SC-18, SC19, SC2-26, and SC27 TTL cords.

• The SB-600 does not have a TTL cord terminal, so requires the AS-10 TTL flash adapter to provide a terminal for the TTL cords.

• The SB-R200 is not compatible with the SC-18, SC19, SC2-26, and SC27 TTL cords, or the AS-10 adapter.

The SB-80DX can be used in multiple flash set-ups with film cameras and Nikon TTL cords in standard TTL mode.

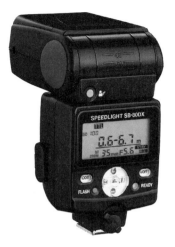

- A maximum of five Speedlights, including the master flash, can be connected via the TTL cords. The total cord length must not exceed 33 ft (10 m).

- Position the master and remote Speedlights keeping in mind the light ratio between them and the direction of the lighting, as discussed above under Lighting: Ratios & Angles.

Set up a compatible camera and Speedlight flash units for TTL flash exposure control using TTL cords, as follows:

1. Set the camera to Aperture Priority (A) or Manual (M) exposure modes.

2. Mount the master flash on the camera or connect it with an SC-28 or SC-17 TTL cord. Switch both the camera and flash to ON.

3. Press the (icon 12) button until **TTL** appears in the LCD panel of the master Speedlight.

4. Connect the remote (slave) flash units to the master flash using the dedicated Nikon TTL cords SC-18, SC19, SC2-26, and SC27.

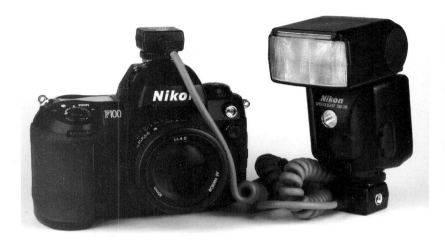

The Nikon F100 film camera with an SB-80DX and SC-17 TTL cord.

5. Turn on all the flash units, and check that each remote flash unit is set to **TTL** standard TTL flash.

6. Finally, confirm the lens aperture value and flash shooting range displayed in the LCD panel of the master flash unit and adjust as necessary to the required values.

7. The camera and flash units are ready to be used.

Wireless TTL Flash

Nikon uses two techniques to provide TTL flash exposure with multiple Speedlights. The first relies on the light from the master unit to trigger the remote unit(s). Thus, all the flash units in the lighting set-up must operate without the use of monitor pre-flashes, preventing the premature triggering on the remote unit(s). Since monitor pre-flashes must be

switched off for this technique, it is limited to Speedlights used with film SLR cameras capable of TTL flash exposure control during the actual exposure. In all instances the master and remote(s) flash units must be set to standard TTL flash exposure control **TTL** .

All Nikon digital SLR cameras require the flash to fire monitor pre-flashes before the exposure so the camera can assess the level of illumination from the master and remote flash unit(s). Consequently, with D-SLRs the only way to perform TTL flash exposure control with multiple Speedlights is to use cameras and Speedlights that support the wireless i-TTL mode of the CLS. Thus, it is not possible to use the D1-series or the D100 for TTL control of multiple Speedlights.

Wireless TTL Flash with Film Cameras

The SB-80DX has a built-in wireless remote (slave) flash sensor, so wireless TTL flash exposure with multiple SB-80DX Speedlights is possible with Nikon film cameras that support TTL flash. Each SB-80DX must be set for wireless multiple flash via the custom menu, as follows:

1. Attach the flash to the camera either directly or with the SC-28/SC17 TTL cord, and switch both the camera and SB-80DX to ON.

2. Press the **SEL** button for at least two seconds to open the custom setting menu.

3. Press the **⊕** or **⊖** to select ⇻ wireless flash mode, and press **⧚** and **⧚** to select ON.

4. Press the **SEL** button for at least 2 seconds to return to the main LCD panel display; ⇄ appears, which confirms the flash is set to act as the master flash.

5. Press the **MODE** button until **TTL** standard TTL flash appears (pre-flashes will not fire even if **TTL ◙** automatic balanced fill flash is displayed).

6. Switch ON the other SB-80DX Speedlight(s) to be used as remote (slave) units.

7. Press the 🔘 button for at least 2 seconds to open the custom setting menu.

8. Press the ➕ or ➖ to select ⇄ wireless flash mode, and press 🔳 and 🔲 to select ON.

9. Press the 🔘 button for at least 2 seconds to return to the main LCD panel display.

10. The LCD panel will display A ⇄ along with zoom🅼 next to the focal length value, and 🔲 . This indicates that the flash is set to function as a remote (slave) unit in Auto mode for TTL flash exposure control.

Note: You can use manual flash exposure with the wireless function of the SB-80DX. Set the camera to Aperture-priority (A) or Manual (M) exposure mode. Set up all Speedlights (as described above) to wireless flash mode as master and remote (slave) units. Press the (MODE) button on each remote unit until M ⇄ appears in the LCD panel, and press the (MODE) button on the master flash until 🅼 appears. Confirm the lens aperture value and shooting distance and adjust the flash output level for each flash after calculating the required amount of illumination based on the guide number, ISO value, and each flash-to-subject distance.

Wireless Slave Flash Controller SU-4

To increase the versatility of using TTL flash exposure control with multiple Speedlights, Nikon introduced the SU-4 Wireless Slave Flash Controller. It can be used with any camera and Speedlight combination capable of producing TTL flash control. This includes the built-in Speedlights of the N50/F50, N60/F60, N65/F65, N70/F70, N75/F75, and N80/F80, provided the cameras are set to Manual exposure (M) or spot metering to ensure monitor pre-flashes are cancelled.

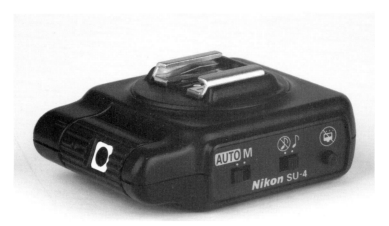

The Nikon SU-4 set to the AUTO position.

The SU-4 allows the user to position a flash(es) off camera as key (main) or fill (supplementary) lights. In its fill flash role the flash/SU-4 combination provides lighting for the subject or the background. If you have two remote Speedlights attached to an SU-4, you can add fill light to both the subject and the background. As soon as the SU-4 senses that the master flash has fired, it triggers its Speedlight. Since the master flash is used with TTL flash exposure, its output is quenched as soon as the camera determines it has provided sufficient illumination. The SU-4 senses that the master flash has ceased firing and quenches the output of its Speedlight immediately as well. The SU-4 can be set to emit an audible warning, so that if the mounted Speedlight emits its maximum output before the main flash has ceased firing, you will be warned that the remote Speedlight may not have delivered sufficient illumination.

Using the SU-4
Here's how to set up a pair of Speedlight flash units, with one attached to an SU-4 in combination with any Nikon film camera with TTL flash exposure control. Although I have used a pair of SB-28s, the SU-4 is compatible with other

Speedlights covered by this book (SB-80DX, and SB-800), as well as a number of earlier models.

1. Attach one SB-28 Speedlight on the camera.

2. Mount the second SB-28 on the SU-4.

3. Switch on the camera and both Speedlights, and ensure the SU-4 is set to AUTO.

4. Press the (MODE) button on each flash until **TTL** standard TTL mode is displayed in its LCD control panel (monitor pre-flashes are now cancelled).

5. Position the second Speedlight with the sensor in the SU-4 pointed toward the main flash, and no more than 20 ft (6 m) away. Nikon suggests the SU-4 can be used up to 23 ft (7 m) from the main flash, but in I have found this to be rather optimistic, particularly if you use the set up outdoors where there are no surfaces nearby to bounce the light from the main flash toward the SU-4 sensor.

6. Check the composition through the viewfinder and ensure that the second Speedlight does not appear in the frame.

7. Once the subject is within the flash shooting range indicated on the main flash, you are ready to shoot.

SU-4 Tips and Techniques

- To improve the lighting quality, consider taking the main flash off camera using either an SC17 or SC-28 TTL flash cord.

- A second flash can be used to provide fill (supplementary) light. Just remember principles of the Inverse Square Law and the suggestions in the Lighting: Ratios & Angles section (above). If you want a 2:1 ratio between the main and remote flash, position the second flash on the SU-4 approximately 1.4x the distance from the subject as the main flash.

- The SU-4 mounted flash can also light a dark background. With a single flash, the effect of the Inverse Square Law will determine the level of background illumination, compared with the illumination of the subject. For, example, the flash illuminates the subject correctly at a flash-to-subject distance of 10 ft (3 m). The background is 10 ft (3 m) behind the subject, so the flash-to-background distance is 20 ft (6 m). The level of illumination from this flash on the background will be 1/4x (i.e. 2 stops lower than the subject). If you place a second SU-4 mounted flash 10 ft (3 m) from the background, it will illuminate the background at the same level as the subject. Remember to check the viewfinder to make sure the second flash cannot be seen. You can adjust the level of background illumination by altering the distance between the second flash and the background.

- It is possible to operate a number of remote Speedlights each mounted on an SU-4. However, the practical limit for the total number of Speedlights in a lighting set up is about four. That is, one master and three remote (slave) units. If you attempt to use more remote Speedlights the

SU-4 sensors will often fail to quench the flash output, as they are unable to differentiate the master flash from the output of the numerous remote units.

- The SU-4 is not "intelligent" – it reacts to any flash pulse, whether it is generated by your master flash or a flash used by another photographer.

Using the SU-4 and SB-80DX

As described above the SB-80DX has its own built-in sensor for wireless TTL flash control of multiple flash units. So, why would you want to use this flash with an SU-4? The answer is, because of the position of the SB-80DX's built-in sensor. It is located on the flash unit's lower right side (when viewed from behind) and it is fixed. To ensure that the remote (slave) SB-80DX Speedlight(s) can detect the flash from the master unit, it is essential that this sensor is pointed toward the master flash. This may limit the position of a remote flash. The movable sensor of the SU-4 adds extra flexibility to the positioning of the remote (slave) flash unit(s). Set up the master and remote SB-80DX Speedlights as described previously in Wireless TTL Flash: Film Cameras and attach each remote (slave) flash unit(s) to an SU-4.

Using the SU-4 and SB-800

The SB-800 Speedlight can be used in conjunction with the SU-4 for wireless TTL control of multiple remote flash units. All the SB-800s must be set to the "SU-4 wireless flash mode" via the custom menu of the Speedlights.

1. Attach the flash to the camera directly or with an SC-28 or SC17 TTL cord, and switch both the camera and SB-800 to ON.

2. Press the ⊛ button for at least 2 seconds to access the custom setting menu.

3. Press the ⊕ , ⊖ , 🔳 , and 🔳 buttons to select (icon 53) wireless flash mode. Press ⊛ to highlight an option in the sub-menu and use the ⊕ &

157

● buttons to select SU-4. Press ⊛ to confirm the selection and then press 📶 .

4. Press the ⊛ button for at least 2 seconds to return to the main LCD panel display; ⇄ will now be displayed to confirm the flash is set to act as the master flash.

5. Press the (MODE) button until 𝗧𝗧𝗟 standard TTL flash appears. Note: pre-flashes will not fire even if 𝗧𝗧𝗟 ◘ + 𝐁𝐋 automatic balanced fill flash is displayed.

6. Switch ON the remote SB-800 Speedlights.

7. Press the ⊛ button for at least 2 seconds to access the custom setting menu. Repeat Step 3 for each remote SB-800 Speedlight.

8. Press the ⊛ button for at least 2 seconds to return to the main LCD panel display; ⇄ will now be displayed to confirm the flash is set to act as a remote (slave) flash.

9. Press the (MODE) button, until A appears next to ⇄ , to set the remote SB-800 Speedlight(s) to Auto mode.

10.Review the lens aperture value and flash shooting distance displayed in the LCD panel and adjust, if required. The master and remote SB-800 Speedlights are now ready to be used.

Note: You can use the SB-800 with an SU-4 for manual flash exposure control of multiple units. Repeat Steps 1 – 4 above. In Step 5 select 𝐌 , and then repeat Steps 6 – 8. In Step 9 select M (manual) mode. Finally, repeat Step 10.

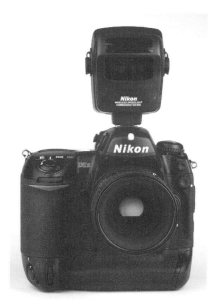

Truly, CLS "state of the art," the D2X and SU-800 Speedlight Commander.

Wireless TTL Flash with Digital Cameras

Before the introduction of the Creative Lighting System (CLS) and the SB-800, SB-600, and SB-R200 Speedlights, it was impossible to have TTL control of multiple Speedlights with a Nikon digital SLR camera. This is because Nikon digital cameras do not use off-the-film (OTF) flash exposure control; instead, they depend on monitor pre-flashes to determine the correct flash output. Since the built-in sensor of a Speedlight, such as the SB-80DX or the SU-4, responds to any flash output, the flash units would be triggered prematurely by the pre-flash in a traditional Nikon multiple flash setup. (This was never a problem with film cameras, because they use flash exposure control OTF, and don't rely strictly on exposure information from the preflashes. Thus, the preflashes could be cancelled with non-digital, multiple flash operation.)

In order to offer wireless, multiple flash capability with its D-SLRs, Nikon incorporated Advanced Wireless Lighting in the Creative Lighting System. This system allows compatible

digital SLR cameras to wirelessly fire multiple CLS Speed-lights with TTL control. In addition to the master flash unit, remote flash units can be divided into sub-groups, each controlled independently, operating in a different flash mode.

Nikon's sophisticated CLS wireless multiple flash technology allows the master flash unit to communicate with up to three groups of remote flashes, all of which can be operating in different modes. Photo ©Nikon Inc.

Communication between multiple Speedlights is performed by a sophisticated system of signals and low-intensity pulses. The spectral range of the pulses sent out by the SB-800 and the built-in Speedlights of compatible cameras, is the same as the output during a flash exposure. The non-visible portion of this output (the IR wavelengths between 800-1000 nm), are used to communicate instructions to the remote units.

The SU-800 Speedlight Commander unit does not have a flash tube; so, it emits only IR control signals. Speedlights SB-800, SB-600, and SB-R200 have a built-in sensor that detects the IR wavelengths from the master flash or SU-800. The camera and master flash/SU-800 do all the communication work; the signals tell the remote (slave) Speedlights how to operate, and the camera monitors and controls the overall flash exposure. (The remote flash units do not send, or relay

any signals themselves as some reviewers have suggested.) Normally, when the SB-800 is used as the master flash, it also participates in the overall flash exposure, but there is an option (Nikon calls this the Commander function) to cancel the flash's output, so it only emits control signals to trigger remote flash units. These signals are visible because they contain the spectrum of light produced by the flash tube. The same functionality is available with the built-in Speedlight of the Nikon D200 digital SLR camera when it is used in its Commander mode and flash cancelled is selected as the flash mode. However, if the built-in Speedlight of the D70-series cameras is set to Commander mode, it only emits control signals, which trigger remote flash units; it does not contribute to the flash exposure.

The pre-flashes, command signals, and main flash output normally occur in a very rapid sequence, which often appears as one single flash pulse. However, since the SB-800 and the built-in Speedlights of the D70 and D200 use the full spectrum for the command signals, as well as the pre-flashes and main flash pulse, it is possible, by using a slow shutter speed and setting the flash to Rear curtain sync, to break the sequence up into sections that are perceptible to our eyes.

To try this, set an SB-800 to Commander mode by selecting Flash cancelled as the flash mode for M (master), or use the built-in flash of the D70 or D200, and set flash cancelled as the flash mode; the built-in Speedlights always operate in Commander mode (i.e. the flash only emits the command signals and does not contribute to the main flash exposure). Select a shutter speed of one second, or longer, and set the flash sync mode on the camera to Rear. Set up a single remote flash (SB-800, SB-600, or SB-R200) as described below.

When you depress the shutter release fully, the following instantaneous sequence takes place:
• The master flash fires the command signal for the remote flash mode setting.

161

- The remote flash emits its pre-flashes. There is a short pause (its duration is determined by the camera's shutter speed), while the shutter remains open.
- Immediately before the shutter closes, the master flash fires the command signal that communicates the correct remote flash output level.
- The main flash burst is fired by the remote Speedlight(s).

Note: Occasionally when high ISOs are used, if the subject is too close to the SB-800, or the camera built-in Speedlight that is acting as a master/Commander flash, the exposure may be influenced by light from the control signals. This is because, as stated above, these control signals include both visible-light and IR.

Note: In Advanced Wireless Lighting mode, several flash functions do not operate. These include: Flash Color Information, wide-area AF-assist, and the auto zoom head function of the remote Speedlight(s).

Master/Commander & Remote Flash Units

A remote flash is any Speedlight, other than the master, used in a multiple flash set up. The key to setting up multiple Speedlights in the Advanced Wireless Lighting system is to remember that all the functions of the remote (slave) Speedlights are set from the master flash. This is also true for the functions of the master flash, including using the master flash as a commander unit when it does not contribute to the flash exposure but just emits control signals. The functions that must be set on the master flash for all units include: the flash mode, flash output compensation level, and the communication channel. On the remote flash it is only necessary to set the communication channel and assign the flash to a particular group.

The master flash/commander unit must be connected to the camera either directly by mounting it in the accessory shoe or via an appropriate TTL flash remote cord such as the SC-17, SC-28, or SC-29.

Daffodils in full bloom, thanks to two remote SB-800s used via wireless TTL control.

Currently, the following can be used as a master flash, or commander unit:
- SB-800 (master flash/commander unit, or commander unit only)
- SU-800 (commander unit only)
- Built-in Speedlights of digital SLR cameras that support Commander function (functionality varies with camera model)

Currently, the following can be used as remote (slave) flash:
- SB-800
- SB-600
- SB-R200

Note: Nikon advises that the practical limit on the number of remote Speedlights that can used in any one group is three.

Available Flash Modes:
SB-800 Master Flash/Commander Unit,
or SU-800 Commander Unit

Flash Mode	SB-800	SB-600	SB-R200
TTL	•	•	•
AA	•	—	—
M	•	•	•
—- (cancelled)	•	•	•
RPT	•	•	—

Note: In all instances when you select TTL as the flash mode in the Advanced Wireless Lighting system (regardless of which Speedlights are being used), flash exposure control is performed as **TTL** + **BL** automatic balanced fill-flash, although **TTL** is displayed on the LCD panel of the Speedlight, or SU-800.

Note: It is not possible to select standard TTL flash mode when using the Advanced Wireless Lighting system.

Note: If a non-CPU type lens is mounted on the camera or **A** non-TTL auto flash is selected in the custom menu of the SB-800, **AA** auto aperture flash mode is cancelled and **A** non-TTL auto flash mode is set automatically.

Note: **AA** is not available with the built-in Speedlight of the D200; when set to commander mode it can only perform **TTL** and **M** flash, or it can be set to --- (flash cancelled). However, an SB-800 Speedlight used as remote flash, and controlled by the D200, can be set to perform **AA** auto aperture flash in either Group A or B.

Note: The built-in Speedlight of the D70-series cameras can only be used as a commander unit in the Advanced Wireless Lighting system (i.e. it can only emit the control signals and does not contribute any light to the flash exposure). Furthermore, it can only control one group (Group A) of remote Speedlights, using one channel (Channel 3), and only support **TTL** , **AA** or **M** flash modes.

164

Note: If MASTER (RPT) is selected with compatible master flash and remote (slave) flash units, they can only be set to perform repeating flash, or --- (flash cancelled) mode. Once RPT has been selected for the master and any remote groups, it is necessary to set the manual flash output level, frequency, and number of flashes.

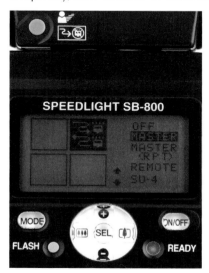

The SB-800 set to act as a master flash.

Using the SB-800

To set the SB-800 to act as the master flash:

1. Attach the flash to the camera either directly, or via the SC-28/SC17 TTL cord, and switch both the camera and SB-800 to ON.

2. Press the ⊛ button for at least 2 seconds to access the custom setting menu.

3. Press the ⊕ , ⊖ , 📶 , and 📷 buttons to select (icon 53) wireless flash mode. Press ⊛ to highlight an option in the sub-menu and use the ⊕ and ⊖ buttons to select MASTER. Press ⊛ to confirm the selection and then press 📶 .

4. Press the ⊛ button for at least 2 seconds to return to the main LCD panel display; ⇆ will now be displayed to confirm the flash is set to act as the master flash.

After completing Step 4 above, set the following on the display in the LCD panel of the master SB-800:
- The flash mode and flash output level for the master flash.
- The flash mode and flash output level for each remote group (A, B, and C).
- The channel number.

The SB-800 LCD panel when set as a master flash with 3 groups.

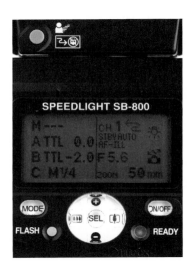

Follow these steps:
1. Press the ⊛ button to highlight M (master) and press the (MODE) button to select the required flash mode (see, Flash Modes Available for SB-800 Master and Remote Speedlights, above).

2. Press the ⊕ ⊖ buttons to increase or decrease the flash output level (if required). Flash output level can be adjusted in 1/3EV steps from -3 to +3EV, for example, -0.7 is equivalent to minus 2/3EV. In manual flash mode the flash out put level can be adjusted between 1/1 and 1/128.

166

3. Press the ⑤ button to highlight A (group A) and press the ⌈MODE⌉ button to select the required flash mode, as in Step 1, and repeat Step 2, if required.

4. Repeat Step 3 to highlight and select the required options for group B & C respectively, as per Steps 1 & 2.

5. Finally, press ⑤ to highlight the channel number and use the ⊕ ⊖ buttons to adjust it as required

Note: If you select —- (flash cancelled) as the flash mode for the master SB-800, it will operate in the Commander function. In this mode, it will not contribute to the flash exposure, but will emit control signals for the remote (slave) units in groups A – C.

To set the SB-800 to act as a remote flash:
1. Switch the SB-800 to ON.

2. Press the ⑤ button for at least 2 seconds to access the custom setting menu.

3. Press the ⊕ ⊖ buttons to select ⊞ wireless flash mode. Press ⑤ to highlight an option in the sub-menu and use the ⊕ , & ⊖ buttons to select REMOTE. Press ⑤ to confirm the selection and then press 〔♦♦♦〕 〔♦♦♦〕 .

4. Press the ⑤ button for at least 2 seconds to return to the main LCD panel display; ⇨ will now be displayed to confirm the flash is set to act as the master flash.

Note: Repeat Steps 1 – 4 for each SB-800 to be used as a remote (slave) unit.

5. Press the ⑤ button to highlight CH and use the ⊕ ⊖ buttons to select the required channel number.

6. Press the ⊛ button to highlight GROUP and use the
 ⊕ and ⊖ buttons to select the required group
 designation (A, B, or C).

 Once you have done this for all of the units, place them
as desired. Check that the ready light is lit on each Speed-
light and shoot. Review the image on the camera's LCD
monitor and adjust the settings of the master and remote
flash unit(s), if necessary. This can be done from the LCD
display of either the master SB-800, or SU-800 (see below
for details of SU-800 Commander function), or relevant sec-
tion of the custom setting menu on cameras that support
Commander flash mode; there is no reason to return to each
remote (slave) flash unit unless you decide to reposition it.

Setting the SB-600 for Remote Operation
The SB-600 can only function as a remote flash in the
Advanced Wireless Lighting system. To set the required
channel and group:

1. Press the ON/OFF button to switch the SB-600 to ON.

2. Press the ZOOM + ⊖ buttons simultaneously to access
 the custom menu and select wireless remote mode by press-
 ing the ⊕ or ⊖ buttons until ⇄ appears.

3. Press the MODE button to select ON.

4. Press the ZOOM + ⊖ buttons simultaneously to return to
 the main LCD display; it will show ⇄ to confirm the SB-
 600 is set to wireless remote mode, and the current selec-
 tion of channel number and group name. Press the MODE
 button and the channel number will begin to blink, use the
 ZOOM + ⊖ buttons to adjust the channel number.
 Repeat the process to alter the group name if required.

5. Finally, press the MODE button to confirm the selections.

Once the remote SB-600 flash unit(s) have been set up, place them as desired, to light the subject and its surroundings. Check that the ready light on each Speedlight is lit, and shoot. Review the image in the camera's LCD monitor and adjust the settings of the master and remote flash unit(s) if necessary. This can be done from the LCD display of either the master SB-800, or SU-800 (see below for details of SU-800 Commander function), or relevant section of the custom setting menu on cameras that support Commander flash mode; there is no need to return to each remote (slave) flash unit.

Setting the SB-R200 for Remote Operation

Turn the relevant dials on the SB-R200 to the required position to set the channel and group. Once one or more remote SB-600 flash units have been set up, place them as required to light the subject and its surroundings. Make sure the ready light is glowing on each Speedlight and shoot. Review your image in the camera's LCD and adjust the settings of the master and remote flash unit(s) if required. This can be done from the LCD display of either the master SB-800, or SU-800 (see below for details of SU-800 Commander function), or relevant section of the custom setting menu on cameras that support Commander flash mode; there is no need to return to each remote (slave) flash unit.

Commander Operation of the SU-800

The SU-800 is a dedicated control unit for operating remote Speedlights in the Advanced Wireless Lighting system. It can be used for two distinct purposes: to control SB-R200 Speedlight units in close-up flash photography (see page 246), and to control remote Speedlights, as described below, for flash photography at standard flash-shooting distances.

1. Open the battery chamber door of the SU-800 and set the switch inside to ＂█ for Commander operation.

2. Switch the camera, SU-800, and all remote flash units to ON; confirm that the ready lights on all units are lit.

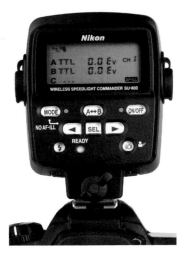

The SU-800's LCD panel set in Commander mode.

3. Make sure that ⇆ , ((, and ☄ are all displayed in the LCD panel of the SU-800; if not, press and hold the ⊛ button for about two seconds until they appear. This confirms that the SU-800 is set to Commander function.

4. The flash mode of each remote flash group can be set on the SU-800 to either **TTL** , **AA** , **M** , or —- (flash cancelled) by pressing the ⊛ button; the flash mode and flash exposure compensation level display will blink (the sequence will begin with group A). Press the (MODE) button to select the required flash mode. If **TTL** , or **AA** mode is selected use either the ◄ , or ► , to adjust the flash exposure compensation level if required. This can be done in steps of 1/3EV over a range of +/-3EV. For example, a setting of -0.7 Ev reduces the flash output by 2/3-stop. If **M** mode is selected, use either the ◄ or ► to adjust the manual flash output in steps of 1EV between 1/1 and 1/128.

5. Press the ⊛ button to confirm the settings for group A; the flash mode and flash exposure compensation level display for group B will begin to blink. Repeat the process of step 4 to set the required values for group B and C.

6. Finally, set the channel number by pressing the ⊛ button. The channel number display will blink. Press the ◄ or ► buttons, to select the required channel number and press ⊛ to confirm the selection (the display will stop blinking).

7. Confirm the ready lights of the SU-800 and any remote flash is lit. If so, the system is ready to be used.

Note: If no entry is confirmed and any part of the flash mode/flash output level display continues to blink, it will only do so six times; if no adjustment is made, the display will stop blinking and the displayed value will be set and saved.

Note: The SU-800 supports four channels (numbered 1 to 4); the same channel number is set to all groups (A, B, and C). If you are working close to another photographer using the Advanced Wireless Lighting system, make sure you each use a different channel number to prevent interference with each other's flash equipment.

Setting the SU-800's AF Assist

To assist the operation of autofocus lenses in low light conditions, the SU-800 has a built-in AF-assist lamp. It can be set to activate automatically, or AF assist can be cancelled. Press the (MODE) + ◄ buttons simultaneously for about two seconds to alternate between AF-ILL AF-assist lamp operation active, or NO AF-ILL AF-assist lamp operation cancelled.

Note: The AF-assist lamp has an effective range of approximately 3.3 to 33ft (1 to 10m), and can be used with focal lengths between 24mm and 105mm. It is not available when the SU-800 is set to Close-up mode.

Setting Repeating Flash (RPT) on the SU-800

The SU-800 can be used to control the SB-800 or SB-600 Speedlights for RPT repeating flash operation. In this configuration the flash mode to control the remote Speedlight(s) can be set to either RPT repeating flash, or - - (flash cancelled).

171

Note: Only the SB-800 or SB-600 can perform [RPT] repeating flash when used as a remote Speedlight; the SB-R200 does not support this function.

1. Press and hold the [SEL] button for about two seconds until [RPT] appears in the LCD panel of the SU-800; this confirms that it is set for repeating flash operation.

2. Press [SEL] and A will start to blink. Press the (MODE) button to set the flash mode for group A to either A [RPT] mode, or A - - (flash cancelled) mode. Press [SEL] to confirm the selection and start B blinking; repeat the process to set the flash mode for groups B and C.

3. When the manual flash output blinks, set the required level between 1/8 and 1/128 by pressing ◄ or ► . Press [SEL] to confirm the selection and start the frequency blinking.

4. Set the required frequency by pressing ◄ or ► and press [SEL] to confirm the selection and start the number of frames blinking.

5. Set the required number of frames by pressing ◄ or ► and press [SEL] to confirm the selection and start the channel number blinking.

6. Set the required channel number by pressing ◄ or ► and press [SEL] to confirm the selection.

7. Once all remote Speedlights are set to remote operation and their ready light is lit, the system is ready to be fired.

Built-in Speedlights in Commander Mode

The built-in Speedlights of some Nikon digital SLR cameras can be set to operate as a master flash, but they must be compatible with the Advanced Wireless System. Currently, this feature is available with the D200 and D70-series cameras.

To use this feature on both these cameras requires the user to access the custom setting menu. On the D200 navigate to CS-e3 (Built-in flash mode) and select the Commander mode option. On the D70-series cameras, open CS-19 (Flash mode) and select the Commander mode option.

The use of the term Commander mode in the flash mode options of the D200 and D70-series cameras implies that the built-in Speedlights of these cameras operate in the same way as an SB-800 set to Commander function: that is, the flash only emits the control signals to the remote flash units and does not contribute to the main flash exposure. In the case of the D70-series cameras this is correct.

However, selecting Commander mode on the D200 provides additional options. These options allow the built-in Speedlight to perform **TTL** and **M** flash exposure control, as well as offering the - - (flash cancelled) option, so that it operates in the same way as an SB-800 set to Commander function. This is another example of the confusion that Nikon's naming regime can cause. It would probably be clearer if Nikon had used the term Master flash mode, rather than Commander mode.

Built-in Speedlight: Nikon D200

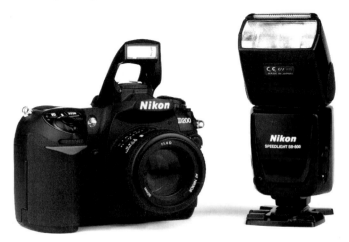

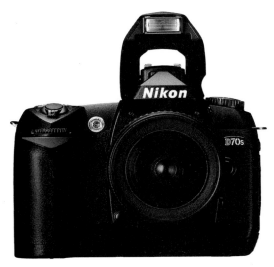

The built-in Speedlight of the Nikon D70s can wirelessly control remote CLS flash units.

In addition to its use in flash photography, the built-in Speedlight of the D200 camera can be set to control one or more remote Speedlights wirelessly in P, A, S, and M exposure modes. This function is compatible with the SB-800, SB-600, and SB-R200. The remote Speedlights can be controlled in these flash modes: **TTL** , **M** , or **AA** with remote SB-800 Speedlights only. Control is limited to two groups; group A and B, using any one of four channels (1 to 4).

To use the Commander mode, which sets the built-in Speedlight of the Nikon D200 camera to act as a master flash:

1. Open the custom setting menu and navigate to Custom Setting-e3 (Built-in flash mode).

2. Highlight the Commander Mode option and press the multi-selector switch to the right to open a sub-menu of flash mode, flash output level, and control channel options.

3. Highlight Built-in/Mode to set the required flash mode and use the up and down buttons on the multi-selector switch to select **TTL** , ☒ , or - - (Flash cancelled). If **TTL** , or ☒ is selected, press the multi-selector switch to the right to highlight Comp (flash output level compensation) and use the up and down buttons of the multi-selector switch to select the required value. Press the multi-selector switch to the right to set and confirm the value, and highlight Group A / Mode.

4. Set the desired flash mode for group A by using the up and down buttons on the multi-selector switch to choose **TTL** , ☒ (SB-800 only), ☒ , or - - (Flash cancelled). If **TTL** , ☒ , or ☒ is selected, and you want to set a flash output compensation level, repeat the procedure from Step 3. Otherwise press the multi-selector switch to the right to highlight Group B / Mode. Repeat Steps 3 and 4 to set flash mode and flash exposure compensation.

5. Highlight Channel and use the up and down buttons on the multi-selector switch to set the required channel number.

6. Finally, press the ENTER button on the back of the camera to confirm and lock the settings made in Steps 3 – 5 above.

7. Once the remote Speedlight(s) are set to operate in the remote flash mode (see above for details), and that the ready light(s) is lit. The system is now ready to be fired.

Built-in Speedlight: Nikon D70-series

The built-in Speedlight of the D70 and D70s cameras can be set to wirelessly control one or more remote Speedlights in P, A, S, and M exposure modes; this feature is compatible with the SB-800, SB-600, and SB-R200.

Note: This built-in flash is limited to controlling just one group—group A, using channel 3 only.

To use the Commander mode of the Nikon D70/D70s cameras:

1. Open the custom setting menu and navigate to Custom Setting-19 (Flash mode).

2. Highlight the Commander mode option and press the multi-selector switch to the right to open a sub-menu of flash mode choices.

3. Select the required flash mode **TTL** , **AA** (for use with remote SB-800 Speedlights only), or **M** .

4. Check that the remote Speedlight(s) are set to operate in remote flash mode (see above for details), and that the ready light is lit. The system is now ready to be used.

Note: If you select **M** flash mode, a further sub-menu is displayed that shows the flash output level options between 1/1 (full) and 1/128. Use the up and down buttons on the multi-selector switch to select the required level, and press it to the right to return to the main custom setting menu.

Effective Master / Commander Ranges

SB-800
When the SB-800 is used as a master flash, Nikon says that the maximum effective operating range between it and the remote Speedlights is 33 ft (10 m) along the central axis of the lens, and 16 ft (5 m) to 23 ft (7 m) within 30° of the central axis of the lens.

SU-800
The SU-800 only emits an IR signal, while the SB-800 and built-in Speedlights, when used as a master flash, relay control signals as part of their full spectrum output. Thus, the SU-800 is a more powerful choice than using Speedlights in the master flash role. Nikon says that it is capable of controlling remote SB-800 and SB-600 Speedlights up to a maximum range of 66 ft (20 m).

176

SU-800 with the SB-R200

When the SU-800 is used as the commander unit, Nikon says that the maximum effective operating range between it and remote SB-R200 Speedlights is 13 ft (4 m) along the central axis of the lens, and 9.8 ft (3 m) within 30° of the central axis of the lens.

Built-in Speedlights: D200 and D70-series

The built-in Speedlights of the D200 and D70-series cameras, used as the master flash, can control remote Speedlights placed within 30° of the central axis of the lens up to a maximum range of 33 ft (10 m). Between 30° and 60° from the central axis of the lens, the maximum range is 16 ft (5 m).

Note: I have found Nikon's quoted maximum operating ranges for the components of the Advanced Wireless Lighting system to be very conservative. For example, I have used SB-800 Speedlights as master and remote units at ranges outdoors of 100 ft (30 m) or more, particularly in situations where there have been reflective surfaces such as walls and foliage close by. This is three times greater than Nikon's suggested maximum range. However, in bright sunlight, which contains a high level of naturally occurring IR wavelengths, you may find the practical limit of the operating range is reduced.

Note: Nikon cautions that communication between the master and remote flash units cannot be performed properly if there is an obstruction between them. In practice I have used remote flash units very successfully without a line-of-sight between the master flash and the sensor on the remote Speedlight(s). However, every shooting situation is unique; so my advice is to set up the lighting system, and take test shots. If you are not satisfied with the results, adjust the location of the remote Speedlights.

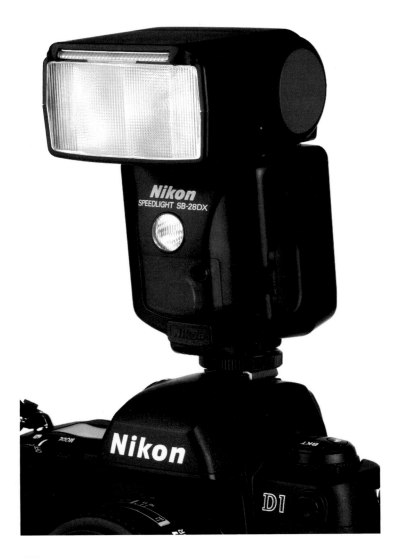

TTL and D-TTL Speedlights

This section describes how to set the controls for the various features and functions of the SB-28, SB-28DX, and SB-80DX Speedlights. The compatibility of various flash features and functions with specific Nikon cameras can be checked in the reference tables in the Camera & Speedlight Compatibility section (see page 262). For full information on how flash modes and features operate and how they affect the final image, refer to: Nikon Flash Nomenclature, Flash Techniques, and Using Your Speedlight. For details on how to set up and use multiple Speedlights, see Using Multiple Speedlights (see page 145).

SB-28 and SB-28DX

The SB-28, introduced in 1997, is the only Speedlight covered in this book that does not support TTL flash with Nikon digital SLR cameras. With these cameras, it can only function in non-TTL automatic or Manual flash modes. This successor to the SB-26, apart from being slightly smaller and lighter, offers only a marginal improvement in flash recycle times and battery power management. Nikon decided to drop the wireless remote slave capability that is available on the SB-26.

The Nikon D1 digital SLR camera necessitated the introduction of the SB-28DX variant. Externally, it is identical to the SB-28, except for different colored control buttons and the nameplate. When attached to a digital SLR, however, the SB-28DX supports D-TTL Nikon's second major iteration of its TTL flash exposure control system (see page 44 for details), which always emits pre-flashes in its TTL modes regardless of the flash head orientation.

✧ *The introduction of the D1 D-SLR camera necessitated the invention of D-TTL because digital cameras could not use off-the-film metering of the flash exposure. Thus, Nikon introduced the Speedlight SB-28DX variant, which emits pre-flashes that supply the D-TTL system with the information it needs to control the exposure.*

Nikon SB-28 – Frontview

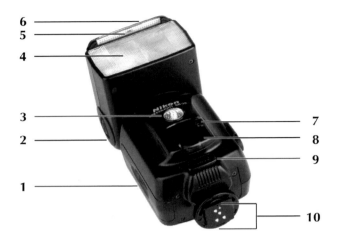

1. Battery compartment lid
2. Flash head lock release
3. Red-eye reduction lamp
4. Flash head/Fresnel lens
5. Wide-angle flash diffuser
6. Built-in bounce card

7. Sensor for non-TTL
 Auto flash
8. AF-assist illuminator
9. External power terminal
10. Hot-shoe contacts

Specifications

Guide Number:	118 (ft) 36 (m) with zoom head at 35mm position
Power:	Four AA size batteries; optional external battery packs
Recycle Time:	4 seconds (4x NiMH 2000mAh)
Number of flashes:	100 at full 1/1 manual setting
Flash duration:	1/830 to 1/8700
Coverage:	18mm (90° horizontal & 102° vertical) + wide-flash adapter
Weight:	11.3 oz (320 g) without batteries
Size:	2.7 x 5 x 3.6 inches (69 x 128 x 90 mm) WxHxD

Nikon SB-28 – Rearview

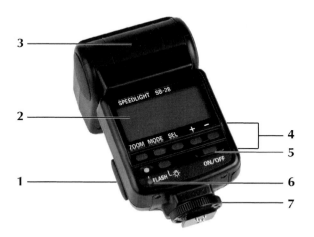

1. Compartment for:
 TTL multiple flash terminal
 (above)
 PC sync terminal (below)
2. LCD panel

3. Tilting angle scale
4. Control buttons
5. ⬚ button
6. Ready light
7. Locking wheel

Case: SS-28

Main features: TTL flash control (SB-28DX–D-TTL) with compatible cameras, automatic flash control, 7 manual power settings, repeating flash, manual FP High-speed Sync, Rear-curtain sync, red-eye reduction compatible, auto-focus assist lamp. Head tilts -7° to +90° from horizontal, rotates 180° counter-clockwise to 90° clockwise. Built-in diffuser panel and bounce card. External power socket, PC sync, and TTL cord terminals.

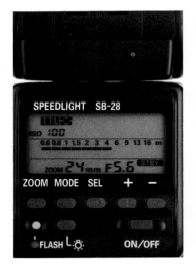 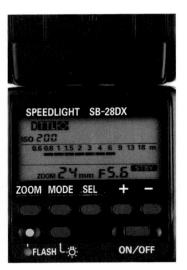

Left: The SB-28 set for TTL flash control. Right: The SB-28DX in D-TTL mode.

Setting TTL Flash

1. Press the ON/OFF button to turn the flash on; or if it is already in its Standby mode, press the shutter release button lightly.

2. There are two TTL options, selected by pressing the (MODE) button:

 • Automatic balanced fill-flash (MODE) with film cameras, and D (MODE) with digital SLR cameras.

 • Standard TTL flash **TTL** with film cameras, and D **TTL** with digital SLR cameras.

Note: If the camera is set to spot metering, only standard TTL flash is available.

3. Since flash exposure control is most effective when the camera has acquired focus, I recommend you set the camera to AF-S (single-servo AF mode).

4. Confirm the camera is set to the required exposure mode and make any necessary adjustments to the shutter speed and/or f/stop.

Note: Remember the maximum aperture value is restricted in Program mode, based on the ISO setting.

Note: On many camera models, when a shutter speed above 1/250 second is selected, attaching and switching on an SB-28/28DX will cause the camera to automatically reset the shutter speed to 1/250 second (some digital cameras permit flash sync at 1/500 second).

Note: In Manual (M) exposure mode, the analog exposure display in the camera's viewfinder will continue to show an exposure indication for the ambient light, even though the SB-28/28DX is attached and switched on.

5. Focus on the subject and check the focus distance from the scale on the lens.

6. Confirm the subject is within the distance range indicated on the LCD panel of the SB-28/28DX. If not move closer or use a larger aperture or higher ISO setting; finally, adjust the composition as necessary.

7. When the ready light glows, the flash can be fired.

Setting Non-TTL Auto Flash (Film cameras)

1. Press the ON/OFF button to turn the flash on; or if it is already in its Standby mode, press the shutter release button lightly.

2. Press the MODE button until **A** appears in the LCD panel.

3. Select either Aperture-Priority (A) or Manual (M) exposure mode.

4. Since flash exposure control is most effective when the camera has acquired focus, I recommend you set the camera to AF-S (single-servo AF mode).

5. Set the desired lens aperture on the camera/lens and adjust the shutter speed to ensure it is at, or below, the maximum flash sync speed.

6. Press the ⟨SEL⟩ button—the aperture value (f/stop) in the LCD panel will blink—then press either the ⊕, or ⊖ button to adjust the aperture value until it matches what is set on the camera or lens.

7. Focus on the subject and check the focus distance on the scale on the lens.

8. Confirm that the subject is within the distance range indicated on the flash unit's LCD panel. If not, move closer or use a larger aperture/higher ISO setting; finally, adjust the composition as necessary.

9. When the ready light glows, the flash is ready to be used.

The SB-28 set for non-TTL Auto flash, for film cameras only.

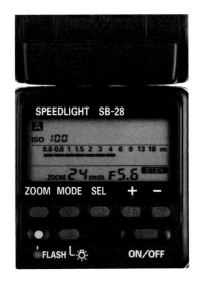

Setting Non-TTL Auto Aperture Flash

1. With digital SLR cameras, the only flash unit in this series that can be used is the SB-28DX.

2. Press the ⟨ON/OFF⟩ button to turn the flash on; or, if it is already in its Standby mode, press the shutter release button lightly.

3. Press the ⟨MODE⟩ button until **A** appears in the LCD panel. (To confirm you are in auto aperture flash mode, the flash exposure compensation indicator appears simultaneously in the LCD panel).

4. Select either Aperture-priority (A) or Program (P) exposure mode.

5. Since flash exposure control is most effective when the camera has acquired focus, I recommend you set the camera to AF-S (single-servo AF mode).

6. Focus on the subject and check the focus distance from the scale on the lens.

7. Confirm the subject is within the distance range indicated on the LCD panel of the SB-28DX. If not, press the ⟨SEL⟩ button and use either the ⊕, or ⊖ button to change the aperture value and ensure the subject is within the flash shooting range.

8. Set the aperture displayed on the LCD control panel on the camera or lens.

9. When the ready light glows, the flash is ready to be used.

Note: When you use a non-CPU type lens (e.g. a manual focus lens, with the exception of the Ai-P types, which have a CPU) this mode is not available.

Note: Auto aperture mode is only available with the SB-28DX and Nikon digital SLR cameras. Used with film cameras, the SB-28 or SB-28DX only supports standard non-TTL automatic flash.

Setting Manual Flash

1. Press the ON/OFF button to turn the flash on; if it is already in its Standby mode press the shutter release button lightly.

2. Press the MODE button until **M** appears in the LCD panel.

3. Select either Aperture-priority (A) or Manual (M) exposure modes and make any necessary adjustments to the shutter speed and/or lens aperture.

4. Since flash exposure control is most effective when the camera has acquired focus, I recommend you set the camera to AF-S (single-servo AF mode).

5. Focus on the subject and check the focus distance on the scale on the lens.

6. Adjusting the lens aperture value (via the camera) causes the aperture value displayed on the Speedlight's LCD panel to change so it reflects the value set on the camera. The range of flash shooting distances will change accordingly; you must match the flash shooting distance displayed in the LCD panel to the focus distance noted in Step 5 above. This can be achieved in one of two ways, or by using a combination of both:

 - Adjust the lens aperture, via the camera, until the distances shown in the two scales match.

 - Press the SEL button to highlight the flash output level, and adjust it by pressing either ⊕ or ⊖ until the distances shown in the two scales match. Then press the SEL button to set that value.

7. When the ready light glows, the flash is ready to be used.

Note: When you use a non-CPU type lens (e.g. manual focus Ai or Ai-S types), the lens aperture is not communicated to the SB-28/28DX. In this case, adjust the aperture value and flash output level (1/1 to 1/64), until the flash shooting distance displayed on the LCD panel of the SB-28/28DX matches the focus distance. Next, adjust the lens aperture so that it matches the aperture value displayed on the flash.

Note: The flash output is adjusted by pressing the ⊏SEL⊐ button to highlight the flash output level on the LCD display; then press either ⊕ or ⊖ to alter its value. It will change in increments of 1/3 stop, between each power level from 1/2 to 1/64. These are displayed as either the fraction (+/-1/3EV) or (+/-2/3EV). For example, 1/4 (-0.3) represents a flash output at 1/4 power less 1/3-stop. To set and lock the required value, press the ⊏SEL⊐ button again.

Rapid, Continuous Shooting
It is possible to use the SB-28/28DX when shooting a rapid sequence of frames. In TTL, Non-TTL, and Manual (at an output level of 1/1, and 1/2) flash modes the Speedlight can output a maximum of fifteen flashes in a single sequence, and when the flash output level is reduced to between 1/4 and 1/64 in Manual flash mode the SB-28/28DX can output a maximum of forty flashes in a single sequence. The maximum effective frame rate will be determined by the recycling time of the Speedlight.

Note: Whenever the SB-28/28DX is used to shoot a rapid sequence up to the maximum number of flashes (as quoted above), it is essential to let the Speedlight cool for at least 10 minutes.

When the flash output level is reduced to 1/8 or less in Manual flash mode, the SB-28/28DX can synchronize with a camera cycling at up to 6 frames per second (fps). The maximum number of consecutive frames that can be shot with guaranteed synchronization of the SB-28/28DX at this frame rate is given in the table below.

Maximum Consecutive Frames with Flash Sync at 6 fps Continuous Shooting

Flash Output Level	Number Of Consecutive Frames
1/8	4
1/16	8
1/32	16
1/64	30

Setting Repeating Flash

1. Press the ON/OFF button to turn the flash on, or if it is already in its Standby mode press the shutter release button lightly.

2. Press the MODE button until **M** **555** appear in the LCD panel.

3. Select M (Manual) exposure mode.

4. Since flash exposure control is most effective when the camera has acquired focus I recommend you set the camera to AF-S (single-servo AF mode).

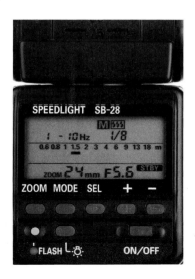

The SB-28'S LCD default display for Repeating flash mode shows (from left to right): Number of flashes = 1, Frequency = 10Hz, Flash output level = 1/8. The user can adjust all three of these settings, as described in steps 5 to 7 on the following page.

5. Press the (SEL) button to highlight the flash output level and use either the ⊕ , or ⊖ button to adjust it to the required value (only settings between 1/8 to 1/128 are available in this mode). To confirm and lock the required value press (SEL) button. The frequency display should now start to flash.

6. Confirm the frequency display is flashing (if not press the ⊖ button until it does). Adjust the frequency to the required level by pressing either the ⊕ , or ⊖ button. To confirm and lock the required value press (SEL) button. The number of flashes display should now start to flash.

7. Confirm the number of flashes display is flashing (if not press the (SEL) button until it does). Adjust the number of flashes to the required level by pressing either the ⊕ , or ⊖ button. To confirm and lock the required value press (SEL) button.

Note: The flash output level you selected in step 5, and the frequency of flashes you selected in step 6 will determine the maximum number of flashes that can be emitted in a single exposure (see table below).

8. To calculate the aperture, it is necessary to first determine the Guide Number according to the flash output level and zoom head position. Use the following table (note figures are for a sensitivity of ISO 100).

Hz / Output Level	1/8	1/16	1/32	1/64
1-2	14	30	60	90
3	12	30	60	90
4	10	20	50	80
5	8	20	40	70
6	6	20	32	56
7	6	20	28	44
8	5	10	24	36
9	5	10	22	32
10	4	8	20	28
20-50	4	8	12	24

Guide Numbers (ISO 100 in ft/m)

Flash Output	18	20	24	28	35	50	70	85
1/1	59/18	66/22	98/22	105/32	118/36	138/42	157/48	164/50
1/2	42/12.7	46/14	69/21	74/22.5	84/25.5	98/30	112/34	118/36
1/4	30/9	33/10	49/15	53/16	59/18	69/21	79/24	82/25
1/8	21/6.4	23/7	35/10.5	37/11.3	42/12.7	49/15	56/17	59/18
1/16	15/4.5	16/5	25/7.5	26/8	30/9	35/10.5	39/12	42/12.7
1/32	10/3.2	11/3.5	17/5.3	19/5.7	21/6.4	25/7.5	22/8.5	30/9
1/64	8/2.3	8.3/2.5	12.5/3.8	13/4	15/4.5	17/5.3	20/6	21/6.3

ISO Sensitivity Factor

For sensitivities other than ISO 100 multiply the guide number by the factors in the following table:

ISO	25	50	100	200	400	800	1600
Factor	x0.5	x0.71	x1.0	x1.4	x2.0	x2.8	x4.0

9. After determining the Guide Number, you must calculate the lens aperture value. Use the following equation:
Lens aperture = Guide number x ISO/ Shooting distance.
Set the calculated aperture value on the SB-28/SB-28DX via the camera for appropriate models, or directly on the flash for cameras that do not support aperture value communication between camera and flash unit.

10. To calculate the minimum shutter speed that can be used for your chosen combination of flashes and frequency use the following equation: Shutter Speed = Number of flashes/Frequency. For example, to use 10 flashes per frame at a frequency of 5Hz, the shutter speed must be set to 2 seconds or longer.

11. When the ready light glows, the flash is ready to be used.

Note: In the literature supplied by Nikon it says that exposure "is the correct exposure for the first flash in the sequence." Of course, the exposure is actually correct for each flash output but the point Nikon is attempting to make is that, if the subject,

or part of the subject, does not move between each flash, the area(s) in which overlap occurs will be overexposed.

Note: Repeating flash is often most effective when the subject is set against a dark background, or you intentionally underexpose the background. If the background receives too much light from the multiple pulses it will be overexposed. Applying the effect of the Inverse Square Law is often the best solution. Placing the subject at a distance from the background will result in significant light fall-off and, thus, a darker background.

Setting FP High-speed Flash Sync

1. Press the `ON/OFF` button to turn the flash on; if it is already in its Standby mode, press the shutter release button lightly.

2. Press the `MODE` button until **M** appears in the LCD panel.

3. Select Manual (M) exposure mode.

4. Since flash exposure control is most effective when the camera has acquired focus, I recommend you set the camera to AF-S (single-servo AF mode).

5. Press either the ⊕ or ⊖ button until **FP** appears in the LCD panel display.

6. It is necessary to determine an appropriate lens aperture and flash output level according to the flash-to-subject distance. Follow the same procedure as set out in steps 8 & 9 above under Set Repeating Flash and set the calculated lens aperture and flash output level on the SB-28/ 28DX.

7. Make sure the aperture value set on the SB-28/28DX is the same as the one set on the camera or lens.

8. Set the shutter speed (no slower than 1/250 second is recommended). Re-check the flash shooting range on the LCD panel and adjust either the aperture value on the camera or the flash-to-subject distance, if necessary.

Flash exposure compensation of -2 EV created a very subtle use of fill-flash, which enhanced detail and highlighted the sheen on the bird's feathers.

9. When the ready light glows, the flash can be used.

Note: The fastest shutter speed that can be used in FP High-speed flash sync mode varies depending on the specific camera model in use.

Setting Flash Exposure Compensation
1. To set and apply a flash exposure compensation factor press the ⊂SEL⊃ button; the flash output compensation level will begin to flash in the LCD panel.

2. Press either the ⊕ or ⊖ button to adjust the flash exposure compensation factor value in increments of 1/3EV over a range of +1.0 to -3.0EV.

3. Once the desired value is displayed, press the ⊂SEL⊃ button to confirm and lock the value.

4. To cancel any flash exposure compensation factor you must use either the ⊕ or ⊖ button to adjust the value to "0." Turning off the SB-28/28DX will not cancel flash exposure compensation.

Note: Flash exposure compensation does not affect the ambient-light exposure calculated by the camera.

Note: I recommend you avoid setting any flash exposure compensation in **TTL** **⦿** and D **TTL** **⦿** since, with this fully automated balanced fill flash option, the camera will apply its own flash exposure compensation and its value is unknown. Therefore, there is no way of knowing in advance how flash compensation will affect the exposure. This makes obtaining repeatable results impossible! Use **TTL**, **A** or **M** flash modes so that any compensation you set will be applied to a known flash output level.

Manually Adjusting the Zoom Head
1. Recent Nikon cameras with a Nikkor lens containing a CPU automatically communicate the lens focal length to the SB-28/28DX. Using this information, the flash automatically

adjusts the position of the flash reflector to match the angle-of-view of the lens. You can also adjust the zoom head manually by pressing the (ZOOM) button. To indicate that you are using the manual zoom head adjustment feature, a small M appears above ZOOM in the LCD panel zoo͞M .

2. To cancel manual zoom head adjustment and return to automatic operation, press the (ZOOM) button repeatedly until to the focal length that is displayed matches the focal length in use and 🔛 appears.

Note: If you use the wide-flash adapter, the SB-28/28DX is set to provide coverage for either a 18mm or 20mm focal length (to switch between these two values use the (ZOOM) button). zoo͞M appears in the LCD panel to note that the wide-flash adapter is in place.

Additional Functions
The SB-28/28DX has a variety of other functions that can be set by a single button or adjusted using a dual-button action to activate or cancel them. The two buttons indicated in the list of functions below must be pressed simultaneously.

Note: A couple of the functions require the flash to be switched off before pressing the buttons.

Single Button Functions
(☀) *LCD Panel Illumination*—switches the LCD panel illumination ON or OFF.

(FLASH) *Flash*—fires a test flash.

Dual-button Functions
(MODE) + (ON/OFF) *Standby function*—sets or cancels the standby function (the buttons must be pressed after the flash is turned off).

(☀) + (ON/OFF) *Unit of Measure (Distance scale)*—selects either meters (m) or feet (ft). (These buttons must be pressed after the SB-28/28DX is turned off. When the flash is turned

on again, the new selection will be active; to return to the former option, repeat the process.)

⌜ZOOM⌝ + ⊕ *Automatic Zoom Head Function*—sets or cancels automatic flash zoom head operation (the buttons must be pressed and held for 2 seconds).

⌜ZOOM⌝ + ⌜SEL⌝ *Zoom Head Position If Wide-flash Adapter Is Missing*—Use this function to manually adjust the zoom head if the built-in wide flash adapter is broken.

⌜MODE⌝ + ⊖ *AF-assist Lamp*—activates or cancels the AF assist illumination feature.

General Notes

- The following functions are set from compatible cameras: Slow flash sync, Rear-curtain sync, and Red-eye reduction.

- The built-in AF-assist lamp, which operates automatically unless cancelled on the SB-28/28DX (as described above), has an effective range of 3.3 ft (1 m) to 26 ft (8 m) and will, typically cover focal lengths between 24mm and 105mm. The effectiveness of the lamp is reduced at the periphery of the frame area. It requires single-servo AF to be set, the central AF sensor to be selected, and focus lock not activated.

- The "F" symbol in the LCD panel blinks to indicate that the aperture value must be set manually. This may occur in non-TTL automatic flash modes, or when a non-CPU type lens is attached to the camera. Use either the ⊕ or ⊖ button to adjust the aperture value.

- Following a flash exposure appear in the top right corner of the LCD panel along with a numerical value; this is an indication that under-exposure may have occurred, but the warning is only visible for approximately three seconds after the shutter closes. To recall the indication, press the ⌜⌗⌝ button. The flash ready symbol in the viewfinder also blinks to note possible underexposure.

Nikon SB-80DX – Frontview

1. Battery compartment cover
2. Sensor for non-TTL Auto flash
3. Sensor for wireless slave flash
4. Flash head lock release button
5. Flash head / Fresnel lens
6. Built-in wide-angle diffuser
7. Built-in bounce card
 (behind wide-angle diffuser)
8. Red-eye reduction lamp
9. AF-assist illuminator
10. External power terminal
11. Hot-shoe contacts

Specifications

Guide Number: 125 (ft) 38 (m) with zoom head at 35mm @ISO 100

Power: Four AA size batteries, and optional external battery packs

Recycle Time: 4 seconds (4x NiMH 2000mAh)

Number of flashes: 110 at full 1/1 manual setting

Flash duration: 1/1050 to 1/41600

Coverage: 14mm (120° horizontal & 110° vertical)

Weight: 11.8 oz (335 g) (without batteries)

Size: 2.8 x 5.0 x 3.6 inches (70.5 x 127.5 x 91.5 mm) WxHxD

Case: SS-80

Nikon SB-80DX – Rearview

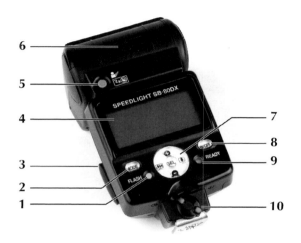

1. (FLASH) button
2. (MODE) button
3. Compartment for:
 TTL multiple flash terminal
 (above) / PC sync
 terminal (below)
4. LCD panel

5. Modeling illuminator button
6. Tilting angle scale
7. (SEL) (+) (−)
 (◂▸◂) (◆) buttons
8. (ON/OFF) button
9. Ready light
10. Locking lever

Main features: TTL flash control (TTL, D-TTL) with appropriate cameras, automatic flash control and 8 manual power settings, repeating flash, manual FP High-speed Sync, Rear-curtain sync, red-eye reduction, modeling lamp and auto-focus assist lamp. Head tilts -7° to +90° from horizontal, rotates 270° counter-clockwise to 180° clockwise. Built-in diffuser panel and bounce card, separate diffusion dome supplied. External power socket, PC sync terminal, and TTL cord terminal. Wireless flash control as master/remote unit (film cameras only).

SB-80DX

Introduced in 2002, the SB-80DX was the successor to the SB-28DX. It features slightly higher Guide Numbers, wider coverage (equivalent to a 14mm lens in the full-frame 35mm format), an extended zoom head range up to 105mm, and wireless remote slave capability. It was also supplied with the SW-10H diffusion dome to produce a softer light. It supports both TTL and D-TTL flash exposure control when used with appropriate Nikon cameras.

Setting TTL Flash

1. Press the ON/OFF button to turn the flash on, or if it is already in its Standby mode press the shutter release button lightly.

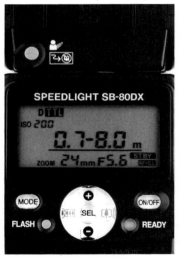 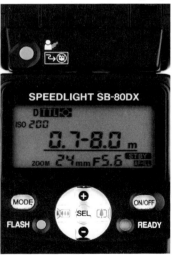

(Left) LCD in TTL mode. (Right) LCD in Automatic balanced fill-flash for digital cameras.

2. There are two TTL options:
 - Automatic balanced fill-flash **TTL ●** for film cameras, and D **TTL ●**, for digital SLR cameras)
 - Standard TTL flash **TTL** , for film SLR cameras, or D **TTL** , for digital SLR cameras), which are selected by pressing the MODE button.

Note: If High-speed Sync mode is selected on the camera $\boxed{\text{FP}}$, it will appear after the TTL symbols. High-speed sync is only available on certain cameras and the flash output level and lens aperture must be manually set for the flash-to-subject distance.

Note: If the camera is set to spot metering, only standard TTL flash $\boxed{\text{TTL}}$ or D $\boxed{\text{TTL}}$ is available.

3. Since flash exposure control is most effective when the camera has acquired focus, I recommend you set the camera to AF-S (single-servo AF mode).

4. Confirm the exposure mode and make any necessary adjustments to the shutter speed and/or lens aperture.

Note: Remember the maximum aperture value is restricted in Program mode, and its value is dependent on the ISO setting.

Note: On many camera models, if a shutter speed above 1/250 second is selected, attaching and switching on an SB-80DX will cause the camera to reset the shutter speed automatically to 1/250 second (some cameras, D1-series, D70-series, and D50 permit flash sync at 1/500 second). If you wish to use a higher shutter speed and the camera supports high-speed flash sync, it is necessary to set High-speed sync mode (see below).

Note: In Manual (M) exposure mode, the analog exposure display in the camera's viewfinder will continue to show a readout for the ambient light, even though the SB-80DX is attached and switched on.

5. Focus on the subject and check the focus distance from the scale on the lens.

6. Confirm the subject is within the distance range indicated on the LCD panel of the SB-80DX; if not move closer or use a larger aperture/higher ISO setting. Finally, adjust the composition.

7. When the ready light glows, the flash is ready to be fired.

The SB-80DX set in AA mode for use with digital SLR cameras.

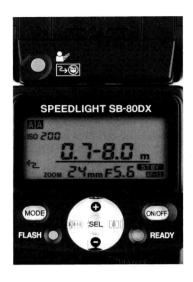

Setting Non-TTL Auto Aperture Flash

1. Press the ON/OFF button to turn the flash on; if it is already in its Standby mode, press the shutter release button lightly.

2. Press the (MODE) button until **AA** appears in the LCD panel.

3. Select either Aperture-priority (A) or Program (P) exposure modes.

4. Since flash exposure control is most effective when the camera has acquired focus, I recommend you set the camera to AF-S (single-servo AF mode).

5. Focus on the subject and check the focus distance from the scale on the lens.

6. Confirm the subject is within the distance range indicated on the LCD panel of the SB-80DX, if not use either the ⊕ or ⊖ button to change the aperture value and ensure the subject is within the flash shooting range.

7. Set the aperture displayed on the LCD control panel on the camera or lens.

8. When the ready light glows, the flash is ready to be fired.

Note: If you use a non-CPU type lens (e.g. a manual focus lens, with the exception of the Ai-P types, which have a CPU) this mode is not available.

Note: **AA** mode is available with Nikon digital SLR cameras. With film cameras that only support standard non-TTL automatic flash, **A** appears in place of **AA**.

Setting Manual Flash

1. Press the ON/OFF button to turn the flash on; if it is already in its Standby mode, press the shutter release button lightly.

2. Press the (MODE) button until **M** appears in the LCD panel.

3. Select either Aperture-Priority (A) or Manual (M) exposure modes and make any necessary adjustments to the shutter speed and/or lens aperture.

4. Since flash exposure control is most effective when the camera has acquired focus, I recommend you set the camera to AF-S (single-servo AF mode).

5. Focus on the subject and check the focus distance from the scale on the lens.

6. Adjusting the lens aperture value (via the camera) causes the aperture value displayed on the LCD panel of the Speedlight to change to reflect the value set on the camera. The range of flash shooting distances will change accordingly; you must match the flash shooting distance displayed in the LCD panel to the focus distance noted in Step 5 above. This can be achieved in one of two ways, or by a combination of both:

- Adjust the lens aperture, via the camera, until the distances shown in the two scales match.

- Press the ⑤ⓔⓛ button to highlight the flash output level and adjust it by pressing either ⊕ or ⊖ until the distances shown in the two scales match. Then press the ⑤ⓔⓛ button to set that value.

7. When the ready light glows, the flash is ready to be used.

Note: If you use a non-CPU type lens (e.g. manual focus Ai or Ai-S types) the lens aperture is not communicated to the SB-80DX. In this case adjust the aperture value and flash output level (1/1 to 1/128) until the flash shooting distance displayed on the LCD panel of the SB-80DX matches the focus distance. Next, adjust the aperture set on the lens to the same aperture value displayed on the flash by rotating the aperture ring of the lens.

Note: The flash output is adjusted by pressing the (icon 13) button to highlight the flash output level shown on the LCD display and then pressing either ⊕ or ⊖ to alter its value. The output setting will change in increments of 1/3-stop, between each power level from 1/2 to 1/128. These are displayed as either the fraction, or the fraction (+/-1/3) and (+/-2/3). For example, 1/4 (-1/3) represents a flash output at 1/4 power less 1/3-stop. To set and lock the required value, press the ⑤ⓔⓛ button again.

Rapid, Continuous Shooting
It is possible to use the SB-80DX when shooting a rapid sequence of frames. In TTL, non-TTL, and Manual (at an output level of 1/1, and 1/2) flash modes, the Speedlight can output a maximum of fifteen flashes in a single sequence, and when the flash output level is reduced to between 1/4 and 1/128 in Manual flash mode, the SB-80 DX can output a maximum of forty flashes in a single sequence. The maximum effective frame rate will be determined by the recycling time of the Speedlight.

Note: The table published in the Nikon manual implies that the SB-80DX can keep pace with a camera cycling at 6 frames per second (fps) up to the maximum number of frames, as quoted above, for continuous flash shooting. This is incorrect.

Note: Whenever the SB-80 DX is used to shoot a rapid sequence up to the maximum number of flashes (as quoted above), it is essential to let the Speedlight cool for at least 10 minutes.

When the flash output level is reduced to 1/8 or less in Manual flash mode, the SB-80DX, it can synchronize with a camera cycling at up to 6 fps. The maximum number of consecutive frames that can be shot with guaranteed synchronization of the SB-80DX at this frame rate is given in the table below.

Maximum Consecutive Frames with Flash Sync at 6 fps Continuous Shooting

Flash Output Level	Number Of Consecutive Frames
1/8	4
1/16	8
1/32	16
1/64	30
1/128	40

Set Repeating Flash

1. Press the ONOFF button to turn the flash on, or if it is already in its Standby mode press the shutter release button lightly.

2. Press the MODE button until **M** **555** appears in the LCD panel.

3. Select Manual (M) exposure mode.

When the SB-80DX's output level is reduced to 1/8 or less and it is used in Manual flash mode, it can synchronize with a camera cycling at up to 6 frames per second (fps).

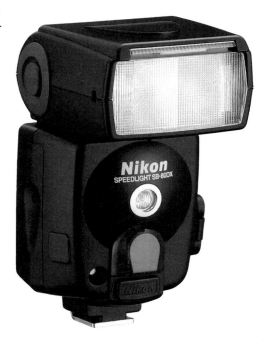

4. Since flash exposure control is most effective when the camera has acquired focus I recommend you set the camera to AF-S (single-servo AF mode).

5. Press the ⑤⑤ button to highlight the flash output level and use either the ⊕ or ⊖ button to adjust it to the required value (only settings between 1/8 to 1/128 are available in 🔢 mode). To confirm and lock the required value press ⑤⑤ button. The frequency display should now start to flash.

6. Confirm the frequency display is flashing (if not press the ⑤⑤ button until it does). Adjust the frequency to the required level by pressing either the ⊕ or ⊖ button. To confirm and lock the required value press ⑤⑤ button. The number of flashes display should now start to flash.

7. Confirm the number of flashes display is flashing (if not press the ⓈⒺⓁ button until it does). Adjust the number of flashes to the required level by pressing either the ⊕ or ⊖ button. To confirm and lock the required value press ⓈⒺⓁ button.

Note: The flash output level you selected in step 5, and the frequency of flashes you selected in step 6 will determine the maximum number of flashes that can be emitted in a single exposure (see table below).

Hz / Output Level	1/8	1/16	1/32	1/64	1/128
1-2	14	30	60	90	90
3	12	30	60	90	90
4	10	20	50	80	80
5	8	20	40	70	70
6	6	20	32	56	56
7	6	20	28	44	44
8	5	10	24	36	36
9	5	10	22	32	32
10	4	8	20	28	28
20-100	4	8	12	24	24

8. To calculate the aperture, it is necessary to determine the Guide Number at the flash output level and zoom head position. Use the tables on the next page.

Guide Numbers (ISO100, ft/m)

Flash Output	A	B	14*	17*	24
1/1	41/12.5	52/16	57/17	62/19	98/30
1/2	29/8.8	37/11.3	39/12	44/13.4	70/21.2
1/4	21/6.3	26/8	28/8.5	31/9.5	49/15
1/8	14/4.4	19/5.7	20/6	22/6.7	35/10.6
1/16	10/3	13/4	14/4.3	16/4.8	25/7.5
1/32	7/2.2	9/2.8	10/3	11/3.4	17/5.3
1/64	5/1.6	7/2	7/2.1	8/2.4	12/3.7
1/128	4/1.1	5/1.4	5/1.5	6/1.7	8.5/2.6
FP	—-	—-	—-	——	35/10.7

Flash Output	28	35	50	70	85	105
1/1	105/32	125/38	144/44	162/52	174/53	184/56
1/2	74/22.6	88/26.9	102/31	116/35.4	123/37.5	131/40
1/4	52/16	62/19	72/22	82/25	87/26.5	92/28
1/8	37/11.3	44/13.4	51/15.6	58/17.7	61/18.7	55/19.8
1/16	26/8	31/9.5	36/11	41/12.5	44/13.3	46/14
1/32	20/6	22/6.7	26/7.8	29/8.8	31/9.4	31/9.9
1/64	13/4	16/4.8	18/5.5	21/6.3	22/6.6	23/7
1/128	9/2.8	11/3.4	13/3.9	14/4.4	15/4.7	16/4.9
FP	37/11.3	42/12.6	47/14.7	55/16.7	58/17.7	61/18.7

A With the wide-flash adapter in place and diffusion dome fitted
B With the diffusion dome fitted
** With the wide-flash adapter in place*

ISO Sensitivity Factor

For sensitivities other than ISO100, multiply the guide number by the factors in the following table:

ISO	25	50	100	200	400	800	1600
Factor	x0.5	x0.71	x1.0	x1.4	x2.0	x2.8	x4.0

9. After determining the Guide Number, you must calculate the lens aperture. Use the following equation:
 Lens aperture = Guide number x ISO/ Shooting distance.
 Set the calculated aperture value on the SB-80DX via the camera for appropriate models, or directly on the flash for cameras that do not support aperture value communication between camera and flash unit.

10. To calculate the minimum shutter speed that can be used with the combination of flashes and frequency, use the following equation: Shutter Speed = Number of flashes/Frequency. For example, to use 10 flashes per frame at a frequency of 5Hz the shutter speed must be set to at least 2 seconds (or longer).

11. When the ready light glows, the flash is ready to be fired.

Note: In the unstructions from Nikon it says that exposure "is the correct exposure for the first flash in the sequence." Of course, the exposure is actually correct for each flash output. The point Nikon is attempting to make is that, if the subject, or part of the subject, does not move between each flash, the area(s) where overlap occurs will be over-exposed.

Note: Usually repeating flash is most effective when the subject is set against a dark background or you intentionally underexpose for the background. If the background receives too much light from the multiple pulses it will be overexposed. (Remember the Inverse Square Law—the best solution is often to place the subject and background at distances that will cause significant light fall-off and, thus, the desired dark background.)

Set FP High-speed Flash Sync

1. Press the ON/OFF button to turn the flash on, or if it is already in its Standby mode, press the shutter release button lightly.

2. Press the MODE button until **M** appears in the LCD panel.

3. Select M (Manual) exposure mode.

4. Since flash exposure control is most effective when the camera has acquired focus, I recommend you set the camera to AF-S (single-servo AF mode).

5. Press either the ⊕ or ⊖ button until FP appears in the LCD panel display.

6. It is necessary to determine an appropriate lens aperture and flash output level according to the flash-to-subject distance. Follow the same procedure as set out in steps 8 & 9 above under Set Repeating Flash and set the calculated lens aperture and flash output level on the SB-80DX.

7. Ensure the same aperture value is set on the SB-80DX is set on the camera or lens.

8. Set the required shutter speed (no slower than 1/250 second is recommended, since this is the normal flash sync speed).

9. Provided the ready light is lit the flash is ready to be used.

Note: The fastest shutter speed that can be used in FP High-speed flash sync mode varies depending on the specific camera model in use.

Setting Flash Exposure Compensation

1. To set and apply a flash exposure compensation factor press either the ⊛ button, or the ⊕ / ⊖ button; the flash output compensation level will begin to flash in the LCD panel.

2. Press either the ⊕ , or ⊖ button to adjust the flash exposure compensation factor value, which is adjusted in increments of 1/3EV (1/6EV with digital SLR cameras) over a range of +3.0 to -3.0EV.

3. Once the required value is displayed press the ⊛ button to confirm and lock the value.

4. To cancel any flash exposure compensation factor you must use either the ⊕ , or ⊖ button to adjust the value to "0". Turning the SB-80DX off will not cancel flash exposure compensation.

Note: Flash exposure compensation does not affect the ambient exposure calculated by the camera.

Note: I recommend you avoid setting any flash exposure compensation in **TTL** **◧** or D **TTL** **◧** since, in these fully automated balanced fill-flash options the camera will apply its own flash exposure compensation, and that value is unknown. Therefore, there is no way of knowing what, if any, effect the flash compensation factor you apply will have. This makes obtaining repeatable results impossible. Use **TTL** , D **TTL** , **A** , or **M** flash modes, as any compensation you set will be applied to a known flash output level.

Manually Adjusting the Zoom Head
1. Recent Nikon cameras used with Nikkor lens containing a CPU communicate the lens focal length to the SB-80DX. This enables the zoom head function of the flash to adjust the position of the flash reflector to provide coverage to match the angle-of-view of the lens (this is the normal configuration of the SB-80DX). To adjust the zoom head position manually press either the **⁜⁜⁜** , or **⁜⁜** button. To indicate that you are using the manual zoom feature a small M appears above ZOOM in the LCD panel zoo^M .

2. To cancel the manual zoom head feature press either the **⁜⁜⁜** , or **⁜⁜** button to the focal length displayed matches the focal length set on the lens.

Note: To cancel the automatic zoom head control use the custom setting menu (see below for details).

Note: If you use the wide-flash adapter, the SB-80DX will provide coverage for either a 14mm or 17mm focal length. If you attach the SW-10H diffusion dome the zoom head will be set automatically to 14mm. In either case, no other zoom head position can be selected.

Custom Setting Menu Functions

Beyond the options displayed in the LCD control panel the SB-800 has a sub-menu of custom settings to control a variety of functions.

Set Custom Function

1. Press and hold the ⑯ button for at least two seconds to display the custom menu options.

2. To scroll through the functions use either the ➕ or ➖ button.

3. To select the required option within each function use either the ➕ or ➖ button to display it on the LCD control panel.

4. To move to another custom setting function use either the ➕ or ➖ button, depending in which direction you wish to scroll.

5. Repeat step 3 until all the required settings have been made.

6. To return to the normal LCD display, either press and hold the ⑯ button for at least two seconds, or push the ⟨ON/OFF⟩ button lightly.

Custom Setting Functions / Options

[⇆] **Wireless Flash Mode** Sets the flash mode for wireless multiple flash photography (see page 152).

[•))] **Sound Monitor (Audible Warning)** Activates or cancels the audible confirmation of flash operation, including the flash units used in wireless multiple flash set-ups.

[NOAF-ILL] **AF-assist Illuminator** Activates or cancels the AF assist lamp feature.

[STBY] **Standby function** Sets the time period before the Standby function is activated.

- Auto—With TTL compatible cameras, flash standby activates when the camera's exposure meter switches off.

- 40 (seconds)

- 80 (seconds)

- 160 (seconds)

- 300 (seconds)

- —- Standby function is cancelled

[m/ft] Distance unit (Unit of Measure) Set either meters (m) or feet (ft).

[M ZOOM] – Power Zoom Function Activates or cancels automatic flash zoom head operation.

[▣] Emergency mode (Zoom Head Position) If the built-in wide flash adapter is accidentally broken off, use this function to manually set the zoom head to positions other than 14mm & 17mm.

[☼] LCD Panel Illuminator Switches the LCD panel illumination ON or OFF.

General Notes

- The following functions are set on compatible cameras: FP High-speed sync mode, Slow-flash sync, Rear-curtain sync, and Red-eye reduction.

- The built-in AF-assist lamp, which operates automatically unless the feature has been cancelled on the SB-80DX, has an effective range of 3.3 ft (1 m) to 33 ft (10 m) and will, generally, cover lenses with a focal length between 24mm and 105mm. The effectiveness of the lamp is reduced at the periphery of the frame area and may vary according to the lens in use. It requires the central AF sensor of the camera to be used.

- The numerical value next to the "F" symbol in the LCD panel blinks to indicate that the aperture value must be set manually. This may occur in non-TTL automatic flash modes, or when a non-CPU type lens is attached to the camera. Use either the **⊕** or **⊖** button to adjust the aperture value, and press **⑤** to lock the chosen value.

- Following a flash output 𝟺𝐸𝐔 may appear in the top right corner of the LCD panel along with a numerical value; this is an indication that under-exposure may have occurred but the warning is only visible for approximately three seconds after the shutter closes. Similarly the flash ready symbol in the viewfinder will blink.

The black and white of the silent film era gets a modern twist ▷
thanks to digital. In this case, standard TTL flash was used to create the look.

212

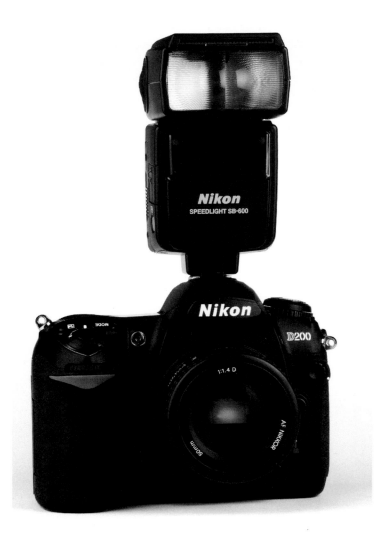

The Creative Lighting System

During 2003 Nikon raised the bar for photography with camera-mounted flash units a considerable distance by introducing the SB-800 Speedlight and D2H digital SLR camera—the first two components of their Creative Lighting System (CLS). The CLS encompasses features and functions, which are as much a part of the cameras as the Speedlight units themselves. These include: i-TTL (the latest iteration of Nikon's through-the-lens flash exposure control), Advanced Wireless Lighting for wireless i-TTL control of control multiple Speedlights, Flash Value (FV) Lock, Flash Color Information Communication, Auto FP High-Speed Sync, and a Wide-Area AF-Assist Illuminator. The CLS flash equipment consists of: SB-800, SB-600, SB-R200 Speedlights, and SU-800 Wireless Speedlight Commander, which are compatible with: the D2-series, D200, D70-series, D50, and F6 cameras. (Although the D70-series and D50, and F6 camera models do not support all the features of the CLS.)

CLS Speedlights

Nikon's Creative Lighting System includes the SB-800, SB-600, and SB-R200 Speedlight flash units. The compatibility of features and functions of Speedlight models and Nikon cameras can be checked in the Camera & Speedlight Compatibility section (see page 262). For full information about flash modes and features, how they operate, and the affect they have on a photograph, refer to Nikon Flash Nomenclature, Flash Techniques, and Using Your Speedlight. For details on how to set up and use multiple Speedlights please refer to Using Multiple Speedlights (see page 145).

Nikon has always been a leader when it comes to flash equipment, and the Creative Lighting System is no exception. The system's flagship flash is the SB-800, and one perfect mate for it is the Nikon D200 digital SLR.

Nikon SB-800 – Frontview

1. Compartment cover
2. Sensor for non-TTL Auto flash
3. Sensor for wireless slave flash
4. Flash head lock release button
5. Flash head
6. Built-in wide-angle diffuser

7. Built-in bounce card
 (behind wide-fangle diffuser)
8. AF-assist illuminator
9. External power terminal
10. Ext. AF assist illuminator
 contacts (for SC-29)
11. Hot-shoe contacts

Specifications:

Guide Number:	125 (ft) 38 (m) with zoom head at 35mm position
Power:	Four AA size batteries, and optional external battery packs
Recycle Time:	4 seconds (4x NiMH 2000mAh)
Number of flashes:	150 at full 1/1 manual setting
Flash duration:	1/1050 to 1/41600
Coverage:	14mm (120° horizontal & 110° vertical)
Weight:	12.3 oz / 350 g (without batteries)
Size:	2.8 x 5.1 x 3.7 inches (70.5 x 129.5 x 93 mm) WxHxD
Case:	SS-800

Nikon SB-800 – Rearview

1. ⟨FLASH⟩ *button*
2. ⟨MODE⟩ *button*
3. *Terminal cover for:*
 TTL multiple flash terminal
 (above) / PC sync (below)
4. *LCD panel*
5. *Modeling illuminator button*

6. *Tilting angle scale*
7. ⟨SEL⟩ ⊕ ⊖
 ⟨▸◂▸⟩ ⟨◖⟩
8. ⟨ON/OFF⟩ *button*
9. *Ready light*
10. *Locking lever*

Main features: TTL flash control (TTL, D-TTL, and i-TTL) with appropriate cameras, automatic flash control and 8 manual power settings, repeating flash, automatic FP High-speed Sync, Rear-curtain sync and red-eye reduction compatible, modeling lamp and auto-focus assist lamp. Supports wireless control of multiple Speedlights, as master or remote unit. Head tilts -7° to +90° from horizontal, rotates 270° counter-clockwise to 180° clockwise. Built-in diffuser panel and bounce card, and separate diffusion dome supplied.

SB-800

Currently Nikon's most sophisticated flash unit, the SB-800, was introduced in 2003. It is an offspring of the SD-80DX, but has additional features and is fully compatible with the Creative Lighting System, including support of i-TTL flash exposure control, when used with compatible Nikon equipment.

Setting TTL Flash

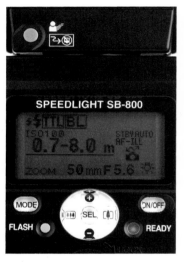 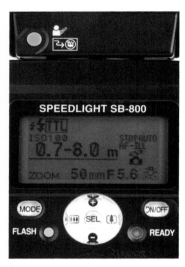

The LCD of an SB-800 set for automatic balanced fill-flash (left), and the flash set for standard TTL (right).

1. Press the ⌊ON/OFF⌋ button to turn the flash on; or, if it is already in its Standby mode, press the shutter release button lightly.

2. There are two TTL options: TTL BL (automatic balanced fill-flash), or TTL (standard TTL flash) that are selected by pressing the ⌊MODE⌋ button.

Note: If High-speed Sync mode is selected on the camera ⌊FP⌋ will appear after TTL BL or TTL. This function is only

218

available on certain cameras; on the F6, D2-series, and D200 it operates automatically, while on all other compatible cameras it must be configured manually.

Note: If the camera is set to spot metering, only TTL (standard TTL flash) is available.

3. Since flash exposure control is most effective when the camera has acquired focus, I recommend you set the camera to AF-S (single-servo AF mode).

4. Confirm the camera is set to the required exposure mode and make any necessary adjustments to the shutter speed and/or lens aperture.

Note: Remember the maximum aperture value is restricted in Program mode and its value is dependent on the ISO setting.

Note: On many camera models, when a shutter speed above 1/250 second is selected, attaching and switching on an SB-800 will cause the camera to be reset the shutter speed, automatically, to 1/250 second (some cameras permit flash sync at 1/500 second). If you wish to use a higher shutter speed and the camera supports high-speed flash sync, select FP mode.

Note: In Manual (M) exposure mode the analog exposure display in the camera's viewfinder will continue to show an exposure readout for ambient light when the SB-800 is attached and switched on.

5. Focus on the subject and check the focus distance from the scale on the lens.

6. Confirm that the subject is within the distance range indicated on the LCD panel of the SB-800, if not, move closer or use a larger aperture/higher ISO setting. Finally, adjust the composition if necessary.

7. When the ready light glows, the flash is ready to be fired.

Setting Non-TTL Auto Aperture Flash

1. Press the ⬚ON/OFF⬚ button to turn the flash on, or if it is already in its Standby mode press the shutter release button lightly.

2. Press the ⬚MODE⬚ button until **AA** appears in the LCD panel.

3. Select either A (Aperture-Priority) or P (Program) exposure modes.

4. Since flash exposure control is most effective when the camera has acquired focus, I recommend you set the camera to AF-S (single-servo AF mode).

5. Select your chosen lens aperture.

6. Focus on the subject and check the focus distance from the scale on the lens.

7. Confirm that the subject is within the distance range indicated on the LCD panel of the SB-800; if not, move closer and use a larger aperture or higher ISO setting. Finally, adjust the composition, if necessary.

8. When the ready light glows, the flash is ready to be fired.

Note: If you use a non-CPU type lens (e.g. a manual focus lens, with the exception of the Ai-P types, which have a CPU), this mode is not available.

Note: **AA** mode is available with most recent Nikon cameras. Earlier cameras only support standard non-TTL automatic flash, and **A** appears in place of **AA** .

Note: Standard non-TTL automatic flash **A** mode can be selected in preference to auto aperture mode **AA** in the SB-800's custom settings menu; select **A/AA** from the menu and choose the required mode.

220

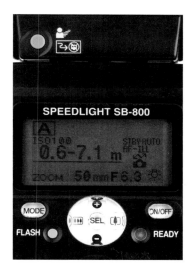

The SB-800 set in A, non-TTL Auto flash (for film cameras).

Setting Distance-Priority Manual Flash

1. Press the ON/OFF button to turn the flash on; or, if it is already in its Standby mode, press the shutter release button lightly.

2. Press the MODE button until **GN** appears in the LCD panel.

3. Select either Aperture-priority (A) or Manual (M) exposure modes and make any necessary adjustments to the shutter speed and/or lens aperture.

4. Since flash exposure control is most effective when the camera has acquired focus, I recommend you set the camera to AF-S (single-servo AF mode).

5. Focus on the subject and check the focus distance from the scale on the lens.

6. Press the **SEL** button to highlight the distance value shown in the LCD panel of the SB-800 and use either the ⊕ or ⊖ button to adjust this distance value to match the distance shown on the focus distance scale of

The SB-800 in Distance-Priority Manual flash mode.

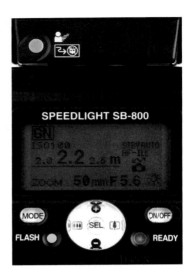

the lens. Press 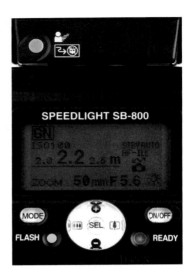 button to confirm the required distance value.

7. When the ready light glows, the flash is ready to be used.

Note: The usable distance range in **GN** mode is 1 to 65 ft (0.3 to 20 m).

Setting Manual Flash

1. Press the ON/OFF button to turn the flash on; or if it is already in its Standby mode, press the shutter release button lightly.

2. Press the MODE button until **M** appears in the LCD panel.

3. Select either Aperture-priority (A) or Manual (M) exposure modes and make any necessary adjustments to the shutter speed and/or lens aperture.

4. Since flash exposure control is most effective when the camera has acquired focus, I recommend you set the camera to AF-S (single-servo AF mode).

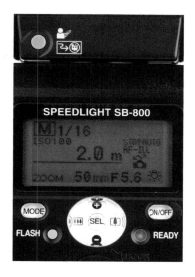

5. Focus on the subject and check the focus distance from the scale on the lens.

6. Whenever you change the lens aperture (via the camera), the Speedlight changes its LCD aperture readout correspondingly. The flash's distance range will respond accordingly; you must match the flash shooting distance displayed in the LCD panel to the focus distance noted in Step 5 above. This can be achieved in one of two ways, or by a combination of both:

• Adjust the lens aperture, via the camera, until the distances shown in the two scales match.

• Press the ⊛ button to highlight the flash output level and adjust it by pressing either ➕ or ➖ until the distances shown in the two scales match. Then press the ⊛ button to set that value.

7. When the ready light glows, the flash is ready to be used.

Note: If you use a non-CPU type lens (e.g. manual focus Ai or Ai-S types) the lens aperture is not communicated to the SB-800. In this case, adjust the aperture value and flash output level (1/1 to 1/128) until the flash shooting distance displayed on the SB-800's LCD panel matches the focus distance. Next adjust the lens aperture to the same value displayed on the flash.

Note: Adjust the flash power by pressing the ⒮⒠⒧ button to highlight the flash output level on the LCD display and then press either ⊕ or ⊖ to alter its value. It will change in increments of 1/3-stop, between each power level from 1/2 to 1/128. These are displayed as a fraction of (+/-1/3) or (+/-2/3). For example, 1/4 (-1/3) represents a flash output at 1/4 power less 1/3-stop. To set and lock the required value, press the ⒮⒠⒧ button again.

Rapid, Continuous Shooting

It is possible to use the SB-800 when shooting a rapid sequence of frames. In the TTL, Non-TTL, and Manual (at an output level of 1/1, and 1/2) flash modes, the Speedlight can output a maximum of fifteen flashes in a single sequence, and when the flash output level is reduced to between 1/4 and 1/128 in manual flash mode the SB-800 can output a maximum of forty flashes in a single sequence. The maximum effective frame rate is determined by the recycling time of the Speedlight.

Note: The table published in the Nikon manual implies that the SB-800 can keep pace with a camera cycling at 6 frames per second (fps) up to the maximum number of frames as quoted above, for continuous flash shooting. This is incorrect.

Note: Whenever the SB-800 is used to shoot a rapid sequence up to the maximum number of flashes (as stated above), it is essential to let the Speedlight cool for at least 10 minutes.

When the flash output level is 1/8 or less and the SB-800 is used in Manual flash mode, it can synchronize with a

camera at up to 6 fps. The maximum number of continuous, consecutive frames that can sync at this frame rate is given in the table below.

Maximum Consecutive Frames with Flash Sync at 6 fps Continuous Shooting

Flash Output Level	Number Of Consecutive Frames
1/8	4
1/16	8
1/32	16
1/64	30
1/128	40

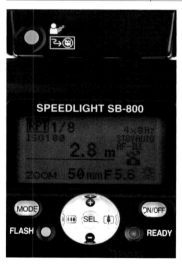

The SB-800's default display for Repeating flash mode shows the flash output level set to 1/8 next to ▣ . *In the top right corner of the display, the number of flashes is set to 1 and the frequency to 10Hz. The user can adjust all three of these settings, as described in steps 5 to 7 on the following page.*

Setting Repeating Flash

1. Press the ⟨ON/OFF⟩ button to turn the flash on, or if it is already in its Standby mode press the shutter release button lightly.

2. Press the ⟨MODE⟩ button until ▣ appears in the LCD panel.

3. Select Manual (M) exposure mode.

4. Since flash exposure control is most effective when the camera has acquired focus, I recommend you set the camera to AF-S (single-servo AF mode).

5. Press the ⊛ button to highlight the flash output level and use either the ⊕ or ⊖ button to adjust it to the required value (only settings between 1/8 to 1/128 are available in **RPT** mode). To confirm and lock the required value, press ⊛ button. The frequency display should now start to flash.

6. Confirm the frequency display is flashing (if not press the ⊛ button until it does). Adjust the frequency to the required level by pressing either the ⊕ or ⊖ button. To confirm and lock the required value press ⊛ button. The number of flashes display should now start to flash.

7. Confirm the number of flashes display is flashing (if not press the ⊛ button until it does). Adjust the number of flashes to the required level by pressing either the ⊕ or ⊖ button. To confirm and lock the required value press ⊛ button.

Hz / Output Level	1/8	1/16	1/32	1/64	1/128
1-2	14	30	60	90	90
3	12	30	60	90	90
4	10	20	50	80	80
5	8	20	40	70	70
6	6	20	32	56	56
7	6	20	28	44	44
8	5	10	24	36	36
9	5	10	22	32	32
10	4	8	20	28	28
20-100	4	8	12	24	24

Note: The flash output level you selected in step 5, and the frequency of flashes, selected in step 6, will determine the maximum number of flashes that can be emitted in a single exposure (see table below).

8. To calculate the aperture, it is necessary to first determine the Guide Number for the flash output level and zoom head position. Use the following table.

Guide Numbers (ISO100, ft/m)

Flash Output	A	B	14*	17*	24
1/1	41/12.5	52/16	56/17	62/19	98/30
1/2	29/8.8	37/11.3	39/12	44/13.4	70/21.2
1/4	21/6.3	26/8	28/8.5	31/9.5	49/15
1/8	14/4.4	19/5.7	20/6	22/6.7	35/10.6
1/16	10/3	13/4	14/4.3	16/4.8	25/7.5
1/32	7/2.2	9/2.8	10/3	11/3.4	17/5.3
1/64	5/1.6	7/2	7/2.1	8/2.4	12/3.7
1/128	4/1.1	5/1.4	5/1.5	6/1.7	8.5/2.6

Flash Output	28	35	50	70	85	105
1/1	105/32	125/38	144/44	162/50	174/53	184/56
1/2	74/22.6	88/26.9	102/31	116/35.4	123/37.5	131/40
1/4	52/16	62/19	72/22	82/25	87/26.5	92/28
1/8	37/11.3	44/13.4	51/15.6	58/17.7	61/18.7	55/19.8
1/16	26/8	31/9.5	36/11	41/12.5	44/13.3	46/14
1/32	20/6	22/6.7	26/7.8	29/8.8	31/9.4	31/9.9
1/64	13/4	16/4.8	18/5.5	21/6.3	22/6.6	23/7
1/128	9/2.8	11/3.4	13/3.9	14/4.4	15/4.7	16/4.9

A: With the wide-flash adapter in place and diffusion dome fitted
B: With the diffusion dome fitted
**With the wide-flash adapter in place*

ISO Sensitivity Factor

For sensitivities other than ISO100, multiply the Guide Number by the factors in the following table:

ISO	25	50	100	200	400	800	1600
Factor	x0.5	x0.71	x1.0	x1.4	x2.0	x2.8	x4.0

9. After determining the Guide Number, calculate the lens aperture value. Use the following equation:
 Lens aperture = Guide number x ISO/ Shooting distance.
 Set the calculated aperture value on the SB-800 via the camera, for appropriate models, or directly on the flash for cameras that do not support aperture value communication between camera and flash unit.

10. To calculate the minimum shutter speed that can be used for the combination of flashes and frequency, use the following equation: Shutter Speed = Number of flashes/Frequency. For example, to use 10 flashes per frame at a frequency of 5Hz, the shutter speed must be set to at least 2 seconds (or longer).

11. When the ready light glows, the flash is ready to be used.

Note: In instructions supplied by Nikon, it says that exposure "is the correct exposure for the first flash in the sequence." However, the exposure is actually correct for each flash output. The point Nikon is attempting to make is that, if the subject, or part of the subject, does not move between each flash, the area(s) in the photo, where the images overlap, will be overexposed.

Note: Use of repeating flash is, generally, most effective when the subject is set against a dark background, or you intentionally underexpose the background. If the background receives too much light from the multiple pulses, it will be overexposed. (Remember the effect of the Inverse Square Law. The best solution is usually to position the subject and background at a distance that will result in significant light fall-off at the background.)

Setting Flash Exposure Compensation

1. To set and apply flash exposure compensation, press the ⑩ button; the flash output compensation level will begin to flash in the LCD panel.

2. Press either the ➊ or ➖ button to adjust the flash exposure compensation factor value, which is adjusted in increments of 1/3EV over a range of +3.0 to -3.0EV.

3. Once the required value is displayed, press the ⑩ button to confirm and lock the value.

4. To cancel any flash exposure compensation factor, you must use either the ➊ or ➖ button to adjust the value to "0". Turning the SB-800 off will not cancel flash exposure compensation.

Note: Flash exposure compensation does not affect the ambient exposure calculated by the camera.

Note: I recommend you avoid using flash exposure compensation in TTL BL. In this fully automated balanced fill-flash option; the camera applies its own flash exposure compensation and this value is unknown. Therefore, there is no way of knowing what, if any, effect the flash compensation factor you apply will have. This also makes obtaining repeatable results impossible! Use **TTL** , **AA** , or **M** flash modes, as any compensation you set will be applied to a known flash output level.

Manually Adjusting the Zoom Head

1. Recent Nikon cameras used with a CPU Nikkor lens communicate the lens focal length to the SB-800. This allows the flash unit to adjust the position of the zoom head's reflector to provide coverage for the angle-of-view of the lens (this is the normal configuration of the SB-800). To adjust the zoom head position manually, press either the 🔲 or 🔲 button; a small M will appear above ZOOM in the LCD panel.

2. To cancel the manual zoom head feature press either the 🔲 or 🔲 button, until the focal length displayed matches the focal length set on the lens.

Note: To cancel the automatic zoom head control, use the custom setting menu (see below for details).

Note: If you use the wide-flash adapter, the SB-800 is set to provide coverage for either a 14mm, or 17mm focal length. If you attach the SW-10H diffusion dome, the zoom head is set automatically to 14mm. In either case no other zoom head position can be selected.

Setting Custom Functions

In addition to the options displayed in the LCD control panel, the SB-800 has a sub-menu of custom settings, which control a variety of functions.

Set Custom Function

1. Press and hold the 🔲 button for at least two seconds to display the custom menu options.

2. To scroll through the functions use either the 🔲 or 🔲 button and either the ➕ or ➖ button.

3. To choose the required option within each function (which must be highlighted), press the ⒮ button. One of the function's options will now be highlighted.

4. Press either the ⊕ or ⊖ button to choose an alternative option within the function, and to select this option, press the ⒮ button.

5. To move to another custom setting function, use either the ▥ or ▣ button and either the ⊕ or ⊖ button.

6. Repeat steps 3 to 5 until all the required settings have been made.

7. To return to the normal LCD display, either press and hold the ⒮ button for at least two seconds, or push the ⓞⓃ/ⓞⒻⒻ button lightly.

Custom Setting Functions / Options

▦ *ISO Sensitivity* To adjust the ISO sensitivity setting within a range of 3 to 8000, use either the ⊕ or ⊖ button.

▦ *Wireless Flash Mode* To set the flash mode for wireless multiple flash photography (see page 159).

♪ *Audible Warning in Wireless Flash Mode* Use to either set or cancel the audible confirmation signal for units used in wireless multiple flash set-ups.

A̲A̲ *Non-TTL Auto Flash* Choose between ᴀᴀ and A̲ flash exposure control modes.

231

[STBY] **Standby function** Use to adjust the time before the Standby function is activated.

- Auto—With TTL compatible cameras, flash standby activates when the camera's exposure meter switches off.

- 40 (seconds)

- 80 (seconds)

- 160 (seconds)

- 300 (seconds)

- —- Standby function is cancelled

[m/ft] **Unit of Measure (Distance scale)** Select meters (m) or feet (ft).

[M ZOOM] **Automatic Zoom Head Function** Activates or cancels automatic flash zoom head operation.

[UP] **Zoom Head Position If Wide-flash Adapter Is Missing** If the built-in wide flash adapter is accidentally broken off, use this function to manually adjust the zoom head position.

[☼] **LCD Panel Illumination** Switches the LCD panel illumination ON or OFF.

[LCD] **LCD Panel Brightness** Adjust the brightness of the LCD panel by pressing either the [◀◀◀] or [◀◀] button.

[AF] **Wide-area AF-assist Lamp** Activates or cancels the wide-area AF assist feature.

[FIRE] **Cancel Flash Firing** Cancels flash output but leaves the wide-area AF-assist lamp active to improve AF performance in low light conditions.

General Notes

- The following functions are set on compatible cameras: FP High-speed sync mode, FV lock, Slow flash sync, Rear curtain sync, and Red-eye reduction.

- The built-in AF-assist lamp, which operates automatically unless the feature has been cancelled on the SB-800, has an effective range of 3.3 ft (1 m) to 33 ft (10 m) and will, generally, cover lenses with a focal length between 24mm and 105mm. The effectiveness of the lamp is reduced at the periphery of the frame area and may vary according to the lens in use. It requires the central AF sensor of the camera to be used.

- The F symbol in the LCD panel blinks to indicate that the aperture value must be set manually. This may occur in non-TTL automatic flash modes, or when a non-CPU type lens is attached to the camera. Use either the ⊕ or ⊖ button to adjust the aperture value.

- Following a flash output EⓋ may appear in the top right corner of the LCD panel along with a numerical value; this is an indication that underexposure may have occurred. This warning is only visible for approximately three seconds after the shutter closes. The flash ready symbol in the viewfinder also blinks to indicate possible underexposure.

Nikon SB-600 – Frontview

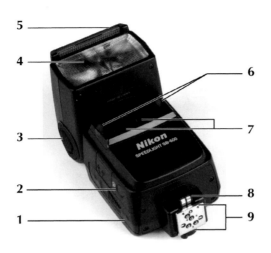

1. *Battery lid*
2. *Sensor for wireless remote flash*
3. *Flash head lock release button*
4. *Flash head*
5. *Built-in wide-angle diffuser*
6. *Auxiliary ready lights*
7. *AF-assist illuminator*
8. *External AF assist illuminator contacts*
9. *Hot-shoe contacts*

Specifications:

Guide Number: 98 (ft) 30 (m) with zoom head at 35mm position/ISO100

Power: Four AA size batteries, and optional external battery packs

Recycle Time: 2.5 seconds (4x NiMH 2000mAh)

Number of flashes: 220 at full 1/1 manual setting

Flash duration: 1/900 to 1/25000

Coverage: 14mm (120° horizontal & 110° vertical)

Weight: 10.6 oz (300 g) without batteries

Size: 2.7 x 4.9 x 3.5 inches (68 x 123.5 x 90 mm) WxHxD

Nikon SB-600 – Rearview

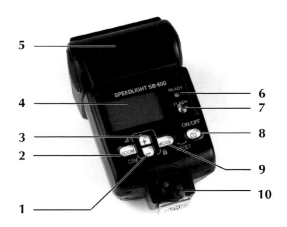

1. ⊟
2. (ZOOM)
3. ⊕
4. LCD panel
5. Tilting angle scale

6. Ready light
7. (FLASH)
8. ON/OFF
9. (MODE)
10. Locking lever

Case:	SS-600
Main features:	TTL flash control (TTL, D-TTL, and i-TTL) with compatible cameras, automatic flash control and 7 manual power settings, automatic FP High-speed Sync, Rear-curtain sync and red-eye reduction capability, built-in diffuser panel, modeling lamp and auto-focus assist lamp. Supports wireless control of multiple Speedlights as a remote unit only. Head tilts 0° to +90° from horizontal, rotates 180° counter-clockwise to 90° clockwise.

SB-600

The second external Speedlight introduced by Nikon for its Creative Lighting System, the SB-600, was launched in early 2004. As the smaller sibling of the more sophisticated SB-800, it offers slightly lower Guide Numbers and fewer features. However, its small size and weight, very quick recycle time, and i-TTL capability make the SB-600 ideal for flash photography in the field.

Note: Unlike the SB-800, the SB-600 lacks an external power socket, PC sync and TTL flash cord terminals, a built-in bounce card, and does not accept the SW-10H diffusion dome.

Note: The SB-600 does not support non-TTL automatic flash [AA] & [A] , or the manual flash options of distance-priority [GN] and Repeating flash [RPT] (Repeating flash is available when used as a remote flash in a wireless setup).

The LCD of an SB-600 set for automatic balanced fill-flash.

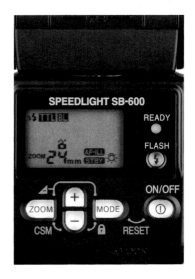

Setting TTL Flash

1. Press the [ON/OFF] button to turn the flash on; if it is already in Standby mode, press the shutter release button lightly.

2. There are two TTL options: TTL BL (automatic balanced fill-flash), or TTL (standard TTL flash). Both are selected by pressing the ⟨MODE⟩ button.

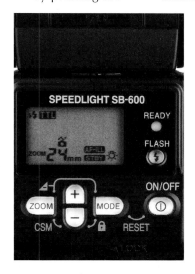

The LCD of an SB-600 set for TTL flash.

Note: If Automatic High-speed sync mode is selected on the camera **FP** will appear after TTL BL or TTL. This function, which operates automatically and is set on the camera, is only available with certain cameras: currently the D2-series, F6 and D200.

Note: When the camera is set to spot metering, only standard TTL flash is available.

3. Since flash exposure control is most effective when the camera has acquired focus, I recommend that you set the camera to AF-S (single-servo AF mode).

4. Confirm that the camera is set to the required exposure mode and make any necessary adjustments to the shutter speed and/or lens aperture.

Note: Remember the maximum aperture value is restricted in Program mode, and this value is dependent on the ISO setting.

Note: On many camera models when a shutter speed above 1/250 second is selected, attaching and switching on an SB-600 will cause the camera to reset the shutter speed, automatically, to 1/250 second (some cameras permit flash sync at 1/500 second). To use a higher flash sync speed the camera must be compatible with the Creative Lighting System, and support automatic high-speed flash sync **FP** mode.

Note: In Manual (M) exposure mode the analog exposure display in the camera's viewfinder will continue to show an indication for ambient light, regardless of the SB-600 being attached and switched on.

5. Focus on the subject and check the focus distance on the scale on the lens.

6. The SB-600 does not display a flash shooting distance range in its control panel LCD. To confirm the subject is within the distance range, refer to Flash Shooting Distance Range (TTL flash modes) in the table below. If it is not within the range for a particular combination of aperture/ISO/zoom head position, use a larger aperture/higher ISO setting, or move closer.

7. When the ready light glows, the flash is ready to be fired.

Flash Shooting Distance Range (TTL flash modes)

ISO Sensitivity						Flash Zoom Head Position						
1600	800	400	200	100	50	14*	24	28	35	50	70	85
5.6	4	2.8	2	1.4	--	3-32 ft 0.9-9.8 m	4.9-52 ft 1.5-16 m	5.2-56 ft 1.6-17 m	5.9-62 ft 1.8-19 m	6.6-66 ft 2.0-20 m	7.5-66 ft 2.3-20 m	8.2-66 ft 2.5-20 m
8	5.6	4	2.8	2	1.4	2.3-23 ft 0.7-7.0 m	3.6-36 ft 1.1-11 m	3.9-39 ft 1.2-12 m	4.3-46 ft 1.3-14 m	4.9-52 ft 1.5-16 m	5.2-56 ft 1.6-17 m	5.9-62 ft 1.8-19 m
11	8	5.6	4	2.8	2	2.0-16 ft 0.6-4.9 m	2.6-27 ft 0.8-8.1 m	2.6-29 ft 0.8-8.8 m	3.0-32 ft 0.9-9.8 m	3.3-36 ft 1.0-11 m	3.9-39 ft 1.2-12 m	3.9-44 ft 1.2-14 m
16	11	8	5.6	4	2.8	2.0-11 ft 0.6-3.5 m	2.0-19 ft 0.6-5.7 m	2.0-20 ft 0.6-6.2 m	2.3-23 ft 0.7-7.0 m	2.6-26 ft 0.8-8.0 m	2.6-30 ft 0.8-9.0 m	2.9-33 ft 0.9-10 m
22	16	11	8	5.6	4	2.0-7.9 ft 0.6-2.4 m	2.0-13 ft 0.6-4.0 m	2.0-14 ft 0.6-4.4 m	2.0-16 ft 0.6-4.9 m	2.0-18 ft 0.6-5.6 m	2.0-21 ft 0.6-6.3 m	2.0-23 ft 0.6-7.0 m
32	22	16	11	8	5.6	2.0-5.6 ft 0.6-1.7 m	2.0-9.2 ft 0.6-2.8 m	2.0-10 ft 0.6-3.1 m	2.0-11 ft 0.6-3.5 m	2.0-13 ft 0.6-4.0 m	2.0-15 ft 0.6-4.5 m	2.0-16 ft 0.6-5.0 m
--	32	22	16	11	8	2.0-3.9 ft 0.6-1.2 m	2.0-6.6 ft 0.6-2.0 m	2.0-7.2 ft 0.6-2.2 m	2.0-7.9 ft 0.6-2.4 m	2.0-9.2 ft 0.6-2.8 m	2.0-10 ft 0.6-3.1 m	2.0-11 ft 0.6-3.5 m
--	--	32	22	16	11	2.0-2.6 ft 0.6-0.8 m	2.0-4.6 ft 0.6-1.4 m	2.0-4.9 ft 0.6-1.5 m	2.0-5.6 ft 0.6-1.7 m	2.0-6.6 ft 0.6-2.0 m	2.0-7.2 ft 0.6-2.2 m	2.0-8.2 ft 0.6-2.5 m
--	--	--	32	22	16	--	2.0-3.1 ft 0.6-1.0 m	2.0-3.6 ft 0.6-1.1 m	2.0-3.9 ft 0.6-1.2 m	2.0-4.6 ft 0.6-1.4 m	2.0-4.9 ft 0.6-1.5 m	2.0-5.6 ft 0.6-1.7 m
--	--	--	--	32	22	--	2.0-2.3 ft 0.6-0.7 m	2.0-2.3 ft 0.6-0.7 m	2.0-2.6 ft 0.6-0.8 m	2.0-3.3 ft 0.6-1.0 m	2.0-3.6 ft 0.6-1.1 m	2.0-3.9 ft 0.6-1.2 m

*The LCD of an SB-600 set for
Manual flash mode.*

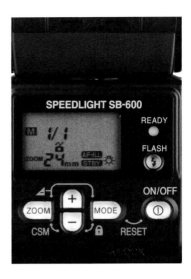

Setting Manual Flash

1. Press the ON/OFF button to turn the flash on; if it is already in
 its Standby mode, press the shutter release button lightly.

2. Press the MODE button until **M** appears in the LCD
 panel.

3. Select either Aperture-priority (A) or Manual (M) exposure
 modes and make any necessary adjustments to the shutter
 speed and/or lens aperture.

4. Since flash exposure control is most effective when the
 camera has acquired focus, I recommend that you set the
 camera to AF-S (single-servo AF mode).

5. Focus on the subject and check the focus distance from
 the scale on the lens.

6. To calculate the aperture, you must first determine the
 Guide Number for the flash output level and zoom head
 position. Use the following table (note figures are for a
 sensitivity of ISO 100).

240

Guide Numbers (ISO100, ft/m)

Flash Output	14*	24	28	35	50	70	85
1/1	45.9/14	85.3/26	91.9/28	98.4/30	118.1/36	124.7/38	131.2/40
1/2	32.5/9.9	60.4/18.4	65/19.8	69.6/21.2	83.7/25.5	88.3/26.9	92.8/28.3
1/4	23/7.0	42.7/13	45.9/14	49.2/15	59.1/18	62.3/19	65.6/20
1/8	16.1/4.9	30.2/9.2	32.5/9.9	34.8/10.6	41.7/12.7	44/13.4	46.3/14.1
1/16	11.5/3.5	21.3/6.5	23/7.0	24.6/7.5	29.5/9.0	31.2/9.5	32.8/10
1/32	8.2/2.5	15.1/4.6	16.1/4.9	17.4/5.3	21/6.4	22/6.7	23.3/7.1
1/64	5.9/1.8	10.8/3.3	11.5/3.5	12.5/3.8	14.8/4.5	15.7/4.8	16.4/5.0

** With the wide-flash adapter in place.*

ISO Sensitivity Factor

For sensitivities other than ISO100, multiply the guide number by the factors in the following table.

ISO	25	50	100	200	400	800	1600
Factor	x0.5	x0.71	x1.0	x1.4	x2.0	x2.8	x4.0

7. After determining the Guide Number, you must calculate the lens aperture value. Use the following equation:
 Lens aperture = Guide number x ISO/ Shooting distance.
 Set the calculated aperture value on the camera for appropriate models, or on the lens.

8. When the ready light glows, the flash is ready to be fired.

Note: If you use a non-CPU type lens (e.g. manual focus Ai or Ai-S types), the lens aperture value must be set on the lens. Determine the Guide Number as in step 6 above, and calculate the aperture value (as in step 7 above).

Note: The flash output level is adjusted by pressing ether the ⊕ or ⊖ button. It will change in output from 1/2 to 1/64 in increments of 1/3-stop. These are displayed as either the fraction, or the fraction alongside (+/-1/3EV) or (+/-2/3EV). For example, 1/4 (-0.3) represents a flash output at 1/4 power less 1/3-stop. To set and lock the required value, press the (ZOOM) + (MODE) buttons simultaneously.

Rapid, Continuous Shooting

It is possible to use the SB-600 when shooting a rapid sequence of frames. In TTL and Manual (at an output level of 1/1, and 1/2) flash modes, the Speedlight can output a maximum of fifteen flashes in a single sequence, and when the flash output level is reduced to between 1/4 and 1/64 in Manual flash mode, the SB-600 can output a maximum of thirty flashes in a single sequence. The maximum effective frame rate will be determined by the recycling time of the Speedlight.

Note: The table published in the Nikon SB-600 instruction manual implies that the SB-600 can keep pace with a camera shooting at 6fps, up to the maximum number of frames quoted above, during continuous flash shooting; this is incorrect.

Note: Whenever the SB-600 is used during the shooting of a rapid sequence up to the maximum number of flashes (as quoted above, it is essential to let the Speedlight cool for at least 10 minutes.

When the flash output level is reduced to 1/8 or less, and the SB-600 is used in Manual flash mode, it can sync with a camera cycling at up to 6 frames per second (fps). The maximum number of consecutive frames that can be shot with guaranteed synchronization of the SB-600 at this frame rate is given in the table below.

Maximum Consecutive Frames with Flash Sync at 6 fps Continuous Shooting

Flash Output Level	Number Of Consecutive Frames
1/8	4
1/16	8
1/32	16
1/64	30

Setting Flash Exposure Compensation

1. To set and apply a flash exposure compensation factor in TTL BL and TTL, press either the ⊕ or ⊖ button; the flash output compensation level should begin to blink in the LCD panel.

2. Press either the ⊕ or ⊖ button to adjust the flash exposure compensation factor value in increments of 1/3EV over a range of +3.0 to -3.0EV.

3. Once the required value is displayed, simultaneously press the ⦅ZOOM⦆ + ⦅MODE⦆ buttons to confirm and lock the value.

4. To cancel any flash exposure compensation factor, you must use either the ⊕ or ⊖ button to adjust the value to "0." Turning the SB-600 off will not cancel flash exposure compensation.

Note: Flash exposure compensation does not affect the ambient exposure calculated by the camera.

Note: I recommend that you avoid setting any flash exposure compensation in TTL BL because, with this fully automated, balanced fill-flash option, the camera will apply its own flash exposure compensation, and this value is unknown. Therefore, there is no way of knowing what effect the flash compensation factor you apply will have. This makes obtaining repeatable results impossible. Use **TTL** standard TTL flash so that compensation can be applied to a known flash output level.

Manual Zoom Head Adjustment

1. When used with a Nikkor lens containing a CPU, recent Nikon cameras communicate the lens focal length to the SB-600. This enables the zoom head function of the flash to adjust the position of the flash reflector to match the angle-of-view of the lens (this is the normal configuration of the SB-600). By pressing the (ZOOM) button, the zoom head position can be adjusted manually. To indicate that you are using the manual zoom feature, a small M appears above ZOOM in the LCD panel zoo&M .

2. To cancel the manual zoom head feature, press the (ZOOM) button until the focal length that is displayed matches the focal length set on the lens.

Note: To cancel the automatic zoom head control, use the custom setting menu (see below for details).

Note: If you use the wide-flash adapter, the SB-600 is set to provide coverage equivalent to the angle of view of a 14mm lens (35mm full-frame format). The automatic zoom head function is deactivated and no other zoom head position can be selected.

Custom Setting Menu Functions

Beyond the options displayed in the LCD control panel, the SB-600 has a sub-menu of custom settings, which control a variety of functions.

Set Custom Function

1. Press and hold the (ZOOM) + (−) buttons simultaneously for at least two seconds to display the custom menu options.

2. To scroll through the functions, use either the (+) or (−) button.

3. To choose the required option within each function, press either the (ZOOM) or (MODE).

4. Repeat steps 2 and 3 until all the required settings have been made.

5. To return to the normal LCD display, either press and hold the (ZOOM) + ⊟ buttons simultaneously for at least two seconds, or push the (ON/OFF) button lightly.

Custom Setting Functions / Options

⇨ **Wireless Remote Flash Mode** Sets or cancels the flash for remote wireless control in multiple flash photography (see page 145).

♪ **Audible Warning in Wireless Flash Mode** Sets or cancels the audible confirmation signal for units used in wireless multiple flash set-ups.

rL **Auxiliary ready-light** Activates or cancels this function when the flash is used as a remote unit for wireless multiple flash photography.

AF-ILL and **NO AF-ILL** **Wide-area AF-assist Lamp** Activates or cancels the wide-area AF assist feature.

AUTO ▬ ▬ ▬▬▬ **Standby function** Sets or cancels the Standby function.

- • Auto: If the camera body is TTL compatible, flash standby activates when the camera's exposure meter switches off.
- • —- Standby function is cancelled

Automatic Zoom Head Function Sets or cancels automatic flash zoom head operation.

ZOOM M **14mm** **Zoom Head Position** If Wide-flash Adapter Is Missing If the built-in wide flash adapter is accidentally broken off, use this function to manually adjust the zoom head position.

LCD Panel Illumination Switches the LCD panel illumination ON or OFF.

General Notes – SB-600

- The following functions are set on compatible cameras: FP High-speed sync mode, FV lock, Slow-flash sync, Rear curtain sync, and Red-eye reduction.

- The built-in AF-assist lamp operates automatically, unless the feature has been cancelled on the SB-600, and has an effective range of 3.3 ft (1m) to 33 ft (10m) and covers lenses with a focal length between 24mm and 105mm. The camera's central AF sensor must be used, and the effectiveness of the lamp is reduced at the periphery of the frame area and may vary according to the lens in use.

- Following a flash output, $\overset{\checkmark}{\text{EV}}$ may appear in the top right corner of the LCD panel, along with a numerical value; this is an indication that underexposure may have occurred. The warning is only visible for approximately three seconds after the shutter closes. Press (ZOOM) + (MODE) simultaneously to recall the display. Also, the flash ready symbol in the viewfinder will blink if the exposure may have been insufficient.

CLS Close-up & Remote Flash Photography

The SU-800 Commander and SB-R200 Wireless Remote Speedlight are designed to provide wireless flash control and functionality with cameras and other flash units in the Creative Lighting System.

Nikon describes the functions of the SU-800 as having two distinct roles: to operate the SB-R200 unit(s) in close-up flash photography, and to operate the SB-800, SB-600, and SB-R200 Speedlights as a remote unit(s) in multiple wireless setups. Unlike the other Speedlights described in this book, the SB-R200 does not have a conventional hot shoe foot; it is designed to attach to either the dedicated lens mount ring SX-1 or the AS-20 stand.

These flower petals were shot at extremely close range with a Speedlight SB-R200, controlled with an SU-800.

With Nikon cameras that are not compatible with the Creative Lighting System, limited functionality is possible for close-up flash photography only. This requires connecting the SU-800 and SB-R200 and a maximum of two flash units with SC-30 cord(s). Non-CLS compatible cameras cannot be used with the SU-800, SB-800, SB-600, and SB-R200 Speedlights for remote wireless flash photography.

For compatibility of the SU-800 and SB-R200 with Nikon camera models, refer to the Camera & Speedlight Compatibility section (see page 262). For full information about the individual flash modes and features, how they operate, and the effect they have on a photograph, please refer to the relevant sections, Nikon Flash Nomenclature, Flash Techniques, and Using Your Speedlight. For details on how to set up and use multiple Speedlights for wireless remote flash photography with the SU-800 (see page 169).

SU-800

Specifications:

Power: One 3V CR123A Lithium battery

Transmission range: Approx. 66 ft (20 m) with SB-800/SB-600
Approx. 13 ft (4 m) with SB-R200

Transmission interval: Approx. 1 second

Number of transmissions: 1200

IR wavelength: Approx. 800 – 1000nm

Coverage: 78° horizontal & 60° vertical

Weight: 5.6 oz / 160 g (without battery)

Size: 2.7 x 53.8 x 2.3 inches (68 x 96 x 58 mm) WxHxD

Main features: Uses infrared-pulse emissions to control compatible remote Speedlights for TTL flash exposure control. Capable of controlling up to three different groups of remote Speedlights on four separate channels. Features a auto-focus assist lamp. It has a pair of terminals for the SC-30 TTL flash cord for connection of up to two SB-R200 Speedlights but there is no PC sync or standard TTL cord terminal. There are no options for using an external power source.

The SU-800 Wireless Speedlight Commander can be used to control the CLS cameras and Speedlight accessory flash units in wireless set-ups. It also commands the SB-R200 for its use in close-up photography. Non-CLS compatible equipment cannot be used with the SU-800 for wireless set-ups.

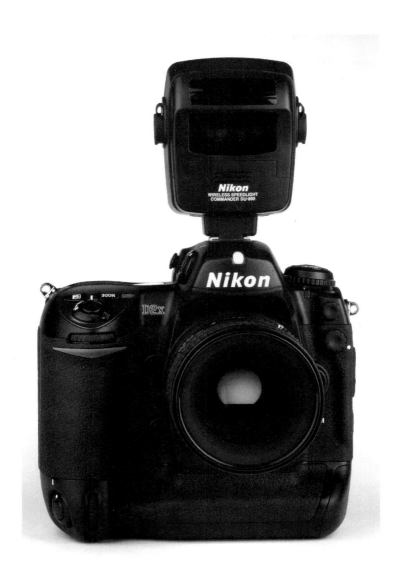

Nikon SB-R200 – Frontview

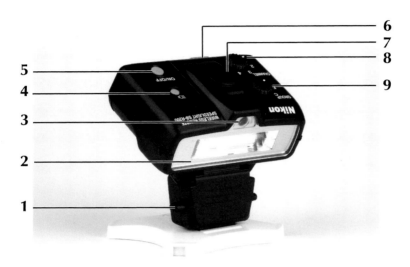

1. *Release button*
2. *Flash head*
3. *AF-assist illuminator*
4. *AF-assist illuminator button*
5. ON/OFF *button*

6. *TTL cord terminal*
7. *Terminal cover*
8. *Channel select dial*
9. *Group select dial*

SB-R200

Specifications:

Guide Number:	33 (ft) 10 (m) (ISO100), 46 (ft) 14 (m) (ISO200)
Power:	One 3V CR123A Lithium battery
Recycle Time:	6 seconds (or less)
Number of flashes:	290 at full 1/1 manual setting
Flash duration:	1/600
Weight:	4.2 oz (120 g) without battery
Size:	3.1 x 3.0 x 2.2 inches (80 x 75 x 55 mm) WxHxD

Nikon SB-R200 – Rearview

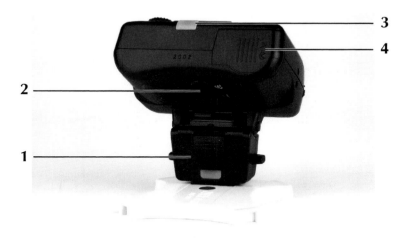

1. Lock switch
2. Sensor for wireless remote flash
3. Ready light
4. Battery lid

Main features: TTL flash control (TTL, D-TTL, and i-TTL) with appropriate cameras, 8 manual power settings (7 for close-up flash), repeating flash, automatic FP High-speed Sync, Rear-curtain sync, modeling lamp (fired from SU-800/camera in close-up mode), target light. Supports wireless control of multiple Speedlights as master or remote unit. Head tilts 60° forward and 45° back around axis. Accepts diffuser dome (SW-11) and filter holder (SZ-1), filter kit (SJ-R200) supplied.

Using Two Groups in Close Up Photography

TTL Operation

This requires an SU-800 attached to a compatible camera (ensure the Commander/Close-up switch in the battery chamber of the SU-800 is set to Close-up) with at least two remote SB-R200 Speedlights, one per group, attached to the SX-1 ring mounted on the lens.

1. Press the (ON/OFF) buttons on the SU-800 and SB-R200 to turn them on; if they are already in Standby mode, press the shutter release button lightly.

2. Confirm that the wireless flash ⇄ , close-up mode ✿ , and CLS-compatible camera 📷 are all displayed in the LCD panel on the SU-800.

3. Press the (MODE) button until TTL appears in the LCD panel of the SU-800.

Note: Nikon's instruction manual does not define how the TTL flash exposure control works in Close-up Flash mode with the SU-800/SB-R200. It can only operate in TTL BL automatic balanced fill flash mode; standard TTL flash exposure control is not possible.

Note: If Automatic High-speed Sync mode is selected on the camera **FP** will appear to the right of TTL. This function is only available on certain cameras such as the D2-series, D200, and F6; it is not available with the D70-series, or the D50.

4. Since flash exposure control is most effective when the camera has acquired focus, set the camera to AF-S (single-servo AF mode).

5. Confirm both Groups A and B are displayed; if not, press the A:B button until they appear.

Note: It is possible to cancel firing of either group A or B by pressing the A:B button. Once cancelled, the group name will no longer be displayed. To have both groups fire, continue to press the A:B button until both groups are indicated.

Note: In Manual (M) exposure mode, the analog exposure display in the camera's viewfinder will continue to show an indication for the ambient light, even with the SU-800/SB-R200 Speedlights attached and switched on.

6. To set the flash output level ratio between the two groups (A & B) press the ⊂SEL⊃ button, the 1:1 ratio will begin to blink. Use ◄ and ► to adjust the ratio (between 1:1 to 1:8 or 8:1). Press the ⊂SEL⊃ button to confirm the required ratio and it will stop blinking.

7. To set flash output level compensation for both groups (A & B), press the ⊂SEL⊃ button. The flash output level compensation value will blink; use the ◄ and ► to adjust this value, which can be set in increments of 1/3EV, between +3.0EV and -3.0EV. Press the ⊂SEL⊃ button to confirm the setting.

8. Press the ⊂SEL⊃ button again to set the channel number. The current option will begin to blink; use the ◄ and ► to change the channel number to the required option. Press the ⊂SEL⊃ button to confirm the required channel number and it will stop blinking.

9. Make sure the same channel number is set on each SB-R200 by turning the channel number dial to the appropriate position.

10. Assign each of the two SB-R200 Speedlights to a particular group (in this instance one would be set to group A and the other to group B). Once the group is set on the SB-R200, by turning the group dial to the appropriate position, each SB-R200 in that group will operate according to the settings input on the SU-800.

11.When the ready lights on the flash units glow red, they are ready to be used.

Note: If the ready lights on the SB-R200 blink immediately after the flash units have fired, it is an indication that the unit operated at maximum output and underexposure may have occurred. (The ready light on the SU-800 and camera will not blink in this situation.) Either adjust the sensitivity (ISO) to a higher value or use a wider lens aperture.

Manual Flash Operation

This requires an SU-800 attached to a compatible camera (make certain the Commander/Close-up switch in the battery chamber of the SU-800 is set to Close-up), with at least two remote SB-R200 Speedlights, one per group, attached to the SX-1 ring mounted on the lens.

1. Press the (ON/OFF) buttons on the SU-800, and SB-R200 to turn them on, or if they are already in Standby mode press the shutter release button lightly.

2. Confirm that the wireless flash ⇆ , close-up mode ❀ , and CLS-compatible camera ⬛ are all displayed in the LCD panel on the SU-800.

3. Press the (MODE) button until M appears in the LCD panel of the SU-800 (Groups A and B will be displayed with an M next to them and the flash output value).

4. Press the (SEL) button to highlight the flash output value for Group A; it will begin to blink. Use the ◀ and ▶ to adjust it. Press the (SEL) button again to confirm the required value and the display for group A will stop blinking; group B will commence blinking. Repeat the procedure to set the required flash output level. Once the value for group B is confirmed, the channel number will commence blinking.

5. Press the ◀ and ▶ to change the channel number to the required setting, and press the ⬡SEL⬡ button again to confirm the selection.

6. When the ready lights glow red on the flash units, they are ready to be fired.

Note: In manual flash output the flash fires at the predetermine level. For close-up flash with the SU-800 and SB-R200 Speedlights this can be set in increments of 1EV, from full output (M1/1) to (M1/64). Each group can be set to a different level to create a lighting ratio between the two groups.

Using Three Groups in Close Up Photography

TTL Operation

This requires an SU-800 attached to a compatible camera (make sure the Commander/Close-up switch in the battery chamber of the SU-800 is set to Close-up) and at least three remote SB-R200 Speedlights, one per group, attached to the SX-1 ring mounted on the lens.

1. Press the ⬡ON/OFF⬡ buttons on the SU-800, and SB-R200 to turn them on; if they are already in Standby mode, press the shutter release button lightly.

2. Confirm that the wireless flash ⇄ , close-up mode ✿ , and CLS-compatible camera ⬆ are all displayed in the LCD panel on the SU-800.

3. Press the ⬡MODE⬡ button until TTL appears in the LCD panel of the SU-800.

Note: Nikon's instruction manual does not define how the TTL flash exposure control works in Close-up Flash mode with the SU-800 / SB-R200; in fact it can only operate in TTL BL automatic balanced fill flash mode; standard TTL flash exposure control is not possible.

Note: If Automatic High-speed sync mode is selected on the camera the **FP** will appear to the right of TTL. This function is only available on certain cameras such as, the D2-series, D200, and F6; it is not available on the D70-series, or the D50.

4. Press and hold the ⊂SEL⊃ button for approximately two seconds until the third group, C, appears along the bottom of the LCD display of the SU-800.

5. Since flash exposure control is most effective when the camera has acquired focus, I recommend you set the camera to AF-S (single-servo AF mode).

6. Confirm that both Groups A and B are displayed; if not, press the A:B button until they appear.

Note: To cancel firing of either group A or B, press the A:B button until the cancelled group's name is no longer displayed. To fire both groups, continue to press the A:B button until both groups are shown.

Note: In Manual (M) exposure mode the analog exposure display in the camera's viewfinder will continue to show an indication for the ambient light, despite the SU-800/SB-R200 Speedlights being attached and switched on.

7. To set the flash output level ratio between the two groups (A & B) press the ⊂SEL⊃ button; the 1:1 ratio will begin to blink, use ◀ and ▶ to adjust the ratio (ratios between 1:1 to 1:8 or 8:1 are available). Press the ⊂SEL⊃ button to confirm the required ratio and it will stop blinking.

8. To set the flash output level compensation for both groups (A & B) press the ⊂SEL⊃ button. The flash output level compensation value will begin to blink; use the ◀ and ▶ to adjust the flash compensation level (values between +3.0EV and -3.0EV can be set in increments of 1/3EV). Press the ⊂SEL⊃ button to confirm the required flash compensation ratio and the value will stop blinking.

9. The manual flash output level for group C will begin to blink; if it does not blink, press the ⊂SEL⊃ button until it does. To adjust the flash output value for group C, use the ◀ and ▶ ; the value can be set in increments or decrements of 1EV from full output (M1/1) to (M1/64). Press the ⊂SEL⊃ button again to confirm the required value and the display for group C will stop blinking

10. Press the ⊂SEL⊃ button again to set the channel number. The current option will begin to blink. Use the ◀ and ▶ to change the channel number to the required option. Press the ⊂SEL⊃ button to confirm the required channel number and it will stop blinking.

11. Set each of the SB-R200 Speedlights to a particular group (in this instance one would be set to each group A, B, and C). Once the group is set on the SB-R200, by turning the group dial to the appropriate position, each SB-R200 in that group will operate according to the settings made for it on the SU-800.

12. When their ready lights glow red, the flash units they are ready to be fired.

Note: If the ready lights on the SB-R200 blink immediately after the flash units have fired, this is an indication that they operated at their maximum output and underexposure may have occurred (the ready light on the SU-800 and camera will not blink in this situation). Either adjust the sensitivity (ISO) to a higher value, or use a wider lens aperture.

Manual Flash Photography

This uses an SU-800 attached to a compatible camera and at least three remote SB-R200 Speedlights, one per group, attached to the SX-1 ring mounted on the lens. The Commander/Close-up switch in the battery chamber of the SU-800 must be set to Close-up.

1. Press the (ON/OFF) buttons on the SU-800, and SB-R200 to turn them on, or if they are already in Standby mode press the shutter release button lightly.

2. Confirm that the wireless flash ⇆ , close-up mode ✿ , and CLS-compatible camera ◌ are all displayed in the LCD panel on the SU-800.

3. Press the (MODE) button until M appears in the LCD panel of the SU-800 (Groups A and B will be displayed with an M next to them and the flash output value).

4. Press and hold the (SEL) button for approx. two seconds until the third group, C, appears along the bottom of the LCD display of the SU-800.

5. Press the (SEL) button to highlight the flash output value for group A; it will begin to blink. Use the ◀ and ▶ to adjust it. When you press the (SEL) button again to confirm this value. the display for group A will stop blinking and group B will start blinking. Repeat the procedure to set the flash output level for groups B and C. Once the value for group C is confirmed, the channel number will begin blinking.

6. Press the ◀ and ▶ to change the channel number to the required setting, and press the (SEL) button again to confirm the selection.

7. When their ready lights glow red, the flash units they are ready to be fired.

258

Note: In manual flash, the flash fires at the predetermined level. For close-up flash, the SU-800 and SB-R200 Speedlights can be set in increments of 1EV from full output (M1/1) to M1/64. Each group can be set to a different level to create a lighting ratio between the groups.

Rapid, Continuous Shooting

It is possible to use the SB-R200 when shooting a rapid sequence of frames. In TTL and Manual (at an output level of 1/1, and 1/2) flash modes, the Speedlight can output a maximum of fifteen flashes in a single sequence, and when the flash output level is reduced to between 1/4 and 1/64 in Manual flash mode the SB-R200 can output a maximum of thirty flashes in a single sequence. The maximum effective frame rate will be determined by the recycling time of the Speedlight.

Note: The table published in the Nikon manual implies that the SB-R200 can keep pace with a camera cycling at 6 frames per second (fps), up to the maximum number of frames quoted above for continuous flash shooting. This is incorrect.

Note: Whenever the SB-R200 is used in shooting of a rapid sequence up to the maximum number of flashes (as quoted above), it is essential to let the Speedlight cool for at least 10 minutes.

When the flash output level is reduced to 1/8 or less, and the SB-R200 is used in Manual flash mode, it can sync with a camera cycling at up to 6 fps. The maximum number of consecutive frames, which can be shot with guaranteed synchronisation of the SB-R200 at this frame rate, is given in the table below.

Maximum Consecutive Frames with Flash Sync at 6 fps Continuous Shooting

Flash Output Level	Number Of Consecutive Frames
1/8	4
1/16	8
1/32	16
1/64	30

Other Functions – Close-up Flash Photography

There are several other extremely innovative functions, which are available when the SU-800/SB-R200 are used in combination for close-up flash photography.

Test Firing

• Two-group close-up – when the test button ⚡ on the SU-800 is pressed, the SB-R200 unit(s) in group A fire at 1/64 manual output, after a delay of approximately one second. This is followed by the firing of the flash unit(s) in group B, after a delay of approximately two seconds.

• Three-group close-up – when the test button ⚡ on the SU-800 is pressed, the SB-R200 unit(s) in group A fire at 1/64 manual output, after a delay of approximately one second. This is followed by the flash unit(s) in group B, after a delay of approximately two seconds, and the unit(s) in group C, after approximately three seconds.

Modeling Illumination in Close-up Mode

Within one second of pressing and releasing the target light button ☰◎ on the SU-800, the modeling illuminator function of the SB-R200 Speedlight(s) will fire a rapid series of pulses at a low output. This is useful for assessing the illumination from the main flash and the position of the shadows it will cast.

Note: Pressing the function button on a compatible camera will also activate this feature; the SB-R200 will emit light pulses for approximately one second.

Note: If the flash is cancelled for a particular group, the modeling illumination function will not operate on with those Speedlight(s).

Focus Assist Lamp

When the target light button ⧉ on the SU-800 is pressed and held for more than one second, the target lamps on all SB-R200 Speedlights will light. The lamps remain lit for sixty seconds before switching off automatically. If you wish to cancel operation of the lamps within the sixty-second period, press and hold the target light button ⧉ for more than one second.

Note: The target light of an SB-R200 can be independently switched on and off by pressing the target light button ⧉ on the flash unit.

Note: A variety of other actions will also cause the target light lamp to switch off. These are: releasing the shutter, test firing the flash, activating the modeling illuminator, activating the FV lock function from the camera, and pressing the ON/OFF button.

Commander Flash Operation

For details of how to set-up and use the SU-800 in Commander Flash mode for wireless control of compatible remote flash units: the SB-800, SB-600, and SB-R200 (see page 169).

Nikon Camera / Nikon SB-28 & SB-28DX Compatibility

i-TTL – Intelligent TTL
D-TTL – Digital TTL
TTL – TTL
BL – Balanced Fill-flash (displayed with TTL)
AA – Auto Aperture flash
A – Non-TTL Automatic flash
GN – Distance priority flash
M – Manual flash
RPT – Repeating flash

1 – D-TTL D2-series cameras and SB-28DX only
2 – D-TTL SB-28DX only
3 – TTL F6 camera only
4 – TTL M Multi-sensor balanced fill-flash
5 – TTL M Matrix balanced fill-flash
6 – AA D2-series & F6 only with SB-28DX only
7 – RPT is not available with F3-series and AS-17
8 – TTL F6 only, D-SLR M manual flash exposure control only
9 – M manual flash exposure control only

Camera	TTL Automatic Flash Exposure Control				Non-TTL Automatic Flash Exposure Control		Manual Flash Exposure Control			Wireless Multiple Flash Exposure Control	
	i-TTL	D-TTL	TTL	BL	AA	A	GN	M	RPT	Advanced Wireless Lighting	SU-4 TTL Controller
D2-series, D200, D70-series, D50, F6		•[1]	•[3]	•[4]	•[5]	•		•	•		•[8]
D1-series, D100		•[2]		•[4]		•		•	•		•[9]
F5, F100, F90s/F90x, N90/F90-series, N80/F80-series, N75/F75-series, N70/F70-series			•	•[4]		•		•	•	•	
F4-series, N65/F65-series, N8008s/F801s, N8008/F801			•	•[5]		•		•	•	•	
N6006/F601, N6000/F601M			•	•[5]		•		•	•	•	
N60/F60-series, N50/F50-series, N5005/F401			•	•[5]		•		•	•	•	
N2020/F501, N4004s/F401s, N4004/F401, N2000/F301			•			•		•	•	•	
FM3A, FA, FE2, FG, F3-series (with AS-17), Nikonos V			•					•	•[7]	•	
FM2N, FM10, FE10, F3-series, N55/F55-series						•		•	•		•[9]

262

Nikon Camera / Nikon SB-80DX Compatibility

Legend

- **i-TTL** – Intelligent TTL
- **D-TTL** – Digital TTL
- **TTL** – TTL
- **BL** – Balanced Fill-flash (displayed with **TTL**)
- **AA** – Auto Aperture flash
- **A** – Non-TTL Automatic flash
- **GN** – Distance priority flash
- **M** – Manual flash
- **RPT** – Repeating flash

1 – **D-TTL** D2-series cameras only
2 – **TTL** F6 camera only
3 – **BL** Multi-sensor balanced fill-flash
4 – Matrix balanced fill-flash
5 – **AA** D2-series and F6 cameras only
6 – **RPT** is not available with F3-series and AS-17
7 – **TTL** F6 only, D-SLR **M** manual flash exposure control only
8 – **M** manual flash exposure control only

Camera	TTL Automatic Flash Exposure Control				Non-TTL Automatic Flash Exposure Control		Manual Flash Exposure Control			Wireless Multiple Flash Exposure Control	
	i-TTL	D-TTL	TTL	BL	AA	A	GN	M	RPT	Advanced Wireless Lighting	SU-4 TTL Controller
D2-series, D200, D70-series, D50, F6	•	•[1]	•[2]		•[5]	•		•	•		•[7]
D1-series, D100		•				•		•	•		•[8]
F5, F100, F90s/F90x, N90/F90-series, N80/F80-series, N75/F75-series, N70/F70-series			•	•[3]		•		•	•		•
F4-series, N65/F65-series, N8008s/F801s, N8008/F801			•	•[3]		•		•	•		•
N6006/F601, N6000/F601M			•	•[4]		•		•	•		•
N60/F60-series, N50/F50-series, N5005/F401			•	•[4]		•		•	•		•
N2020/F501, N4004s/F401s, N4004/F401, N2000/F301			•			•		•	•		•
FM3A, FA, FE2, FG, F3-series (with AS-17), Nikonos V						•		•	•[6]		•
FM2N, FM10, FE10, F3-series, N55/F55-series						•		•	•		•

263

Nikon Camera / Nikon SB-600 Compatibility

i-TTL – Intelligent TTL
D-TTL – Digital TTL
TTL – TTL
BL – Balanced Fill-flash (displayed with **TTL**)
AA – Auto Aperture flash
A – Non-TTL Automatic flash
GN – Distance priority flash
M – Manual flash
RPT – Repeating flash

1 – Only as a remote unit in Advanced Wireless Lighting system
2 – **BL** is not displayed when performing balanced fill flash

Camera	TTL Automatic Flash Exposure Control				Non-TTL Automatic Flash Exposure Control		Manual Flash Exposure Control			Wireless Multiple Flash Exposure Control	
	i-TTL	D-TTL	TTL	BL	AA	A	GN	M	RPT	Advanced Wireless Lighting	SU-4 TTL Controller
D2-series, D200, D70-series, D50, F6	•			•				•		•[1]	
D1-series, D100		•		•				•			
F5, F100, F90s/F90x, N90/F90-series, N80/F80-series, N75/F75-series, N70/F70-series			•	•				•			
F4-series, N65/F65-series, N8008s/F801s, N8008/F801			•	•				•			
N6006/F601, N6000/F601M			•	•²				•			
N60/F60-series, N50/F50-series, N5005/F401			•	•²				•			
N2020/F501, N4004s/F401s, N4004/F401, N2000/F301			•					•			
FM3A, FA, FE2, FG, F3-series (with AS-17), Nikonos V								•			
FM2N, FM10, FE10, F3-series, N55/F55-series											

i-TTL – Intelligent TTL
D-TTL – Digital TTL
TTL – TTL
BL – Balanced Fill-flash (displayed with **TTL**)
AA – Auto Aperture flash
A – Non-TTL Automatic flash
GN – Distance priority flash
M – Manual flash
RPT – Repeating flash

1 – Only as a remote unit in Advanced Wireless Lighting system
2 – **BL** is not displayed when performing balanced fill flash

Nikon Camera / Nikon SB-28 & SB-28DX Compatibility

Camera	TTL Automatic Flash Exposure Control				Non-TTL Automatic Flash Exposure Control		Manual Flash Exposure Control			Wireless Multiple Flash Exposure Control	
	i-TTL	D-TTL	TTL	BL	AA	A	GN	M	RPT	Advanced Wireless Lighting	SU-4 TTL Controller
D2-series, D200	•									•	•¹
D70-series, D50, F6	•										•¹
D1-series, D100		•									
F5, F100, F90s/F90x, N90/F90-series, N80/F80-series, N75/F75-series, N70/F70-series			•	•	•	•	•	•	•		•
F4-series, N65/F65-series, N8008s/F801s, N8008/F801			•	•	•	•	•	•	•		•
N6006/F601, N6000/F601M			•	•		•	•²	•	•		•
N60/F60-series, N50/F50-series, N5005/F401			•	•³		•	•	•	•		•
N2020/F501, N4004s/F401s, N4004/F401, N2000/F301			•	•³		•	•	•	•		•
FM3A, FA, FE2, FG, F3-series (with AS-17), Nikonos V			•		•	•	•	•	•⁴		•
FM2N, FM10, FE10, F3-series, N55/F55-series						•	•	•	•		•⁵

Feature Comparison

The following table sets out the major specifications of the Nikon Speedlights covered by this book.

	SB-28	SB-28DX	SB-80DX	SB-600	SB-800	SB-10-R200
GN ft/m (ISO100)	118/36 @35mm	118/36 @35mm	125/38 @35mm	98/30 @35mm	125/38 @35mm	33 @24mm
GN ft/m (ISO200)	167/51 @35mm	167/51 @35mm	174/53 @35mm	138/42 @35mm	174/53 @35mm	46/14 @24mm
Recycle Time (sec)	6.5	6.5	6	3.5	6 (4 with SD-800)	6
Duration (maximum)	1/830	1/830	1/1050	1/900	1/1050	1/600
Coverage (automatic)	24, 28, 35, 50, 70, 85mm	24, 28, 35, 50, 70, 85mm	24-105mm (5mm steps from 35mm)	24, 28, 35, 50, 70 85mm	24-105mm (5mm steps from 35mm)	Fixed reflector
Coverage (manual)	18, 20mm	18, 20mm	14, 17mm	14mm	14, 17mm	24mm
Flash head tilts	Yes	Yes	Yes	Yes	Yes	Yes
Flash head rotates	Yes	Yes	Yes	Yes	Yes	Yes (around lens)
TTL	Yes	Yes	Yes	Yes	Yes	Yes
D-TTL	No	Yes	Yes	Yes	Yes	Yes
i-TTL	No	No	No	Yes	Yes	Yes
(AA) Auto Aperture	Yes	Yes	Yes	No	Yes	No
(A) Non-TTL Auto flash	Yes	Yes	Yes	No	Yes	No
Manual flash	Yes (7 levels)	Yes (7 levels)	Yes (8 levels)	Yes (7 levels)	Yes (8 levels)	Yes
FP High-speed sync	Yes (Manual only - film and D-SLR cameras)	Yes (Manual only - film and D-SLR cameras)	Yes (Manual only - film and D-SLR cameras)	Yes (Automatic for cameras that support CLS)	Yes same as SB-600	Yes same as SB-600
Repeating flash	Yes	Yes	Yes	No	Yes	No
Flash Value lock	No	No	No	Yes	Yes	Yes
Flash Colour Info	No	No	No	Yes	Yes	Yes
Wireless (TTL flash)	35mm film cameras only	35mm film cameras only	35mm film cameras only	CLS - SLR (Only as remote flash)	CLS - SLR	CLS - SLR (Only as remote flash)
(Wireless (manual flash)	No	No	Digital and 35mm	Digital and 35mm	Digital and 35mm	Yes
Multiple flash TTL with leads	35mm film cameras only	35mm film cameras only	35mm film cameras only	35mm film cameras only	35mm film cameras only	35mm film cameras only (requires SC-30 cord)

Guide Numbers (GN) have been quoted for a sensitivity of ISO 200 since this represents the base sensitivity level for the D2Hs, D2H, D1H, D100, D70 and D50 cameras.

	SB-28	SB-28DX	SB-80DX	SB-600	SB-800	SB/10-R200
AF-assist lamp	Yes	Yes	Yes	Yes	Yes	Yes (requires SU-800, or SB-800)
AF-assist with SC-29	No	No	No	Yes	Yes	No
Modelling light	No	No	Yes	No	Yes	Yes (LED focus light)
PC sync terminal	Yes	Yes	Yes	No	Yes	No
TTL lead terminal	Yes	Yes	Yes	No	Yes	Yes (SC-30)
LCD screen	Yes	Yes	Yes	Yes	Yes	No
Foot lock type	Screw	Screw	Lever	Lever	Lever	Clips to SX-1 Ring, or AS-20 Stand
Power	4x (LR6 / AA)	4x (LR6 / AA)	4x (LR6 / AA)	4x (LR6 / AA)	4x, or 5x (LR6 / AA)	1x CR-123A
External power	Yes	Yes	Yes	No	Yes	No
Weight (g / oz)	335 / 11.8	335 / 11.8	335 / 11.8	300 / 10.6	350 / 12.3	120 / 4.2
Supplied Accessories	SS-28 soft case	SS-28 soft case	Supplied: SW-10H diffusion dome, and SS-80 soft case	Supplied: AS-19 stand, and SS-600 soft case	Supplied: SD-800 Battery pack, SW-10H diffusion dome, AS-19 stand, SJ-800 filter set, and SS-800 soft case	AS-20 stand, SJ-R200 filter set, SZ-1 filter holder, and SS-R200 soft case
Comment	Wireless TTL requires SU-4	Wireless TTL requires SU-4	Wireless TTL with built-in slave cell	Multiple TTL flash with leads requires AS-10		Requires SU-800, SB-800, or built-in Speedlight of D200, D70/70s as Commander Unit for wireless TTL flash. SB-R200 cannot be attached to standard ISO - type accessory shoe

Resources

A number of manufacturers and suppliers provide equipment to complement and enhance the performance of Nikon camera and flash equipment.

Chimera Lighting—manufactures lighting accessories, including a softbox for portable flash units — http://www.chimeralighting.com

Gitzo—manufactures tripods and monopods — http://www.gitzo.com

Gossen—manufactures light meters for measuring ambient and flash light — http://www.gossen-photo.de/english/

Kirk Enterprises—manufactures camera and flash accessories, including flash brackets — http://www.kirkphoto.com

Lark Books—publishes Magic Lantern Guides books and DVDs on Nikon equipment, plus other books on digital photography techniques and software— http://www.lark-books.com

Lastolite—manufactures lighting accessories for portable flash units, as well as reflectors, diffusers and other light modifying devices — http://www.lastolite.com

Lee Filters— manufactures both lens and lighting filters — http://www.leefilters.com

LumiQuest—manufactures light modifying accessories, such as reflectors, diffusers, soft boxes, etc. — http://www.lumiquest.com

Manfrotto—manufactures tripods, lighting stands, and flash support accessories — http://www.manfrotto.com

Novoflex—manufactures lighting and camera accessories, including flash brackets — http://www.novoflex.de

Really Right Stuff—manufactures camera, flash, close-up, and panoramic photography accessories — http://www.reallyrightstuff.com

Sto-fen— manufactures light modifiers for portable flash units — http://www.stofen.com

Stroboframe— manufactures flash brackets and accessories — http://www.tiffen.com

Glossary

A
See Aperture-Priority mode.

AA
Auto aperture. Refers to a Nikon flash mode in which the flash level is automatically adjusted for aperture.

aberration
An optical flaw in a lens that causes the image to be distorted or unclear.

Adobe Photoshop
Professional-level image-processing software with extremely powerful filter and color-correction tools. It offers features for photography, graphic design, web design, and video.

Adobe Photoshop Elements
Designed for the amateur photographer, the Elements program lacks some of the more sophisticated controls available in Photoshop, but it does have a comprehensive range of image-manipulation options, such as: cropping, exposure and contrast controls, color correction, layers, adjustment layers, panoramic stitching, and more.

AE
See automatic exposure.

AF
See automatic focus.

AF-D
AF Nikkor lenses that communicate the distance of the focused subject to a compatible camera body in order to improve the accuracy of exposure calculations for both ambient light and flash. (AF-G, AF-I, and AF-S lenses also perform this function.) AF-D lenses are focused by a motor mounted in the camera body.

AF-G
AF Nikkor lenses that lack a conventional aperture ring. They are only compatible with those cameras that permit the aperture to be set from the camera body.

AF-I
The first series of AF Nikkor lenses to have an internal focusing motor.

AF-S
AF Nikkor lenses that use a silent wave focusing motor mounted within the lens. The technology used in AF-S lenses permits faster and more responsive automatic focusing as compared to the AF-I and AF-D lenses.

AI
Automatic Indexing

AI-S
Nikon F-mount lens bayonet for manual focus Nikkor lenses. They have a small notch milled out of the bayonet ring.

algorithm
A sequence of steps, often complex, used to solve a problem, or in the case of a camera and flash process data to perform exposure measurement calculations.

ambient light
See available light

angle of view
The area seen by a lens, usually measured in degrees across the diagonal of the film frame.

anti-aliasing
A technique that reduces or eliminates the jagged appearance of lines or edges in an image.

aperture
The opening in the lens that allows light to enter the camera. Aperture is usually described as an f/number. The higher the f/number, the smaller the aperture; the lower the f/number, the larger the aperture.

Aperture-Priority mode
A type of automatic exposure in which you manually select the aperture and the camera automatically selects the shutter speed.

artifact
Information that is not part of the scene but appears in the image due to technology. Artifacts can occur in film or digital images and include increased grain, flare, static marks, color flaws, etc.

artificial light
Usually refers to any light source that doesn't exist in nature, such as incandescent, fluorescent, and other manufactured lighting.

astigmatism
An optical defect that occurs when an off-axis point is brought to focus as sagittal and tangential lines rather than a point.

Auto Aperture (AA) flash
An enhanced form of non-TTL Auto Flash (see below) that takes in to consideration additional information transmitted from the camera and lens, including the ISO sensitivity, aperture, focal length, and exposure compensation factor.

automatic exposure
When the camera measures light and makes the adjustments necessary to create proper image density on sensitized medium.

automatic flash
An electronic flash unit that reads light reflected off a subject (from either a pre-flash or the actual flash exposure), then shuts itself off as soon as ample light has reached the sensitized medium.

automatic focus
When the camera automatically adjusts the lens elements to sharply render the subject.

available light
The amount of illumination at a given location that applies to natural and artificial light sources but not those supplied specifically for photography. It is also called existing light or ambient light.

backlight
Light that projects toward the camera from behind the subject.

backup
A copy of a file or program made to ensure that, if the original is lost or damaged, the necessary information is still intact.

barrel distortion
A defect in the lens that makes straight lines curve outward away from the middle of the image.

bit
Binary digit. This is the basic unit of binary computation. See also, byte.

bit depth
The number of bits per pixel that determines the number of colors the image can display. Eight bits per pixel is the minimum requirement for a photo-quality color image.

BL flash mode
The Automatic Balanced Fill-Flash mode for the SB-800 or SB-600 Speedlights; the BL icon always appears next to the TTL icon in the LCD panel of the Speedlight.

bounce flash
The technique of using a nearby surface to bounce the light from a flash unit on to the subject to help reduce contrast and shadows.

bounce light
Light that reflects off of another surface before illuminating the subject.

brightness
A subjective measure of illumination. See also, luminance.

buffer
Temporarily stores data so that other programs, on the camera or the computer, can continue to run while data is in transition.

built-in flash
A flash that is permanently attached to the camera body. The built-in flash will pop up and fire in low-light situations when using the camera's automated exposure settings.

built-in meter
A light measuring device that is incorporated into the camera body.

bulb
A camera setting that allows the shutter to stay open as long as the shutter release is depressed.

byte
A single group of eight bits that is processed as one unit. See also, bit.

card reader
Device that connects to your computer and enables quick and easy download of images from memory card to computer.

CCD
Charge Coupled Device. This is a digital camera sensor that is sensitized by applying an electrical charge to the sensor prior to its exposure to light. It converts light energy into an electrical pulse.

chromatic aberration
Occurs when light rays of different colors are focused on different planes, causing colored halos around objects in the image.

chrominance
Hue and saturation information.

chrominance noise
A form of artifact that appears as a random scattering of densely packed

colored "grain." See also, luminance and noise.

close-up
A general term used to describe an image created by closely focusing on as subject. Often involves the use of special lenses or extension tubes. Also, an automated exposure setting (not available with all cameras).

CLS
Creative Lighting System. This is a flash control system that Nikon introduced with its SB-800 and SB-600 Speedlights, See also, Speedlight.

CMOS
Complementary Metal Oxide Semiconductor. Like CCD sensors, this sensor type converts light into an electrical impulse. CMOS sensors are similar to CCD's, but allow individual processing of pixels, are less expensive to produce, and use less power. See also, CCD.

CMYK mode
Cyan, magenta, yellow, and black. This mode is typically used in image-editing applications when preparing an image for printing.

color balance
The average overall color in a reproduced image. How a digital camera interprets the color of light in a scene so that white or neutral gray appear neutral.

color cast
A colored hue over the image often caused by improper lighting or incorrect white balance settings. Can be produced intentionally for creative effect.

color space
A mapped relationship between
colors and computer data about
the colors.

CompactFlash (CF) card
One of the most widely used removable memory cards.

complementary colors
In theory: any two colors of light that, when combined, emit all known light wavelengths, resulting in white light. Also, it can be any pair of dye colors that absorb
all known wavelengths, resulting
in black.

compression
Method of reducing file size through removal of redundant data, as with the JPEG file format.

contrast
The difference between two or more tones in terms of luminance, density, or darkness.

contrast filter
A colored filter that lightens or darkens the monotone representation of a colored area or object in a black-and-white photograph.

CPU
Central Processing Unit. This is the "brains" of a computer or a lens that perform principle computational functions.

critical focus
The most sharply focused plane within an image.

cropping
The process of extracting a portion of the image area. If this portion of the image is enlarged, resolution is subsequently lowered.

dedicated flash
An electronic flash unit that talks with the camera, communicating things such as flash illumination, lens focal length, subject distance, and sometimes flash status.

default
Refers to various factory-set attributes or features, in this case of a camera, that can be changed by the user but can, as desired, be reset to the original factory settings.

depth of field
The image space in front of and behind the plane of focus that appears acceptable sharp in the photograph.

diaphragm
A mechanism that determines the size of the lens opening that allows light to pass into the camera when taking a photo.

diffusion dome/panel
A light modifying attachment that fits over the flash tube of a Nikon Speedlight to diffuse its light output.

digital zoom
The cropping of the image at the sensor to create the effect of a telephoto zoom lens. The camera interpolates the image to the original resolution. However, the result is not as sharp as an image created with an optical zoom lens because the cropping of the image reduced the available sensor resolution.

diopter
A measurement of the refractive power of a lens. Also, it may be a supplementary lens that is defined by its focal length and power of magnification.

direct flash
The technique of using light direct from the flash to light the subject; it produces a harsh form of light with pronounced, deep shadows

download
The transfer of data from one device to another, such as from camera to computer or computer to printer.

dpi
Dots per inch. Used to define the resolution of a printer, this term refers to the number of dots of ink that a printer can lay down in an inch.

DPOF
Digital Print Order Format. A feature that enables the camera to supply data about the printing order of image files and the supplementary data contained within them. This feature can only be used in conjunction with a DPOF compatible printer.

D-TTL
A flash control system that relies on a series of pre-flashes to determine the output required from a Nikon Speedlight. The system does not monitor the flash output during the actual exposure. See also, Speedlight.

D-type Nikkor
A series of lenses that have a built-in CPU that is used to communicate the focus distance information to the camera body, improving the accuracy of exposure measurement.

DX
Nikkor lenses designed specifically for the Nikon DX format sensor.

dye sublimation printer
Creates color on the printed page by vaporizing inks that then solidify on the page.

ED glass
Extra-low Dispersion glass.
Developed by Nikon, this
glass was incorporated into
many of their camera lenses
to reduce the effects of
chromatic aberration. See
also, chromatic aberration.

electronic flash
A device with a glass or
plastic tube filled with gas
that, when electrified, cre-
ates an intense flash of
light. Also called a strobe.
Unlike a flash bulb, it is
reusable.

electronic rangefinder
A system that utilizes the
AF technology built into a
camera to provide a visual
confirmation that focus has
been achieved. It can oper-
ate in either manual or AF
modes.

EV
Exposure Value. A number
that quantifies the amount
of light within a scene,
allowing you to determine
the relative combinations of
aperture and shutter speed
to accurately reproduce the
light levels of that exposure.

EXIF
Exchangeable Image File
Format. This format is used
for storing an image file's
interchange information.

exposure
When light enters the cam-
era and reacts with the sen-
sitized medium. The term
can also refer to the
amount of light that strikes
the light sensitive medium.

exposure meter
See light meter

extension tube
A hollow metal ring that
can be fitted between the
camera and the lens. It
increases the distance
between the optical center
of the lens and the sensor
and decreases the minimum
focus distance of the lens.

f/
See f/stop

FAT
File Allocation Table. This is
a method used be com-
puter operating systems to
keep track of files stored on
the hard drive.

file format
The form in which digital
images are stored and
recorded, e.g., JPEG, RAW,
TIFF, etc.

fill-flash
The technique to help
reduce the overall contrast
in a scene, or subject by
mixing light from a flash
unit to the main continuous
ambient light source.

filter
Usually a piece of plastic
or glass used to control
how certain wavelengths of
light are recorded. A filter
absorbs selected wave-
lengths, preventing them
from reaching the light sen-
sitive medium. Also, soft-
ware available in image-
processing computer pro-

grams can produce special
filter effects.

FireWire
A high speed data transfer
standard that allows outly-
ing accessories to be
plugged and unplugged
from the computer while it
is turned on. Some digital
cameras and card readers
use FireWire to connect to
the computer. FireWire
transfers data faster than
USB. See also, Mbps.

firmware
Software that is perma-
nently incorporated into a
hardware chip. All com-
puter-based equipment,
including digital cameras,
use firmware of some kind.

flare
Unwanted light streaks or
rings that appear in the
viewfinder, on the recorded
image, or both. It is caused
by extraneous light entering
the camera during shoot-
ing. Diffuse flare is uni-
formly reflected light that
can lower the contrast of
the image. Zoom lenses are
susceptible to flare because
they are comprised of
many elements. Filters can
also increase flare. Use of a
lens hood can often reduce
this undesirable effect.

f/number
See f/stop.

focal length
When the lens is focused
on infinity, it is the distance
from the optical center of
the lens to the focal plane.

focal plane
The plane on which a lens forms a sharp image. Also, it may be the film plane or sensor plane.

focus
An optimum sharpness or image clarity that occurs when a lens creates a sharp image by converging light rays to specific points at the focal plane. The word also refers to the act of adjusting the lens to achieve optimal image sharpness.

FP high-speed sync
Focal Plane high-speed sync. Some digital cameras emulate high shutter speeds be switching the camera sensor on and off rather than moving the shutter blades or curtains that cover it. This allows flash units to be synchronized at shutter speeds higher than the standard sync speed. In this flash mode, the level of flash output is reduced and, consequently, the shooting range is reduced.

f/stop
The size of the aperture or diaphragm opening of a lens, also referred to as f/number or stop. The term stands for the ratio of the focal length (f) of the lens to the width of its aperture opening. (f/1.4 = wide opening and f/22 = narrow opening.) Each stop up (lower f/number) doubles the amount of light reaching the sensitized medium. Each stop down (higher f/number) halves the

amount of light reaching the sensitized medium.

full-frame
The maximum area covered by the sensitized medium.

full-sized sensor
A sensor in a digital camera that has the same dimensions as a 35mm film frame (24 x 36 mm).

FV (Flash Value) Lock
A feature for Nikon cameras compatible with the CLS that allows the user to lock a particular flash output value even if the aperture, composition, or focal length is altered.

GB
See gigabyte.

gigabyte
Just over one billion bytes.

GN
See guide number.

GN flash mode
A form of manual flash exposure control that automatically controls the light output from a compatible Speedlight according to the shooting range set even if the lens aperture is adjusted.

gray card
A card used to take accurate exposure readings. It typically has a white side that reflects 90% of the light and a gray side that reflects 18%.

gray scale
A successive series of tones ranging between black and white, which have no color.

Guide Number
A number used to quantify the output of a flash unit. It is derived by using this formula: GN = aperture x distance. Guide numbers are expressed for a given ISO film speed in either feet or meters.

hard drive
A contained storage unit made up of magnetically sensitive disks.

histogram
A graphic representation of image tones.

hot shoe
An electronically connected flash mount on the camera body. It enables direct communication between the camera and an external flash, and synchronizes the shutter release with the firing of the flash.

icon
A symbol used to represent a file, function, or program.

IF
Internal Focusing. This Nikkor lens system shifts a group of elements within the lens to acquire focus more quickly without changing the overall length

of the lens (as occurs with conventional, helical focusing mechanisms).

image-processing program
Software that allows for image alteration and enhancement.

infinity
In photographic terms, the theoretical most distant point of focus.

interpolation
Process used to increase image resolution by creating new pixels based on existing pixels. The software intelligently looks at existing pixels and creates new pixels to fill the gaps and achieve a higher resolution.

Inverse Square Law
In terms of the output from a Speedlight it defines the amount of light fall-off, and is equal to the reciprocal of the square of the distance between the flash and the subject.

infrared (IR) light
A section at the red end of the spectrum where the light has a particular range of wavelengths that cannot be perceived by the human eye, or recorded by normal daylight balanced film, or the sensor in a digital camera.

IR
See Infrared light.

IS
Image Stabilization. This is a technology that reduces camera shake and vibration. It is used in lenses, binoculars, camcorders, etc.

ISO
From ISOS (Greek for equal), a term for industry standards from the International Organization for Standardization. When an ISO number is applied to film, it indicates the relative light sensitivity of the recording medium. Digital sensors use film ISO equivalents, which are based on enhancing the data stream or boosting the signal.

i-TTL
A Nikon TTL flash control system that has a refined monitor pre-flash sequence and offers improved flash exposure control. See also, TTL.

JFET
Junction Field Effect Transistor, which are used in digital cameras to reduce the total number of transistors and minimize noise.

JPEG
Joint Photographic Experts Group. This is a lossy compression file format that works with any computer and photo software. JPEG examines an image for redundant information and then removes it. It is a variable compression format

because the amount of left-over data depends on the detail in the photo and the amount of compression. At low compression/high quality, the loss of data has a negligible effect on the photo. However, JPEG should not be used as a working format – the file should be reopened and saved in a format such as TIFF, which does not compress the image.

KB
See kilobyte.

kilobyte
Just over one thousand bytes.

latitude
The acceptable range of exposure (from under to over) determined by observed loss of image quality.

LBCAST
Lateral Buried Charge Accumulator and Sensing Transistor array. This is an array that converts received light into a digital signal, attaching an amplification circuit to each pixel of the imaging sensor.

LCD
Liquid Crystal Display, which is a flat screen with two clear polarizing sheets on either side of a liquid crystal solution. When activated by an electric cur-

rent, the LCD causes the crystals to either pass through or block light in order to create a colored image display.

LED
Light Emitting Diode. It is a signal often employed as an indicator on cameras as well as on other electronic equipment.

lens
A piece of optical glass on the front of a camera that has been precisely calibrated to allow focus.

lens hood
Also called a lens shade. This is a short tube that can be attached to the front of a lens to reduce flare. It keeps undesirable light from reaching the front of the lens and also protects the front of the lens.

lens shade
See lens hood.

light meter
Also called an exposure meter, it is a device that measures light levels and calculates the correct aperture and shutter speed.

lithium-ion
A popular battery technology (sometimes abbreviated Li-ion) that is not prone to the effects of nickel-cadmium (Ni-Cd) batteries, or the low temperature performance problems of alkaline batteries.

long lens
See telephoto lens.

lossless
Image compression in which no data is lost.

lossy
Image compression in which data is lost and, thereby, image quality is lessened. This means that the greater the compression, the lesser the image quality.

low-pass filter
A filter designed to remove elements of an image that correspond to high-frequency data, such as sharp edges and fine detail, to reduce the effect of moiré. See also, moiré.

luminance
A term used to describe directional brightness. It can also be used as luminance noise, which is a form of noise that appears as a sprinkling of black "grain." See also, chrominance, and noise.

M
See Manual exposure mode.

Mac
Macintosh. This is the brand name for computers produced by Apple Computer, Inc.

macro lens
A lens designed to be at top sharpness over a flat field

when focused at close distances and reproduction ratios up to 1:1.

macro photography
A generic term that describes the photography of subjects at a magnification up to a reproduction ratio of 1:1 (life size)

main light
The primary or dominant light source. It influences texture, volume, and shadows.

Manual exposure mode
A camera operating mode that requires the user to determine and set both the aperture and shutter speed. This is the opposite of automatic exposure.

manual flash
A form of flash exposure control; the Speedlight emits a fixed level of light. It is useful in situations where it is not possible to rely on the automatic control of flash output.

MB
See megabyte.

Mbps
Megabits per second. This unit is used to describe the rate of data transfer. See also, megabit.

megabit
One million bits of data. See also, bit.

megabyte
Just over one million bytes.

megapixel
A million pixels.

memory
The storage capacity of a hard drive or other recording media.

memory card
A solid state removable storage medium used in digital devices. They can store still images, moving images, or sound, as well as related file data. There are several different types, including CompactFlash, SmartMedia, and xD, or Sony's proprietary Memory Stick, to name a few. Individual card capacity is limited by available storage as well as by the size of the recorded data (determined by factors such as image resolution and file format). See also, CompactFlash (CF) card, file format.

menu
A listing of features, functions, or options displayed on a screen that can be selected and activated by the user.

microdrive
A removable storage medium with moving parts. They are miniature hard drives based on the dimensions of a CompactFlash Type II card. Microdrives are more susceptible to the effects of impact, high altitude, and low temperature than solid-state cards are. See also, memory card.

middle gray
Halfway between black and white, it is an average gray tone with 18% reflectance. See also, gray card.

midtone
The tone that appears as medium brightness, or medium gray tone, in a photographic print.

mode
Specified operating conditions of the camera or software program.

modeling illuminator
A low power lamp built-in to a Speedlight that emits light to emulate the light from the main flash tube to help assist in the assessment of the lighting direction and quality.

moiré
Occurs when the subject has more detail than the resolution of the digital camera can capture. Moiré appears as a wavy pattern over the image.

monitor pre-flashes
See pre-flashes.

MOSFET
Metal Oxide Semiconductor Field Effect Transistor, which is used as an amplifier in digital cameras.

NEF
Nikon Electronic File. This is Nikon's proprietary RAW file format, used by Nikon

digital cameras. In order to process and view NEF files in your computer, you will need Nikon View (version 6.1 or newer) and Nikon Capture (version 4.1 or newer).

Nikkor
The brand name for lenses manufactured by Nikon Corporation.

noise
The digital equivalent of grain. It is often caused by a number of different factors, such as a high ISO setting, heat, sensor design, etc. Though usually undesirable, it may be added for creative effect using an image-processing program. See also, chrominance noise and luminance.

non-TTL Auto Flash
The output of the Speedlight is monitored by a small, built-in sensor, which sends a signal to shut down the flash once sufficient light has reached the subject.

normal lens
See standard lens.

Off-the-Film metering (OTF)
A form of flash exposure control performed by Nikon film cameras, which measures the amount of light from the flash reflected off the film during the main exposure.

operating system (OS)
The system software that provides the environment within which all other software operates.

overexposed
When too much light is recorded with the image, causing the photo to be too light in tone.

P
See Program mode.

pan
Moving the camera to follow a moving subject. When a slow shutter speed is used, this creates an image in which the subject appears sharp and the background is blurred.

PC
Personal Computer. Strictly speaking, a computer made by IBM Corporation. However, the term is commonly used to refer to any IBM compatible computer.

perspective
The effect of the distance between the camera and image elements upon the perceived size of objects in an image. It is also an expression of this three-dimensional relationship in two dimensions.

pincushion distortion
A flaw in a lens that causes straight lines to bend inward toward the middle of an image.

pixel
Derived fro picture element. A pixel is the base component of a digital image. Every individual pixel can have a distinct color and tone.

plug-in
Third-party software created to augment an existing software program.

polarization
An effect achieved by using a polarizing filter. It minimizes reflections from non-metallic surfaces like water and glass and saturates colors by removing glare. Polarization often makes skies appear bluer at 90 degrees to the sun. The term also applies to the above effects simulated by a polarizing software filter.

pre-flashes
A single, or series, of brief, low intensity light pulses emitted by some Nikon Speedlights to assist in the evaluation of the brightness and contrast in a scene, and the subsequent calculations performed by the camera to assess the required flash output.

Program mode
In Program exposure mode, the camera selects a combination of shutter speed and aperture automatically.

RAM
Stands for Random Access Memory, which is a computer's memory capacity, directly accessible from the central processing unit.

RAW
An image file format that has little or no internal processing applied by the camera. It contains 12-bit color information, a wider range of data than 8-bit formats such as JPEG.

RAW+JPEG
An image file format that records two files per capture; one RAW file and one JPEG file.

Rear curtain sync
A feature that causes the flash unit to fire just prior to the shutter closing. It is used for creative effect when mixing flash and ambient light.

red-eye reduction
A feature that causes the flash to emit a brief pulse of light just before the main flash fires. This helps to reduce the effect of retinal reflection.

Repeating flash mode
In this mode the flash emits a series of light pulses at a level and frequency determined by the user rather than a single light pulse.

resolution
The amount of data available for an image as applied to image size. It is expressed in pixels or megapixels, or sometimes as lines per inch on a monitor or dots per inch on a printed image.

RGB mode
Red, Green, and Blue. This is the color model most commonly used to display color images on video systems, film recorders, and computer monitors. It displays all visible colors as combinations of red, green, and blue. RGB mode is the most common color mode for viewing and working with digital files onscreen.

S
See Shutter-priority mode.

saturation
The intensity or richness of a hue or color.

sharp
A term used to describe the quality of an image as clear, crisp, and perfectly focused, as opposed to fuzzy, obscure, or unfocused.

short lens
A lens with a short focal length – a wide-angle lens. It produces a greater angle of view than you would see with your eyes.

shutter
The apparatus that controls the amount of time during which light is allowed to reach the sensitized medium.

Shutter-priority mode
An automatic exposure mode in which you manually select the shutter speed and the camera automatically selects the aperture.

slow sync
A flash mode in which a slow shutter speed is used in order to allow low-level ambient light to be recorded be the sensitized medium.

SLR
Single-lens reflex. A camera with a mirror that reflects the image entering the lens through a pentaprism or pentamirror onto the viewfinder screen. When you take the picture, the mirror reflexes out of the way, the focal plane shutter opens, and the image is recorded.

small-format sensor
In a digital camera, this sensor is physically smaller than a 35mm frame of film. The result is that standard 35mm focal lengths act like longer lenses because the sensor sees an angle of view smaller than that of the lens.

Speedlight
The brand name of flash units produced by Nikon Corporation.

standard lens
Also known as a normal lens, this is a fixed-focal-length lens usually in the range of 45 to 55mm for 35mm format (or the equivalent range for small-format sensors). In contrast to wide-angle or telephoto lenses, a standard lens views a realistically proportionate perspective of a scene.

Standby mode (STBY)
A mode in which the Speedlight partially shuts down after a period of inactivity to help conserve battery power

stop
See f/stop.

stop down
To reduce the size of the diaphragm opening by using a higher f/number.

stop up
To increase the size of the diaphragm opening by using a lower f/number.

strobe
Abbreviation for stroboscopic. An electronic light source that produces a series of evenly spaced bursts of light.

stroboscopic
See Repeating Flash mode.

synchronize
Causing a flash unit to fire simultaneously with the complete opening of the camera's shutter.

telephoto effect
When objects in an image appear closer than they really are through the use of a telephoto lens.

telephoto lens
A lens with a long focal length that enlarges the subject and produces a narrower angle of view than you would see with your eyes.

thumbnail
A miniaturized representation of an image file.

TIFF
Tagged Image File Format. This popular digital format uses lossless compression.

tripod
A three-legged stand that stabilizes the camera and eliminates camera shake caused by body movement or vibration. Tripods are usually adjustable for height and angle.

TTL
Through-the-Lens, i.e. TTL metering.

USB
Universal Serial Bus. This interface standard allows outlying accessories to be plugged and unplugged from the computer while it is turned on. USB 2.0 enables high-speed data transfer.

vignetting
A reduction in light at the edge of an image due to use of a filter or an inappropriate lens hood for the particular lens.

viewfinder screen
The ground glass surface on which you view your image.

VR
Vibration Reduction. This technology is used in such photographic accessories as a VR lens.

wide-angle lens
A lens that produces a greater angle of view than you would see with your eyes, often causing the image to appear stretched. See also, short lens.

Wi-Fi
Wireless Fidelity, a technology that allows for wireless networking between one Wi-Fi compatible product and another.

Wireless Lighting System
A communication method used to control remote Speedlights by sending signals in the form of light pulses from a master flash, or commander unit.

zoom lens
A lens that can be adjusted to cover a wide range of focal lengths.

Nikon Resource Page
Visit Nikon Sites Around the World

Nikon Corporation (http://www.nikon.com)
Nikon Imaging Global Headquarters (http://nikonimaging.com)

The Americas
Canada (http://www.nikon.ca)
USA (http://www.nikonusa.com)

Europe & Africa (http://www.europe-nikon.com)
Austria (http://www.nikon.at)
Belgium (http://www.nikon.be)
Czeck Republic (http://www.nikon.cz)
Denmark (http://www.nikon.dk)
Finland (http://www.nikon.fi)
France (http://www.nikon.fr)
Germany (http://www.nikon.de)
Hungary (http://www.nikon.hu)
Italy (http://www.nital.it)
Netherlands (http://www.nikon-nl.nl)
Poland (http://www.nikon.pl)
Russia (http://www.nikon.ru)
Sweden (http://www.nikon.se)
Switzerland
 Schweiz (http://www.nikon.ch)
 Suisse (http://www.europe-nikon.com/home/fr_CH/homepage/broad/site.html
United Kingdom (http://www.nikon.co.uk)

Asia and Australia
Australia (http://www.nikon.com.au)
China (http://www.nikon.com.cn)
Hong Kong (http://www.nikon.com.hk)
Japan (http://www.nikon.co.jp)
Korea (http://www.nikon.co.kr)
Malaysia (http://www.nikon.com.my)
Singapore (http://www.nikon.com.sg)
Taiwan (http://www.npt.com.tw)

Nikon D80

The 10.2 megapixel Nikon D80 camera was introduced in August 2006. Its built-in Speedlight has an ISO 100 Guide Number of 42 (feet), 13 (meters), and uses the camera's 420-pixel RGB sensor for i-TTL flash exposure control. The D80 is fully compatible with the Nikon Creative Lighting System, including the Advanced Wireless Lighting System. Its built-in Speedlight operates as a commander unit to control up to two groups of remote Speedlights (SB-800, SB-600, and SB-R200 only).

A full range of flash sync modes is available, including automatic (A), fill-flash, red-eye reduction, red-eye reduction with Slow sync, Slow sync, and Rear-curtain sync. Plus, the D80 supports auto aperture (AA) and distance priority flash modes when used in conjunction with the SB-800 Speedlight. Regardless of whether you use the built-in Speedlight, the SB-600, or SB-800, the D80 camera supports i-TTL automatic balanced fill-flash in all exposure modes with either Matrix or center-weighted metering. If you select spot metering, the camera supports standard i-TTL flash. Standard i-TTL flash is also available with the D80 when it is selected on either the SB-800 or SB-600 Speedlights.

The Nikon D80 has a maximum flash sync speed of 1/200th second, but also supports automatic FP high-speed sync flash with the SB-800, SB-600, and SB-R200 (auto FP high-speed sync flash is not available with the built-in Speedlight).

Index